Voicetracks

Leonardo

Roger F. Malina, Executive Editor

Sean Cubitt, Editor-in-Chief

See <http://mitpress.mit.edu> for a complete list of titles in this series.

Voicetracks

Attuning to Voice in Media and the Arts

Norie Neumark

The MIT Press
Cambridge, Massachusetts
London, England

This book was set in ITC Stone Sans Std and ITC Stone Serif Std by Toppan Best-set Premedia Limited. Printed and bound in the United States of America.

Library of Congress Cataloging-in-Publication Data

Names: Neumark, Norie, author.
Title: Voicetracks : attuning to voice in media and the arts / Norie Neumark.
Description: Cambridge, MA : The MIT Press, 2017. | Series: Leonardo book series | Includes bibliographical references and index.
Identifiers: LCCN 2016039113 | ISBN 9780262036139 (hardcover : alk. paper)
Subjects: LCSH: Voice in art. | New media art--Themes, motives.
Classification: LCC N8257.5 .N48 2017 | DDC 302.23--dc23 LC record available at https://lccn.loc.gov/2016039113

10 9 8 7 6 5 4 3 2 1

For MM and Z&Z

Contents

Series Foreword

Leonardo/International Society for the Arts, Sciences, and Technology (ISAST)

Leonardo, the International Society for the Arts, Sciences, and Technology, and the affiliated French organization Association Leonardo have some very simple goals:

1. To advocate, document, and make known the work of artists, researchers, and scholars developing the new ways in which the contemporary arts interact with science, technology, and society.
2. To create a forum and meeting places where artists, scientists, and engineers can meet, exchange ideas, and, when appropriate, collaborate.
3. To contribute, through the interaction of the arts and sciences, to the creation of the new culture that will be needed to transition to a sustainable planetary society.

When the journal *Leonardo* was started some forty-five years ago, these creative disciplines existed in segregated institutional and social networks, a situation dramatized at that time by the "Two Cultures" debates initiated by C. P. Snow. Today we live in a different time of cross-disciplinary ferment, collaboration, and intellectual confrontation enabled by new hybrid organizations, new funding sponsors, and the shared tools of computers and the Internet. Above all, new generations of artist-researchers and researcher-artists are now at work individually and collaboratively bridging the art, science, and technology disciplines. For some of the hard problems in our society, we have no choice but to find new ways to couple the arts and sciences. Perhaps in our lifetime we will see the emergence of "new Leonardos," hybrid creative individuals or teams that will not only

develop a meaningful art for our times but also drive new agendas in science and stimulate technological innovation that addresses today's human needs.

For more information on the activities of the Leonardo organizations and networks, please visit our websites at http://www.leonardo.info/ and http://www.olats.org.

Roger F. Malina

Executive Editor, Leonardo Publications

ISAST Governing Board of Directors: Nina Czegledy, Greg Harper, Marc Hebert (Chair), Gordon Knox, Roger Malina, Tami Spector, Darlene Tong

Acknowledgments

I pay my respects and acknowledgments to all Traditional Custodians on whose land I live, work, and travel through.

This book has been a long time in the making and has benefited from many conversations with friends and colleagues along the way. I want to begin by thanking those who read the manuscript: Anna Gibbs, Ansa Lønstrup, Maria Miranda, John Tebbutt, Chris Caines, and Malcolm Angelucci all generously offered astute advice and through their incisive thinking pressed me to clarify my ideas. And then there have been the mysterious peer reviewers whose wise comments and insightful suggestions went straight to the heart of things. Sincere appreciation goes to them all.

This work has greatly benefited from fellowships. I am most grateful to the Section for Aesthetics and Culture at Aarhus University, Denmark, where I was privileged to be a Guest Professor while working on this material in Spring 2014. Each day in Aarhus I'd walk to campus and feel joy in anticipation of a day spent reading, conversing, thinking, writing. Colleagues there generously engaged with my project and made my visit enjoyable and stimulating. I'd particularly like to acknowledge Ansa Lønstrup, with whom I shared so many important and thought-provoking conversations, as well as Birgitta Stougaard Pedersen, Charlotte Rørdam Larsen, Pia Rasmussen, Mary Russo, Dan Warner, Steen Nielsen, Thomas Bjørnsten, Marie Høglund, Anette Vandsø, and of course all those who shared ideas in the lively Aesthetics Seminars and other gatherings. The Sound focal theme year at the Society for the Humanities, Cornell University, was another hotbed of exciting thinking about sound—thanks to the keen intellectual leadership of Tim Murray—and I was fortunate to have a brief invited Fellowship there in 2012.

The project began while I was at the University of Technology (UTS), Sydney, Australia, where friends and colleagues, especially Ross Gibson and Theo van Leeuwen, engaged in provocative conversations about voice well

before it became the hot topic it is now. In 2010 I moved to Melbourne, Australia, where the Centre for Creative Arts at La Trobe University, in its short but vigorous life, was a hothouse of creative collaborations among academics, students, and artists. Among the colleagues there who generously discussed my approach for this book, I'm particularly grateful to Peta Tait for her continuing support and for sharing her profound knowledge about animal studies. As artists and budding academics, the students I supervised at La Trobe were a source of lively conversations that contributed much to my thinking. They include Jan Brueggemeier, Gary Devilles, John Hopkins, Lynne Kent, Eugenia Lim, Eloise Ross, Liz Thompson, and Shannon Young. During the final year of writing I was based at the Victorian College of the Arts (VCA), University of Melbourne, which provides a unique and dynamic atmosphere for artists and thinkers engaged in creative arts and new materialism. Barbara Bolt has been a key figure in this work at VCA—and beyond—and a much-appreciated supporter of my work.

Participation in conferences and seminars has been vital to this project. I'd especially like to acknowledge *Sound Studies: Mapping the Field*—the 2014 European Sound Studies Association Conference—where vibrant discussions about sound and voice were invaluable for this book. The 2015 Australasian Animal Studies Association conference, *Animal Publics: Emotions, Empathy, Activism*, also provided much food for thought, including amazing vegan lunches. *Transversal Practices: Matter, Ecology and Relationality*—the VI International Conference on New Materialisms (2015)—extended my understandings of new materialism. The intense discussions about voice at the *Voice/Presence/Absence* conference at UTS in 2013 crucially invigorated this project at an early stage.

Previous publication of material that I've reworked here has been essential to my thinking process, and I would like to gratefully acknowledge those publications and their editors: "Mapping Soundfields: A User's Manual," *Journal of Sonic Studies*, no. 10 (October 2015); "Enchanted Voices: Voice in Australian Sound Art," in *Voice Studies: Critical Approaches to Process, Performance and Experience*, edited by Thomaidis Konstantinos and Ben Macpherson (London: Routledge, 2015); "Mapping Sounding Art: Affect, Place, Memory," in *Routledge Companion to Sounding Art*, edited by Marcel Cobussen, Vincent Meelberg, and Barry Truax (London: Routledge, 2017).

The support for this book at the MIT Press has been generous and indispensable. From the beginning, my editor, Doug Sery, believed in and encouraged the project—including my writing approach—and I am truly grateful for his invaluable guidance and support. Susan Buckley provided conscientious and thoughtful assistance throughout the publication process. I was especially fortunate, too, with the sensitive and creative copy-editing advice of Matthew Abbate.

Without the wonderful artists whose works I listened to for this book, none of it would have been possible. Some are people I know and some are strangers, but all have made vital and inspiring work that nourished and provoked my writing. I particularly want to thank those who generously provided the images which so enliven this book

Finally, I express my deepest gratitude to Maria Miranda. As an art collaborator, Maria constantly surprises me with the possibilities that she imagines for us. As a reader of endless versions of the manuscript, she has gently prodded me to rethink and rework even when I resisted. Maria's ideas and lateral thinking have been crucial to this book. And as a partner, the care Maria gives to me, and our companion cats Ziggy and Zazie, has sustained me and brought real joy to my life.

1 Introduction: Voice, Voicetracks, New Materialism

Ahem ... clearing the throat

I begin with a clearing of the throat, a cough, as I remember a crucial conceptual art piece by Yoko Ono recorded in 1963—her cough piece. In this work Ono coughs for 32'31" (Ono 1961)—making a most significant work for conceptual sound art at the time and resonating still. This is a work that affects me most deeply and viscerally, evoking both an affect and a memory, each time I listen. It reminds me of the contagion of the vocal eruption that is the cough, the cough moving from Ono to me, to which my inevitable bodily response is to cough uncontrollably along with it. And it also reminds me of a time, decades ago, when I made my first radio programs at the ABC (Australian Broadcasting Corporation), the Australian national broadcaster, and how we were expected to cut out the coughs, the ums, the ahs, the ahems, the hesitations—literally excising them from the analog tape. But somehow even then I couldn't quite let go of these vocalizations and eruptions and I would stick the cut-up bits of tape on the wall, hoping they might eventually sneak back in. Feeling my own attachments to these nonverbal utterings that I grasped in my very fingertips, I sensed the complexities of voice, and I have followed its lure ever since, through my own theoretical and practice-based work.

Finding the write voice

As I set out to write this book tracking voice through media, the arts, and new materialism, I find myself wondering, in what voice should I speak here? What is the write voice, the right voice of writing that accommodates both traditional scholarly concerns as well as the situated knowledge that resonates with my own and others' media and artworks? How can I write in

a way that responds to the calls of creative works, calls to me as a listener—calling for thinking? How can I evoke and engage with the thinking that happens in the making of art? And when I think about the context for the book, I wonder: What is the right writing to engage with the affects, aesthetics, and ethics of voice in the new materialist turn (which, since the late 1990s, has been unfolding transversally across not just the arts and feminism but also philosophy, science studies, and cultural and media theories as anthropocentrism has come more prominently into question)? What can writing about voice offer to new materialism and, in turn, what might new materialism offer to voice studies in the posthumanist era?[1] And how does this matter politically?

I will be engaging with these questions by writing from my own encounters with creative works in media and the arts. Listening and conversation will be crucial to my writing strategy, as I endeavor to find the write voice that entangles—and that brings into conversation—'situated knowledge' and 'carnal knowledge' with theoretical and critical discourses around voice, sound, media, and the arts. Through my encounters with creative practices I hope to unfold a method of thinking through conversations—developing knowledge through and from situated listenings and carnal responses. Before turning to situated knowledge and carnal knowledge and the write voices they provoke for me, I would like to introduce some of the key concepts from voice studies and new materialism that I will be calling on.

Tracking voices

In the second half of the twentieth century, tracking voices got a lot more complicated. Once upon a time it seemed easy, when human voices spoke with presence and authenticity—that was until critical theory raised fundamental doubts about presence and authenticity, not to mention voice itself.[2] But then to the rescue came various theories of intersubjectivity and performativity, which helped to breach the impasse and open ways of listening to (human) voices anew. Meanwhile, a number of *post* theories of various sorts were also tracking voices in other ways: from Don Ihde's and Alphonso Lingis's postphenomenology to new materialists, theorists were listening to voices of animals, things, and now assemblages. As Don Ihde

proposed in 1976, "the things of the world *have voices* that we can listen to" (Ihde 2007, 190, my italics).

A recent key cultural theorist of voice, Steven Connor, like Ihde, also follows Merleau-Ponty's listening to "the world's own capacity to give voice" (Connor 2000, 10). Both of these theorists have a sense of voice that is animated and animating in a way that speaks of the vitality and vibrancy to which I'll return with the discussion of new materialism; and, further, it suggests why voice can make such an important contribution to the thinking of new materialism.

As new materialism rethinks subjectivity beyond the unitary, self-interested, individualist, human subject (Braidotti 2013, 49–50), as it turns our attention to what Erin Manning and Brian Massumi figure as the *more-than-human*,[3] it becomes more possible to engage in Ihde's listening to voices beyond the human, the literal voices of things and of nature, as they speak and tell us things. As Karen Barad puts it, for feminists like Vicki Kirby and herself, matter *speaks*: "Matter feels, *converses*, suffers, desires, yearns and remembers" (Dolphijn and van der Tuin 2012, 59, my italics; see also 108). While (new) materialism's ethical and relational ways of listening seem more or less recent (especially if we fail to remember the West's own 'prescientific' and animist past), there are of course cultures that have tracked these voices in sophisticated ways for a very long time—beginning with First Nations peoples. Indigenous Australians continue to remind us of the materialism of voice, of the multiplicity of voice, of the groundedness of voice in country, as Deborah Bird Rose explains:

Country in Aboriginal English is not only a common noun but also a proper noun. People talk about country in the same way that they would talk about a person: they speak to country, sing to country, visit country, worry about country, feel sorry for country, and long for country. People say that country knows, hears, smells, takes notice, takes care, is sorry or happy. Country is not a generalised or undifferentiated type of place, such as one might indicate with terms like 'spending a day in the country' or 'going up the country'. Rather, country is a living entity with a yesterday, today and tomorrow, with a consciousness, and a will toward life. (Rose 1996, 7)

This resonates with the thinking of feminists like Karen Barad and with Don Ihde's phenomenological listening—a listening with his "whole body," embedded in a particular place and situation (Ihde 2007, 44). Social anthropologist Tim Ingold—who has been deeply influenced by Indigenous cultures and for whom what Ihde calls *embedment* is crucial—experiences it

thus: "to follow sound [and I would add voice] that is to *listen* is to wander the same paths" (Ingold 2011, 139).

Listening to voice in media and the arts in today's posthumanist context in the West, where there is a rapidly developing field of voice studies[4] as well as new materialist work, will require a transdisciplinary or transversal approach—drawing upon sound studies, animal studies, new materialism, and aesthetics, as well as voice studies itself. Paradoxically, at the same time as there is a growing commitment to transdisciplinarity in the humanities and social sciences—a transdisciplinarity that enables a book like this— there is also an explosion of new fields and disciplines. But this is a paradox that I'm embracing here, as I foreground voice studies—a younger sister to the relatively recent discipline of sound studies—not so much for territorial reasons but to address the specificities of voice itself. But let me begin by talking about affect, since it is such a key aspect of voice throughout both voice studies and new materialist discourses.

Affects, emotions, and feelings ...

in my body ...
As I jump with joy, my lungs open and I sing out. When I recoil with fear, I hold back my breath and swallow my voice. And as sadness weighs down my heart, my limbs turn to lead and my voice constricts in my throat.

and across bodies ...
I remember one of my cats, my companion of twenty-two years. She felt my emotions with me and for me. Emotions I didn't 'know' I had, even though as it turned out my body was wracked with affect, contagious affect, that my brave little cat took on, racing up and down the hallway. Like a poltergeist, I thought then (yes, I was watching a lot of that sort of television during difficult days). And so the affect went from my body to that of my cat—she spirited it away, generously, crazily, taking it on and letting it out. As I watched her, as I listened to her paws pounding the floorboards, voicing my anxiety, I realized just how deeply disturbed I was.

Emotions are both familiar and strange in their bodily movements, movements shaped by affect and expressed, *vocalized* as they emerge from those bodies. At the level of quotidian familiarity, I think we have all experienced emotions as feelings that are in our bodies and that move and

contour our bodies—and that contour our voices as they do. And we have experienced how voice—our own voices or the voices of others that we listen to—in turn can contour our emotions. Anna Gibbs figures voice, an "amplifier of affect," as doing more than vocalizing and expressing emotions—it activates, shapes, and indeed produces them for the speaker and listener.[5]

Emotions (etymologically speaking, the word comes from the Latin *emovere*, to move out) are also social and relational as they move between bodies, human and animal, and between things and machines. At this point, with the *affective* turn in philosophy and cultural theory, debates around emotion and affect raise their voices.[6] The debates about affect are philosophically complex and beyond the scope of this book. I will present here a working approach to affect, emotion, and feeling, but also try to remain open to where their differences blur. Erik Shouse has provided one way of summarizing the differences that I find useful as a starting point: "Feelings are *personal* and *biographical*, emotions are *social* and affects are *prepersonal*" (Shouse 2005, 1). Focusing on affect, Shouse offers prelinguistic infant vocalizations as an example (Shouse 2005). Affects, in this sense, are conceptualized as *doing* things: they are understood as presymbolic 'intensities' and movements prior to our personal and conscious sense of investments and attachments. Thinking affect from a Deleuzian perspective, Brian Massumi, a key figure in affect studies, approaches affect energetically, as a "capacity," of which emotion is a "selective activation" (cited in Gibbs 2010, 187).

Affect and emotion often seem to blur when they perform cultural and political investments and attachments between individuals, objects, communities, collectivities, worlds.[7] Working with William James's theory of emotions, Vinciane Despret evokes the entanglement of emotion and affect—the affective movement and the sociality of emotions (Despret 2004, 125–170). "An emotion, according to James, is not what is felt but what makes us feel. Each emotional experience is an experience of 'making available,' an experience by which both the body and what affects it produce each other—each of the events creates an occasion for the others. In other words, our feelings dispose our bodies, our bodies dispose our feelings" (Despret 2013b, 71). For James, there is a dual movement in this producing of/by emotion—we effect it and it effects us, as it moves (in) the mind, bodies, and things—and between them (Despret 2004, 126–127).

Like John Dewey's pragmatism, this entangles knowing with doing (Bernstein 2013).

Emotion and affect have also been analyzed through the figures of contagion and mimesis. As with the Deleuzian sense of contagion, the relationship of mimesis to affect is crucial because affect, and its movements and forms, play a vital role in mimetic communication and in aesthetic practice (Gibbs 2015, 1; see also Gibbs 2010, 187). Most usefully for the purpose of understanding media and the arts, Anna Gibbs works with mimesis as the transmission of affect, including 'corporeal copying' and 'affective spectatorship' (Gibbs 2015, 1). Gibbs's approach to the 'affect contagion' of mimesis attends to all the senses, modes, and movements involved, including those of voice and vocalizations, in a way that resonates with voice and its vitality (Gibbs, 2010). With Gibbs, the usual focus on vision, particularly in media, gives way to a more nuanced sense of spectatorship and mimetic movement, as it attunes and synchronizes human bodies and more-than-human bodies (Gibbs 2015, 3).

This affect contagion reminds me of what Salomé Voegelin says about the voice of Maurice Merleau-Ponty in her book on listening. In a section delightfully titled "being honeyed," Voegelin tells of listening to Merleau-Ponty's radio voice as he describes a painting by Cézanne, and the effects his bodily voice *produces* on listeners' bodies as the paintings are "produced in their imagination, invented and tasted through their ears." "His voice becomes the honey that drips into my ears and engages me without taking certain shape; it remains a roving complexity that grasps me ... [as] Merleau-Ponty's voice binds me to honey's sugary stickiness and the lemon's sour flesh" (Voegelin 2010, 9–10).

Being honeyed ... through the ear ... and through reading the writing of voice by another, reading and listening to another. Merleau-Ponty's voicing his sweet and sour mimetic response to a painting 'grabs' me just as it does Voegelin, producing in turn a mimetic response in her and then me. As I listen with and to Voegelin—and remember radio voices in my own past that have grasped and held me with their palpability—my thoughts flow in honeyed richness and mimesis comes into focus.

Mimetic responses such as these can take place across humans and other animals, across the living and nonliving, working through different sensory modalities, including auditory, as Gibbs discusses (Gibbs 2015, 2–4). Mimesis, as she understands it, speaks of voice and new materialism,

raising important questions about attunement across species through media and the arts—questions that resonate particularly with and through voice. In a range of modalities of voice—including coughing, laughter, yawning, and the gulping of vomiting—most of us will have experienced just such an attunement, as these voices provoke mimetic responses in us, responses with which the arts particularly can work aesthetically.

What is also interesting for voice in these discussions and debates is the way—if we focus on the body when it is both personal and social—that 'personal' feelings and 'social' emotions are entangled and difficult to separate. What I hope to evoke and develop here is an understanding of voice that can help us think about this. Voice works intersubjectively, relationally, affectively, and emotionally—transmitting and moving through us and between us and others. Voice, which is more than/different from the speech and the meanings it may carry, encompasses and transmits both preverbal and nonverbal vocalizations of intensities (affects) as well as expression of feelings and emotions. What this raises for me is how voice complicates the concept of affect—voice is both moved by affect and expresses the nonverbal affect that can provide the vitality, intensity, and movement that color and contour the feeling and emotion expressed by that voice. In this sense the paradoxes of voice help us understand the paradox of the relationship between affect, feeling, and emotion. Emotion cannot be understood without the affect that animates it. Attention to emotion and affect helps us listen to voice's intensities and to its transmissions between bodies—to voicing and vocalization as expressive and performative. In short, it is how these emotions and affects work through voice as mediator, as movement, as performative and expressive, and as transmitting attachments that I listen to as audible in the works I encounter. And to attend to the affect in voice, I sense, we need to listen differently.

Listening to human voice

Before turning to the more-than-human voices to which new materialism attunes us differently, and the ways that listening opens our ears to their materiality and movement, I will summarize my understanding of the complex assemblage that is the human voice. Human voices call to us in many ways, often speaking of intimate connections—talking, singing,

whispering, breathing—between us and others (human and more-than-human). They call across spaces and media. Voice has been theorized in many ways, from the metaphorical to the literal sonic and much in between and across. This attention to voice is certainly not new in philosophy, psychoanalysis, cultural studies, media studies, and aesthetics.

In previous work I elaborated on transdisciplinary understanding of the modalities, techniques, and performativities of human voices, particularly mediated voices.[8] I proposed that an embodied, textured, material voice is not the same as the "authentic" self-present voice that worried Jacques Derrida. I considered how voice is fundamentally and expressively paradoxical, with an ambiguity and supplementarity that take it beyond the phonocentrism and logocentrism that Derrida criticized. Starting with the life-and-death ground zero of breath, its inspiration and expiration, its puffing and panting, and then moving to stuttering, muttering, and various garbled and nonsemantic utterances, I explored how we can hear the affect and emotion in voice, apprehend its aesthetics—to listen within and beyond language. Let me briefly rehearse some of these discussions here.

Even with the growing literature around voice and the emergence of the field of voice studies, it is difficult to *define* voice. Steven Shaviro's response to the paradox of voice is found *in between*: "The voice always stands in between: in between body and language, in between biology and culture, in between inside and outside, in between subject and Other, in between mere sound or noise and meaningful articulation. In each of these instances, the voice is both what links these opposed categories together, what is common to both of them, without belonging to either" (Shaviro 2006). Or you might figure this in-betweenness, with performance theorist Amelia Jones, as a *hinging* quality of voice—bending and connecting, opening and intertwining (Jones 2010, 146).

Intersubjectivity is a significant aspect of voice for one of its most important philosophers, Adriana Cavarero. She argues that the intersubjectivity of voice is about unique beings listening to each other, communicating their uniqueness to each other, in a call-and-response duet that is fundamentally a *reciprocal* relation (Cavarero 2005, 5). For her, as for many in the emerging field of voice studies, listening is crucial for apprehending voice.

Cavarero, like other theorists of voice such as Mladen Dolar, recognizes the materiality, the sonorousness, of the human voice. She argues, for

instance, that there is a problem with Derrida's figure of *speech*: in joining the sonorous (material) with the meaningful as a *unitary* figure, he makes it difficult to think the difference and specificity of voice. Another important theorist of the politics and poetics of voice (and sound), Brandon LaBelle, also foregrounds the complex materiality of voice. He listens to the human voice through the oral imaginary, focusing on the materiality of the mouth and the 'interweave' between voice and mouth, between sense and non-sense, between sonic materiality and the semantic (LaBelle 2014, 185 and passim).

The materiality of the human voice is not straightforward, however. It is also uncanny. In its movements in time and in space, in its presence/absence, voice resonates with the presence/absence of the uncanny. Uncannily, voice emerges from the body and also carries the body with it. It emanates from it but is not fully disembodied. It carries its embodiment within itself and from one body to another. It is *haunted* by the body. The uncanny, in Freud's sense of *unheimlich* or unhomely, suggests how voice carries a trace of its 'home', the body of the speaker, but also leaves that home as it performs speaking.[9] And the voice in digital media is even more uncanny, with a second 'home'—the digital realm of 1s and 0s—which it must leave in order to sound analogically. There is an amplified haunting sense here that we know where the digital voice lives, even if we can't go there.

The uncanny bears traces of the connection of materiality and movement in the human voice. Voice is both a bodily phenomenon and movement. As movement, it traverses the individual body, as well as from and between bodies and spaces, contouring them as it goes, bringing worlds into being: "Listen, says a voice, some being is giving voice"—and in so doing "bringing the speaker's world into being" (Connor 2000, 4). To do this, to move and effect in this way, the *production* of voice is also a matter of *work*—a mouthing, an act, an event, a performative (LaBelle 2014, 1–13; Connor 2000, 3–6).

Performativity has been a particularly productive concept for human voice. Thanks to the seminal writing of Judith Butler, performativity is now a very familiar concept in general and especially for feminist theory. Butler works with J. L. Austin's concept of performative utterances—utterances "that accomplish, in their very enunciation, an action that generates effects," as Andrew Parker and Eve Kosofsky Sedgwick put it (Parker and Sedgwick 1995, 3). Focusing on performativity in relation to performance,

spatiality, and postmodernism, Parker and Sedgwick importantly expand understandings of its significance, beyond an earlier focus on questions of gender and identity. They also unpack the complexities and contradictions of its wider usage across a range of fields including philosophy and literature. For them, the vital aspects of performativity, across these various usages, are "the torsion, the mutual perversion, as one might say, of reference and performativity"—in short, its queerness (Parker and Sedgwick 1995, 3, 5). Bringing this queer performativity into conversation with posthumanist materialism, Karen Barad goes a step further, or to the side. Shifting attention to "matters of practices/doings/actions," she proposes an understanding of performativity that moves away from language altogether and actually contests the unexamined and assumed power of language and representation over and above the "stuff of reality" (Barad 2003, 802).

Within an art context, performativity allows us to focus on voice as enacting and embodying rather than (transparently or authentically) expressing or representing (LaBelle 2006, 63). For me performativity has been useful as a way to take voice away from the essential and instead to approach it as gesture and event. It is a way to point to what voices *do*, how they *create*, but also, as Judith Butler suggests, to destabilize meaning rather than just convey it.

Breath has a lot to say about the performative and material human voice, as Steven Connor (2000) and Brandon LaBelle (2014) compellingly explore. Voice begins with the breath, which moves and carries the voice from inside our bodies out, animating it, contouring it, giving it rhythm and life, and expressing its rhythm and life. Ephemeral and intimate, breath is both bodily and not, starting in one body and connecting to another. It animates language but is not itself language. It crosses, divides, and blurs boundaries. It is porous and speaks of porosity.

We can particularly sense the bodily phenomenality and movement of voice at work with breath. Breath is contoured by affect, and it carries affect. Breath is also undecidable, ambiguous to the listener, especially mediated breath, where it's difficult to tell an inhale from an exhale. Speaking of inhales, a little *sotto voce* aside here—I've noticed with interest the way Scandinavian people sometimes breathe *in* as they say 'yes,' so it becomes a vocal/physical gesture of agreement, in which they seem to breathe the other into themselves, performatively, intersubjectively breathing agreement.

Breath also connects us to the place through which it resonates and the others in that place and in the shared medium of air. It not only connects people, intersubjectively, it also connects people to animals and things, voicing the connections between breath and the natural environment. I listen to this in *The Algae Opera* of artists BurtonNitta (Michael Burton and Michiko Nitta), for example, which literally breathes life into the natural environment, giving voice to the relationship between human breath and plant life on our planet. In this work, it is an opera singer's copious voiced breath that literally breathes life into algae. Masked in a specially designed piece of biotechnology, an algae headdress, the opera singer, the algae, the audience and I (watching documentation) form a strange relationship, a curious assemblage. The carbon dioxide in her breath feeds the algae, which later will be fed to the audience, so that they can literally "taste her song" (Burton and Nitta n.d.).

In *The Algae Opera*, the head mask, attached to tubing which channels the breath to an algae tank, is a strange mixture of a Greek mask, a persona, and a beautiful lunglike filigree that looks like a seahorse. The singer feels part sea creature herself as she intones her algae opera. I listen to the voice as medium here, life-giving medium, medium for life. Meanwhile the other sense of medium merges into the undertones as, medium-like, the singer crosses an ether and connects me to another life form. And when the audience eats the algae, I sense that that they are actually ingesting the singer's voice. In an odd way, the work makes me think about John Baldessari's 1972 video of teaching a plant the alphabet. As far as I know (I wonder if anyone ever followed up with those plants?), that work was more humorous and conceptual than literal, in contrast to the literal relationships between plant life and voice that animate works made after the new materialist turn. And it is with new materialist ears that I encounter *The Algae Opera* as it provokes a listening to breath between the human and nonhuman—opening an awareness of the vibrancy of breath and the productiveness of its connections. It voices and breathes life into a sense of intersubjectivity beyond the human.

Before I move beyond the human voice, let me return briefly to listening and how it inflects a write voice. Philosopher Salomé Voegelin figures listening as a particular practice, a sensibility, "an act of engaging with the world" (Voegelin 2010, 3 and passim)—this is a listening which, I notice, provokes, demands, and produces a certain writing voice. Writing about the

subjectivity of listening to sound art, Voegelin cannot suppress her writerly *I* but instead relies on it, putting it into essaying conversation with the more conventional, abstract philosophical listener. This approach confirms for me, by the way, my own preference for an essaying writing voice in a book that centers on *listening* to voice. It is the wonderfully hybrid form of the essay, after all, as Anna Gibbs reminds me, that is paradoxically personal and conversational as well as interpretive. Its "false starts ... digressions, meanderings and wanderings"[10] speak to my looking for the write voice, which has, perhaps, been at the historical heart of essay writing, as it is for me here. *Ahem ...*

Listening beyond human(ist) voices: new materialities, new subjectivities

While my concern in this book is to move beyond human voice and to engage in a conversation with new materialism—opening materially to voices beyond the human, to voices of the world—I am also interested in the ways that uncanniness and paradox shape these other voices too. And, just as materiality is crucial in the human voice, it also takes us beyond human voices. In *Listening and Voice*, his seminal text first published in 1976, Don Ihde works with a phenomenology of auditory experience. As his book's very title tells us, Ihde draws attention to the connection between listening and voice. Following Martin Heidegger's injunction that "existentially things 'speak,'" Ihde listens to the "voice of the environment, of the surrounding life-world." He attends to the voices of material things and the material voices of things, listening, he says, to the way that "the voice of each thing bespeaks something of its *per-sona*" (Ihde 2007, 23, 115–116, 154). Ihde's invoking of the figure of *per-sona* sings out to me like an algae opera: in recalling the Greek mask, *persona*, it speaks of the performativity, and sonority, of voice—human and more-than-human.

To listen to these voices of the material things of the world, Ihde argues, we need to widen our thinking, going beyond an understanding of *speaking* as confined to what humans do through language and expanding our listening. He evokes the way we can *give voice* to things that at first appear silent by engaging with them: "First, we may miss the voices of things because they are often, left by themselves, mute or *silent*. ... Yet each thing can be given a voice. The rock struck, sounds in a voice; the footstep in the sand speaks muffled sound" (Ihde 2007, 190). Reading his words, I

remember the urge I still have to run sticks along fences as I walk by—provoked by the fences themselves that call out for this engagement, calling out from their silence, and reminding me of the complexity of 'silence' and its voice.

Philosopher Alphonso Lingis also listens to the voices of things—listening and thinking through the prism of animism and fetishism. Other species, voices of the absent or dead, and things can all address us, summon us forth and direct us—luring, provoking, charming and hexing, as he puts it (Lingis 2009, 273–274). Lingis regrets that the animism that speaks through art in modern Western culture only finds voices that *we* project *onto* things, unlike earlier animism and fetishism; he would prefer, instead, a recognition of a different conscious and lived "relationship with the material universe" and, with it, a different listening to its voices (Lingis 2009, 278–281). The artworks and media that I will engage with below do invite just such a listening—not to the projection of 'our' voices onto them, but to the material voices of things themselves.

With the new understandings of subjectivity in the posthuman era, relations extend beyond person-to-person. And voice expresses these relations—between humans, animals, things, and their environment (Ihde 2007, 193). It is interesting that, like Cavarero, Ihde deploys the figure of *duet* and focuses on an intersubjectivity of voice as he listens to "the *otherness* revealed by voice" (Ihde 2007, 147). Ihde's understandings resonates for me with philosopher Rosi Braidotti's expanded ethical concept of nomadic, posthuman subjectivity, where the self opens outward, interconnecting with others, human and nonhuman (Braidotti 2013, 188–190, 49–50). And it is voice, I would suggest, that can act to produce—to evoke—these interconnections. Indeed, voice always/already disturbs classic ideas of subjectivity, as Kaja Silverman elaborated in 1988, in ways that will make it particularly useful for new materialism.[11]

New materialism

The debates within and around the terms "posthumanism" and "new materialism" are extensive, and I cannot detail them here. Briefly, however, it seems "posthumanism" has often been the preferred term of those working in science and STS (science and technology studies), while "new materialism" seems to work well transversally[12] for artists and (some)

philosophers. There are, of course, some significant exceptions, and there are also many who abjure both terms. In any case, I am using "posthumanism" to refer to the era or context and new materialism as an umbrella for a broad set of theories. While this accords with the preference of a number of influential theorists, including Jane Bennett, Barbara Bolt, and Estelle Barrett, I also recognize that they and many other theorists have been deeply influenced by feminists who work with the term "posthumanism," including particularly Rosi Braidotti and Karen Barad. In short this is very tricky ground, and my hope is not to get mired in muddy disagreements but to try to track a way through that enables me to work with and acknowledge a range of important thinkers.[13] Hopefully this strategy can be deft of foot rather than sleight of hand, and will facilitate the conversations I hope to engage in.

As an umbrella term, a tendency—a Foucauldian toolbox of concepts even—new materialism itself is agile, indeterminate, and plural. As I have already signaled, it opens up (from) fundamental questioning of anthropocentrism and human subjectivity. With this comes a rethinking of culture, politics, and ethics (Connolly 2013, 399) and, I would note, aesthetics. In their important text *New Materialism: Interviews and Cartographies* (2012), Rick Dolphijn and Iris van der Tuin do not attempt to specify new materialism as a singular theory. Rather, as they explore enactments, movements, entanglements, and intra-actions with, and of, new materialism, they provide a most valuable set of mappings of the ways of thinking—rereadings and rewritings—that produced it and that it produces. Van der Tuin and Dolphijn foreground new materialism's transversality across "feminist theory, science and technology studies, and media and cultural studies" (Dolphijn and van der Tuin 2012, 100). To these I would add practices in media and the arts which themselves are material ways of thinking, doing, and producing knowledge.[14] Inspired by Karen Barad, I would see these artful ways of thinking, these knowledges, these "living and breathing reconfigurings of the world," as "responsible and responsive to the world's patternings and murmurings" (Barad 2012, 207). Barad's attunement to the world's deep murmurings, its hum (Barad 2012, 218), invigorates the conversations around voice in this book.

What I hope to do here, in bringing new materialism and voice in the arts into full-throated and politically vibrant conversation, is to contribute to the deepening of both. In her *Vibrant Matter*, a most influential book for

new materialist thinking, Jane Bennett regularly evokes voice both literally and metaphorically to convey the expressivity of things and assemblages. "Thus spoke the grid," she says, in her discussion of the New York blackout of 2003 (Bennett 2010, 36). Like Barad, Bennett recognizes this *speaking* as something not just humans do and its more-than-human expressivity as something humans need to attune to (Bennett 2010, 104). As Dolphijn and van der Tuin (rereading Vicki Kirby) put it, "matter appears as something that is not only spoken about or spoken with, but rather as itself something simply *speaking*" (Dolphijn and van der Tuin 2012, 108, their italics).

Speaking is, then, not new to this conversation, but here I will be attending to speaking through the voice that animates it. And in the context of this conversation, the entanglements of voice, of speaking with listening, also come to the fore. For Bennett and other new materialist thinkers (and practitioners), listening is a way of attending to a thing—not to its experience from *its* point of view, which we cannot penetrate though we can sense it (hence, by the way, her acceptance of anthropomorphism), but to its performativity in an assemblage. Thus we can focus on listening to the voices of things within assemblages and, furthermore, the voices of assemblages themselves.

Assemblage is a key concept for new materialism, even if it is figured differently by different theorists. For Bennett, assemblages of things are important affectively and ethically. They are constantly changing and effecting change (Bennett 2012, 231). My own way into the theories about assemblages was initially via actor-network theory, or ANT, and Sarah Whatmore's inspiring *hybrid geography*. Whatmore speaks intriguingly of "inter-corporeal intimacies" between the human and the nonhuman. Following Alfred North Whitehead's idea that "the body is only a peculiarly intimate bit of the world," Whatmore suggests a porosity where "the corporeality of the body and of the world fold through each other" (Whatmore 2002, 117–119). ANT figures this folding as networks and relations across categories—including between animate beings, inanimate objects, concepts or ideas or ideologies, institutions or organizations, and spaces. What Bruno Latour and others involved in ANT—and STS—have been doing, by developing a way to talk about animate-inanimate relations, is a useful point of departure to trouble an absolute, essential, human-centered otherness—perhaps to actually trouble otherness altogether—because with

ANT all can be actors in a network. As Latour delightfully puts it, we need to get past the idea that "things don't talk" (Latour 2005, 107). While ANT does approach social networks as contingent and performative, there is a lingering structuralist tone that worries some. Tim Ingold, for instance, who seeks to emphasize relations, prefers the figure of meshwork, whose entangled and interwoven lines are "the trails along which life is lived" (Ingold 2007, 81).[15]

Philosopher of science Vinciane Despret draws out the nonstructuralist, forceful aspects of assemblages, or in the original French, as she prefers, *agencements*—"an active process of attunement that is never fixed once and for all. An *agencement* is a rapport of forces that makes some beings capable of making other beings capable, in a plurivocal manner" (Despret 2013a, 38). I note how integral voice is to this figure, the *plurivocality* of its manner, of its attunement. And the forces that attune *agencement* and its agencies, Despret continues, do not just induce, arouse, spark, instigate, engage, and inspire—they evoke and provoke: "Agency, therefore, appears clearly as the capacity not only to make others do things but to incite, inspire or *ask* them to do things" (Despret 2013, 38, 40, my italics).

Bringing together STS, feminism, queer, Marxist, antiracist, and post-structuralist understandings, Karen Barad significantly shifts the human-centered connotations of agency with her figure of *agential realism* (Barad 2003). She cuts it free from humans and their intentions and individualist subjectivities. And, just as Foucault does with power—shifting it from something that people *have* to an unfixed relationship—Barad does with *agency*. She understands it not as an 'attribute' but as an intra-action, a material "enactment, a matter of possibilities for reconfiguring entangle-ments" that do not necessarily involve humans (Dolphijn and van der Tuin 2012, 54–55; Barad 2003, 817, 826–827).

Even with these significant inflections—with their shift from the usual humanist, causal sense of agency to an iterative and dynamic one of "ebb and flow ... entanglements ... relationalities ... (re)articulations" (Barad 2003, 817–818)—agency of any color remains a tricky, human-centered concept for many.[16] I am often asked whether, by talking about the voice of things, I am giving them 'agency,' which somehow colludes with humanist thinking, extending human qualities to them. And even though Despret's and Barad's refiguring of agency does dispel this worry, I am also moved by Tim Ingold's approach, as he shies away from agency altogether. What I

sense from Ingold—who metaphorically and literally alerts readers of *Being Alive* to the way the world is "telling us things" (Ingold 2011, xii)—is that telling (which to me is a voiced telling) expresses the vitality or vibrancy that is part of being alive, of being in the world.

Enchanted listening

Before her vital work on vibrant matter in 2010, political philosopher Jane Bennett contributed significantly to new materialism, with her rethinking of enchantment as "a state of openness to the disturbing-captivating elements in everyday experience … a window onto the virtual secreted within the actual" (Bennett 2001, 131). Enchantment and wonder—where we are "caught up and carried away" (Bennett 2001, 5)—tune us up and into the world and make audible the voices of nonhumans and things, and their relations with each other and with humans.

Bennett developed her understanding of enchantment in contrast to the figure of reenchantment, which posits that the world has lost its enchantment. She argues instead that the modern world is already enchanted, if we can just sense it. And when we sense it, when we let it surprise us, we can engage more openly and generously in "productive assemblages" with other beings and things (Bennett 2001, 131). Sensing the enchantment and wonder of the modern world, then, animates our new materialist understandings and our ethical and political engagements: "Without modes of enchantment, we might not have the energy and inspiration to enact ecological projects, or to contest ugly and unjust modes of commercialization, or to respond generously to humans and nonhumans that challenge our settled identities" (Bennett 2001, 174).[17]

With attention to affect, ethics, and aesthetics, Bennett revitalizes the old figure of enchantment, letting it loose and opening up ways to look, listen, and sense that disturb and intensify. It is affect, after all, that makes us feel investments and attachments, as she elaborates. Enchantment's intensity of sense perception resonates with Barbara Bolt's discussions of the poetic *revealing* of art in Heidegger's thinking. Bolt makes clear that this revealing, this 'bringing-forth' into unconcealment, is the "'work' that art *does*" (Bolt 2011, 39–41). This bringing forth into unconcealment, like Bennett's sensing with/of enchantment, speaks of making perceptible what is already there—the work of art, indeed.

And to me, it is voice, an artful voice in particular, that has both the poetic potential to reveal and the aesthetic potential to make the always/already enchantment of the modern world audible. I am interested that Bennett suggests that one way to think about listening to the voices of enchantment, to make them audible, is through 'overhearing'—in the alchemical sense. Alchemy has long spoken to artists, so I am particularly drawn to Bennett's argument here. With alchemical hearing and overhearing, inadvertent material seeps in as you hear things simultaneously, superimposed—transforming the whole of what you are hearing. In short, alchemical overhearing is a listening to the knowledge that something already has. Itself an 'old' knowledge, alchemical listening resonates with new materialism in this recognition of the knowledge that things have and that they can voice—in particularly evocative and provocative ways, I would note, in creative practices.[18]

Overhearing and listening through new materialism can make audible and enhance our understandings of voice. Of course, this is not 'new,' as already many years ago Don Ihde, among others, explored how humans, animals, and things have a voice or 'give' voice. These voices speak from the world and tell us about themselves and the world. But in our current posthuman condition, there is pressing need to take this audition further, to listen in different ways to these different voices. To do this, I would reiterate my ambitions for this book—to be part of a conversation between voice studies and new materialism, to extend our thinking about voice itself, on one hand, and, on the other hand, to deepen the understandings of the relations between people, animals, and things that new materialist thinkers in the posthumanist era are developing. And, importantly, the conversation can, I believe, respond to the political and ethical concerns that compel new materialism.

Listening through 'pataphysics

Like alchemy, 'pataphysics, too, perhaps unexpectedly can resonate with new materialism. I am interested in such other, unexpected connections with new materialism, so I'd like to briefly wander down this unlikely path to see where it takes us. 'Pataphysics, the absurd creation of French writer Alfred Jarry from the turn of the last century, is the noninstrumental and nonsensical 'science' of which Jarry is an exemplary figure. The

word is a neologism playing on physics and metaphysics. In *Exploits and Opinions of Doctor Faustroll Pataphysician: A Neo-Scientific Novel*, Jarry defines his 'pataphysics as "the science of imaginary solutions and … above all, the science of the particular, despite the common opinion that the only science is that of the general. 'Pataphysics will examine the laws governing exceptions, and will explain the universe supplementary to this one" (Jarry 1980, 192).

While the "imaginary solutions" of 'pataphysics have been particularly inspiring for my exploration of voice through my creative practice, to which I return in the conclusion, it is the emphasis on *particularity* that speaks to me at this point. In his book *'Pataphysics: The Poetics of an Imaginary Science*, Christian Bök points out that 'pataphysics sits beside science playing with and against its truth effects. It "rules out the rule," as Bök puts it, and revels in the fragmentary, the exception, nonsense, and the anomalous.[19] While the emphasis on nonsense perhaps takes us in another direction (though it can, I would propose, have its own enchantments!), Jarry's refusal of universality and the particularity of his 'pataphysics accords with new materialism. A different, though still bodily, way into the particular and the fragmentary or partial is through situated and carnal knowledge. Before I address them directly, let me write them in another voice.

Returning to breathing, coughing, and materiality—clearing the throat, once more

It began with a tickle in my throat in Beijing in 2012, where, on an artist's residency, I made sound recordings of streets and parks and subways—recordings that I found were endlessly punctuated with coughing, my own and other people's. These were coughs so quotidian in Beijing that I didn't always notice them until I listened back. Just as Yoko Ono's coughs were a reminder of the bodily eruption of voice, voice broken by coughing, the Beijing coughs that punctuated my recordings were an evocation of something in the air—namely the particulate matter 2.5 in an AQI or Air Quality Index of 450+ moving from air to lungs to air—provoking the cough and expelled with the cough.[20] Particulate matter 2.5 speaking to us, as Jane Bennett might have it, or "giving voice" to the AQI. Allowing us to "feel pollution coming back at" us (Latour 2013). If Gaia has become "ticklish," as Isabelle Stengers and Bruno Latour would have it (Latour 2014, 3), that tickle was in our throat and lungs as we coughed.

These Beijing coughs asserted themselves in a work called Coalface, *which I made with my collaborator, Maria Miranda, in Melbourne in 2013. They punctuated the playlist that filled the room and emerged as voicings of the assemblage in which, within the medium of air, are enfolded particulate matter 2.5, the Chinese government's pollution and industrial policies, traffic, manufacturing industries working overtime to satisfy the desires for cheap goods in the West and spewing out their pollution, coal from Australia which helps to fuel much of China's growth spurt, the lungs of the local people walking by us, and our own coughing too as we gathered our material. ... Each day as we worked on the installation, with the playlist to animate us, we listened to the coughs give voice to the assemblage and to the need to engage with all the ethical, political, emotional, and aesthetic concerns at the coalface back in Australia.*

Situated and carnal knowledge

In order to support the voice that I have deployed above and the essaying mode of this book, I turn now to a discussion of situated knowledge and carnal knowledge. Situated knowledge was a term coined by Donna Haraway to focus on location and accountability; it aimed to address the relativism and social constructivism that she considered problematic (Haraway 1988, 588). Haraway—a seminal thinker for new materialism, feminist politics, and transdisciplinarity—understood situated knowledge as partial and particular (Haraway 1988, 584). In tune with her feminism, both the body and engagement with political and ethical issues came to the fore:

I am arguing for politics and epistemologies of location, positioning, and situating, where partiality and not universality is the condition of being heard to make rational knowledge claims. These are claims on people's lives. I am arguing for the view from a body, always a complex, contradictory, structuring, and structured body, versus the view from above, from nowhere, from simplicity. ... We seek [knowledges] ruled by partial sight and limited voice—not partiality for its own sake, but, rather, for the sake of the connections and unexpected openings situated knowledges make possible. (Haraway 1988, 589–590)

Partiality not universality; connections and unexpected openings. These are the hallmarks of situated knowledge that shape and are shaped by a particular approach to voice—and the write voice. While the voice that speaks (in) such knowledge is necessarily partial and limited, for Haraway it was vital to understand that voice—its knowledge—as conversational and

to recognize that all conversations take place *somewhere*, in a particular situation (Haraway 1988, 594).[21] The 'object' of such knowledge must also be re-cognized as an actor, having its own agency, rather than being represented as "a passive and inert thing" (Haraway 1988, 591).

As I indicated earlier, my concern here is not to enter the debates between and within new materialism (and/or posthumanism), even less so to address their various responses to, say, speculative realism and object-oriented ontology. I would just note, however, that feminist political concerns with relationality[22] and situatedness can be a significant point of difference. Rosi Braidotti, as ever, makes the point cogently:

The so-called speculative realists tend to be paradoxically dis-embedded and dis-embodied: they are really speaking from nowhere, though they try to hide it. They are unable to account for where they are speaking from. To me, however important it is that we concern ourselves with a-subjective or non-human matter, the politics of locations of the subject is something we cannot let go. What we should be speaking about are extended minds, distributed cognition, experiments with forms of affirmative relational ethics that take these parameters into account. (Braidotti and Vermeulen 2014)

In this and in much of her work, Braidotti, like Haraway, has been a foundational thinker for new materialism even though she herself has worked within the framework of posthumanism. For me this underlines, by the way, the sometimes fluid relations between them, particularly for feminist thinkers, and the reason why I am not keen to draw sectarian lines, particularly as my own context is the arts rather than philosophy.

The fluid *situation* of knowledge, and of writing about art, has more recently become, for art writer Jane Rendell, a question of what she calls "site-writing." Site-writing is the practice that Rendell has developed to write from and about "the sites—material, emotional, political and conceptual—of the artwork's construction, exhibition and documentation, as well as those remembered, dreamed and imagined by the artist, critic and other viewers" (Rendell 2010, 1). It involves a rethinking of what criticism is and can be. In her site-writing, the critic, like the sites about which she writes, is engaged materially, emotionally, politically, ideologically, and conceptually (Rendell 2014, 17). Performing this work, her writing style brings to the fore the locatedness, nonabstraction, and intersubjectivity and exchange involved in her engagements with works of art and architecture (Rendell 2014, 20).

The wonderfully evocative name "site-writing" emphasizes the situatedness of Rendell's thinking and writing—and of her approach to the works with which she engages. It also suggests a performative writing from within, an entanglement with the objects about which she writes, rather than pretending some disinterested, critically distant judgment. Importantly, too, site-writing speaks of her literal and material approach to space and architecture as well as to writing about them as a critic (Rendell 2014, 17). Site-writing's intertwining of the metaphorical and literal in relation to space resonates with my own intentions to think voice as an intertwining or hinge between the metaphorical and the literal.

Rendell's materialist and feminist project is performative in its understandings and its practice. In a 2014 presentation, she described how she refigured Haraway's and Braidotti's "feminist figuration" in order to tell a critique "through three different registers: pathos or a more emotional tone, logos the adoption of rational argument, and ethos, the conveyance of values which motivate a culture, a corporation etc" (Rendell 2014, 2). Rendell brought all three registers into play to address one specific real-life ethical and political situation of her own;[23] and it is in this move that her writing particularly speaks to me—even though my own tendency is to interweave the registers rather than move between them. Rendell's extension of situated knowledge to situated practice and her own particular situation between art, architecture, and critical theory—understanding of which for her, too, came out of the process of writing a book—resonates with and inspires my project here (Rendell 2006, 8). The "embodied" critique that emerges from such writing, she says, "comes close to practice" (Rendell 2014, 5). Which brings me to carnal knowledge.

Carnal knowledge, as elaborated in Barrett and Bolt (2013), builds on understandings of situated knowledge and the recognition of the body in knowledge. They figure carnal knowledge "as a relationship 'between'— between the human and non-human, the material and immaterial, the social and the physical" (Bolt 2013, 6). As artists and theorists themselves, Barrett and Bolt bring the focus directly onto creative practice, as a form of knowledge that performatively entangles the material and the discursive, the affective and the symbolic—both in the artist's making and the audience's aesthetic experience (Bolt 2013, 3; Barrett 2013, 63). They deploy carnal knowledge to address the equally problematic trajectories where, on the one hand, (modernist formalist) materialism emphasized matter

at the expense of the social and situated, and, on the other, "arts' very materiality has disappeared into the textual, the linguistic, and the discursive" (Bolt 2013, 4). To bypass this impasse Bolt turned to Heidegger's questioning of "dumb," "mute," and "irrational" matter which passively waits for human (artistic) action (Bolt 2013, 5). Given my concern with voice, I'm particularly drawn to Heidegger's criticism of the understanding of matter as *dumb* and *mute*. For me, this speaks not just of matter but also inflects the ways we perceive silence. Recalling Ihde's postphenomenological listening to the silence of things and attuning now through new materialism, I will apprehend 'silence' as even more than that of things that can be given voice, as Ihde puts it. It is a silence (which will echo throughout this book, and particularly in the final chapter) that is always/already replete with voice—voices of memory and voices of relationships.

Carnal knowledge speaks of a performativity that is particular to creative practice. For Barrett it is important to think this performativity beyond Austin's performative utterances, which, she notes, rely on "already constituted discourse." Instead, she calls upon Julia Kristeva's "more radically transgressive performativity: performativity as the bringing into view of the as yet unimaginable through the extension of language" (Barrett 2013, 68). Barrett helps us understand how creative practice *performatively* gives us access to this *unimaginable*. What Barrett proposes here works for me as opening onto a way of listening to voice not as communicating and fixing semiotic meaning in contemporary art, but rather to attend to radical and transgressive performativity in art's aesthetic and affective qualities. This resonates with Karen Barad's material/discursive, human/nonhuman, and relational performativity. Performativity for Barad is a sort of mattering of matter, practices, doings, and actions and intra-actions that entangle and traverse (transverse) binary and disciplinary divides (Barad 2003, 802–803, 808, 818).

Carnal knowledge is also, fundamentally, the knowledge of art practice—art practice as a form of knowing, opening onto knowledge through another way of perceiving, as Erin Manning puts it (Manning 2015). In this sense, in my situated listening to the voices and voicetracks of artworks, I will be attentive to their knowledge and try to engage in a warmly embodied conversation with them, rather than laying down a cool critique. But this is not idle chat or personal self-revelation. I listen for the perceptions

and knowledge that artworks open and bring these perceptions and knowledge into conversation with the knowledges of voice studies and new materialism—remembering, of course, the contingent, situated located character of all knowledge and all knowing.

I recognize that I have been using the figure of conversation perhaps a bit casually,[24] so I would now like to clarify how it works for me. I understand conversation as part of a listening practice or strategy—there is no conversation without listening—and listening, the first step in conversation, is in a way always/already shaped within a conversation. In short, I listen to media and artworks in a context, which includes the various discourses and materialities with which I wish to engage. Conversation for me is more of a methodology than, say, the exchange of human speech or the conveying of some preexisting knowledge. Conversational mode, and with it the write voice, will come close, I hope, to what Paul Carter figures as the *material thinking* of an art practice (Carter 2004, xi). As Maria Miranda reminds me, in our collaborative practice, conversation and walking have always been part of our process, the ground of our practice—the path we walk, and talk, that grounds our practice. As a practice, conversation is a process that is always incomplete; it requires time and engagement and openness to another, and recognition of one's own situated knowledge and carnal knowledge, one's location within the conversational event (Manning 2015).[25] In a way, I am inspired by Karen Barad's apprehension of the ontological indeterminacy of the *apparatus* in quantum field theory physics: thinking conversation as an apparatus, I understand it as ontologically inseparable from its object, as an intra-action where the human and more-than-human are always/already entangled (Barad 2015).

Situated knowledge and carnal knowledge, in their various instantiations, both call for a particular voice of writing—about and through affect, about and through bodily response, about and through performativity. This 'voice' of writing is of course not the same as the spoken voice about which it sometimes writes. Nonetheless, the voice of writing can be more than metaphoric; it can poetically evoke the texture of the text, the situation and embodiment of the writer and the writing, the conversation that it engages, the different modes and registers deployed. It can also foreground the way different writing voices write voice differently—more or less, for instance, engaging with or distancing themselves from affect. I would say that there is a place for both in a book about voice—so that the writing can resonate

with the voices about which, with which in a sense, it writes. My aim, then, is to find a way of writing from and about situated and carnal knowledge, tracking voice across its various registers—across the affective and the symbolic, the literal and the metaphoric.

Voicetracks

To do this, I have chosen to work with the figure of voicetrack.[26] *Voicetrack* entangles voice with track, and it speaks of their entanglement. I hope that this figure can also signal the way voice is always/already situated or grounded. But more than that, I hope that the gesture of appending the noun/verb *track* to *voice*—itself also a noun and verb—evokes the performativity of voicetracks, like voice itself. A further reason that I've chosen to work with "voicetrack" is that it riffs off but somewhat derails the term "soundtrack." Soundtrack is very familiar across a range of media; and, thanks to that familiarity, *track* now immediately makes us think of media, whether popular media or media art. One of my aims with the term "voicetrack" is to play on the familiarity of "soundtrack"—to hold on to the way track signals media, but to shift the emphasis specifically to voice. In that sense the term "voicetrack" works, in a shorthand way, to say "voice in art and media."

But beyond this shorthand, "voicetrack" is also a term that can evoke *both* the literal and the metaphorical and, I hope, help us get past any worry about a nonmateriality of the metaphoric (Braidotti 2009, 527–528). Let me say a bit more about how "voicetrack" will work literally and metaphorically in the book. To begin with the literal. Voicetracks are what I will engage with, through examples of art and media works. I would note that many of these works are contemporary artworks or installations, rather than conventional media or media artworks, even though they do engage with and rely on media. In this they speak to the increasingly porous boundaries between media art and contemporary art, which make the figure of voicetrack all the more useful. In the examples, I will pay attention to the voices within the literal voicetracks: What are the voices there? How do they relate to each other? How do they move from and between people, animals, things? How do they affect us and the world? How can we come to sense these voices through a different, new materialist way of attuning to and with these works?

One of the particular aspects of "voicetrack" that I will think about through my examples is movement. The figure "track" is particularly evocative of movement, and the movement of voice is a key concern of the book, as I signaled earlier. Following a voicetrack, listening to it, also evokes Tim Ingold's figure of wayfaring. Wayfaring for Ingold is a textured and texturing process; it is a making—a making with—others. As they wayfare, human and more-than-human beings move, living in and with the earth. They lay trails rather than follow trails (Ingold 2007, 81). Wayfaring attends to "the ground we walk, the ever-changing skies, mountains and rivers, rocks and trees, the houses we inhabit and the tools we use, not to mention the innumerable companions, both non-human animals and fellow humans, with which and with whom we share our lives. They are constantly inspiring us, challenging us, telling us things" (Ingold 2011, xii).

Telling us things. I hear in Ingold's approach here an inflection of new materialism that comes from his anthropological attention to Inuit cultures in particular. And even though Ingold has serious qualms about the term and the approach of new materialism, as I've mentioned, the foundation of his thinking in Indigenous culture is part of what makes his writing resonate with me in Australia, where Aboriginal understanding of *country* has taught us so much and has so much to say about (new materialist) conceptions of voice.

And metaphorically. In its strangeness, its seeming familiarity, the figure "voicetrack" works to trouble the ways we think about voice. It evokes something unexpected, unimaginable—something at the edge of what we know already, something uncanny perhaps, which requires this new term to bring it out and explore it. It takes us down the track of imaginative ways of thinking about and sensing the voices of the world in the posthuman era. In the metaphor of voicetrack, the word "track" evokes the new materialist possibilities of voice. By combining voice (which we normally associate with humans and sometimes animals) with track (which we know as an inanimate thing), "voicetrack" metaphorically suggests the potential for a new materialist exploration of voice—human, animal, thing, and assemblages.

The term "voicetrack" has particular traction because it invites us to think and imagine its new materialist qualities both literally and metaphorically. Rather than reject the metaphorical for its nonmateriality, I hope to hear the vibration between the literal and the metaphorical as they

intertwine in voice, and voicetrack. Voicetrack, I hope, can speak to the pressing need to develop new figures and concepts in order to listen differently to a multiplicity of voices—to accept very different voices as having status politically and ethically in the posthuman era. Prefixing "voice" to "track" invites us to listen to other voices, whether human or more-than-human, animate or inanimate, and it provides a way to listen to these other voices in different ways—aesthetically and ethically, sensorially and semiotically. It invites us to think about what the voices are that speak there, in those voicetracks. I will be asking this question in order not just to get at how we can hear that voice, but also to reinvigorate what we sense and know through that voice. The figure of voicetrack will also work, finally, organizationally to hold the book together and to provide a way for readers to journey across theory and practical examples—providing another way into voice, voice studies, and new materialism.

Literally and metaphorically, then, voicetrack has the potential to help us think about how assemblages speak, how they voice themselves as well as enmeshing within themselves the voices of human, animals, and things, shaping and making possible these other voices. The final appeal for me of voicetrack that I would mention is the way tracks play a key role in First Nations' cultures (Ingold 2011, 151), which are attuned, as I've said, to hearing voice beyond just human voices, to hearing voices of *country*, as Indigenous Australians put it. In these ways I will use the term voicetrack to track how voices of humans, animals, and things move through art and media and alert us to their new materialist potentials and possibilities of their aesthetics and affects.

Voice, sound and new materialism, once more

Why voice? people keep asking me. Why don't you just listen to animals and things as sound or noise or even music? This question has haunted me for years and haunts this writing.

In response to this provocation, to allay possible cavils from sound studies,[27] and to conclude this introduction, I would like to elaborate on the reasons proposed above for focusing on *voice* beyond just sound and beyond the human. While I certainly recognize that voice does sound and while it may be musical in some media and artworks, there is something particular about voice that new materialism helps us apprehend (and vice versa).

With a vitality, to which new materialism is attuned, voice *calls* out, calling upon others to listen, to think. This is not a call constructed by the listener, human or otherwise, but a call from, a call upon, a call to—a call that affects and effects. It is a call of vitality, of life. And it is a call of otherness, as Steven Connor argues: "A consequence of the breakdown of the old certainties about the distinctions between the human and the inhuman is to release the possibility of hearing voices as other, and the otherness of voice" (cited in Cull 2012, 98).

Specifying voice rather than sound or music, then, allows a foregrounding of otherness and relationality and, with them, of ethics and politics. This is not the traditional humanist political ethics where voice signifies a way for humans (or animals) to exercise rights. Rather than this humanist sense of voice, I work with voice to evoke "a way of speaking ... [that] *produces* bodies rather than representing them," as Laura Cull puts it (Cull 2012, 83). And like Cull, I understand the bodies it produces as *thinking* bodies, whose carnal knowledge is enlivened by and expressed by voice.

Returning to Tim Ingold to think about the relation of voice to sound, I would quickly foreshadow one of the ways he has influenced my thinking, to which I return in chapter 3. While Ingold's insistence on being in an environment to perceive sound can get tricky when encountering mediated voice, I still find much in his understanding that can speak to media and media art and that media art can speak to. In particular, I am drawn to his notion of ensounding as a way to think about voice's sounding—rather than the sound of voice. Ensounding for Ingold comes from his sense that sound, like the wind, is a *medium* in which we perceive, rather than an *object* that we perceive: it is "a phenomenon of *experience*—that is, of our immersion in, and commingling with, the world in which we find ourselves" (Ingold 2011, 137–139). He speaks of *enwinding* and *ensounding* to convey how "the living body, as it breathes, is necessarily swept up in the currents of the medium," be it wind or sound. For Ingold, "what applies to wind also applies to sound. After all, the wind whistles, and people hum or murmur as they breathe. ... If that is so, then, we should say of the body, as it sings, hums, whistles or speaks, that it is *ensounded*. ... To follow sound, that is to *listen*, is to wander the same paths" (Ingold 2011, 139). These paths—along which this singing, humming, whistling, murmuring, and speaking voice (human and more-than-human) is ensounded—are

what I call voicetracks. These are the paths I will wander along and listen to here.

In the encounters in this book, it is voice and voicetracks that call out to me to wander these paths, to wayfare along with them. But I should repeat that although I apprehend voice as *ensounded*—happening within and experienced within sound, vibrating and moving through and with sound—I do not understand voice as the same as sound, nor as reducible to sound or to vibration. Sound is rather the medium, as Ingold puts it, in which and through which voice calls out and is heard.

And a final caveat: although I will be talking about myself as listening, and while I understand voice as telling *us* things, my take on voice is not a roundabout way to recenter humans from another direction—as listeners who somehow authorize or enable those voices. Rather, my hope is to trouble human-centeredness and self-presence from another direction, where they, we, are affected and effected by the voices of more-than-humans—animals, things, assemblages—that vibrate through our, and their, bodies and call upon us to listen. This, finally, is why I think through voice, rather than sound or music. And this is why I will draw upon my own bodily response, my own listening to track voicetracks in the chapters that follow.

And to follow …

The following chapters will engage with a range of media and artworks to explore voice and the new materialist turn. In chapter 2, I will attend to artists working with animal sounds and voices, bringing animal studies into the conversation. Here affect and ethics come to the fore. Chapter 3 listens to voices of place. Ground is not abstract, here, but specific, placed; and the works examined are often installation works, where voicetracks are a track to a specific place. Chapter 4 listens to the voices of technologies that speak themselves rather than the voices they might mediate. It also explores things, but unlike in the previous chapter, things are 'out of place' or rather do not speak of place but of themselves. Chapter 5 introduces the concept of 'unvoicing' to explore both disturbances in imagetrack/voicetrack relations and unsettling of what voice is—where it comes from and how it speaks. In chapter 6, I foreground the ethics, and politics, which are woven throughout the book, and return to the voice of the writing and

the voice of making. This brings me to some of my own work through which many of my understandings and apprehensions of voice in earlier chapters have developed. And, one more time, I listen here to silence, as befits a final chapter. Throughout these chapters, voicetrack will work conceptually and organizationally to bring diverse works into conversations as they speak about voice and new materialism. By working with the figure of voicetrack I hope the book attunes us to voice differently and contributes something new to an important conversation between voice studies and new materialism.

The write voice, one more time

And I hope, when people next ask me why I speak about the 'voices' of animals and things and places ... I can now say that my project has been to find the write voice to speak of voice in this unimaginable listening and listening to the unimaginable ... I can now say, that's what having a conversation with the voicetracks of art and media—with ears and imagination attuned by new materialism—has given me. And, I hope, can give to you who read this.

2 Animal Tracks: Affect, Aesthetics, Ethics

When W. J. T. Mitchell noted the growing presence of animals in artworks at the turn of the twenty-first century, he argued that in this "biocybernetic age" there has been a breakdown of barriers between anthro/animal/machine. In Mitchell's view, animals had become a new other: "the animal replaces the racialized or sexualized other as the frontier of cultural difference" (Mitchell 2001). Since then, the number of publications and exhibitions involving art about or with animals has been growing even more rapidly—to the point where it is now quite common for artists to be working with animals and animal-human relations. And within academia as well, animal studies has become a well-established area. As Steve Baker explored in his thought-provoking text *The Postmodern Animal*, postmodernism's multiplicities and confusion of boundaries opened a welcoming ground for animal artwork, which in turn played an important role in rethinking nature and culture—particularly human and animal subjectivities, identities, relations, and, I would add, voices (Baker 2000). And in the posthumanist era when nature is no longer mute (Barad 2003, 827), listening through new materialism to voices in the various art assemblages, of which animals are part, can, I hope, contribute to these rethinkings.

Theoretically and ethically, new materialism helps us attend to animals' voices, opening us to a recognition of their own specificity, singularity, and *entanglements* with others (Wolfe 2003, 6; Massumi 2014, 60). This means that while animals' voices are foregrounded in the works that I'll engage with in this chapter, they are not to be heard in isolation. They are rather to be listened to as voices within the works and voices of what Dominique Lestel figures as hybrid communities, communities of interrelations and mutual co-constituting, where animals and humans share affects, meanings, and interests (Chrulew 2015). While different theorists approach these

entanglements through their own particular critical lenses, my focus is not on the differences between them but rather on what they share and what they offer for listening to and with animals in media and artworks and, in turn, what this listening offers for new materialism in this posthumanist era.

Kathy's cat: Kitty and kitty assembled in the face of death

I want to begin to think about and with animals and their very material voices by engaging with Kathy High's disturbing, affectively powerful video work *Everyday Problems of the Living, a Serial* (2000–2005). For me, the work viscerally demands a new materialist listening to voicings of human-nonhuman relations as it makes audible deep and uncanny attachments and attunements. In its viscous and noisy and uncanny way, the work also speaks ethically of the caring tenderness of the attachment between Kathy and her cat. I return to this work, which I first saw years ago, still moved by the caring tenderness of my own companion cat—in the face of the death of my mother, her warm-bodied purring sustained me in the gut-wrenching abyss of grief.

At the beginning of the serial, the videomaker describes the work as part of "a year long project about … anxieties surrounding living and dying. … Thinking that she might die in the year 2000, High decided to 'perform her death,' creating a different tape around the topic each month" (High 2000–2005).

The first episode, *Domestic Vigilancia*, on which I'll focus, is from January 2000. January was clearly a very anxious month, opening a very anxious year, and so the episode opens with a voice that is particularly materially anxious, contoured as it is with vomit projecting from the mouth of this very anxious cat. As he repetitively sprinkles the voicetrack with his vocal matter, he has a lot to say, though not through language.

The episode *Domestic Vigilancia* begins as Kathy (aka Kitty)—fearing that the death she has always anticipated awaits her in this year—calls a telephone medium. In this episode, what I see are awkward close-ups of Kathy's cat, vomiting and gagging, guided by Kathy's hand (which is all that I see of her) onto newspaper. The camera work is close, unsteady. Meanwhile I hear Kathy on the phone to a medium, at first having trouble getting through. Kathy leaves the phone hanging as she attends to her cat who

vomits his way through the conversation, during which I hear Kathy's voice, flat, verging on affectless, and the medium's, which is bizarrely animated. Kathy's voice sounds distant, as if from somewhere else—the great beyond?—while more present is her caring hand, as she gently guides the vomiting cat to newspaper. It is the cat who is the vocal and visual central character of the work—the 'front person' for the assemblage. Indeed, the more Kathy's voice is distant—even-toned, flat, detached, *as if* already dead?—the more present are the cat's outpourings. A painful call to life at its most basic, a call from the gut as much as from the heart. Emotion resounds in this work—in the psychic medium's telephonic voice, in Kathy High's own voice, deadened with fear and anticipation of her own death, and in her cat's voice, which channels both of these into utterances from the depths of his own guts.

I listen to the *gut*tural utterances from Kathy's cat and I gasp—gagging and gulping along with the video's voicetrack. My attention fixates on the

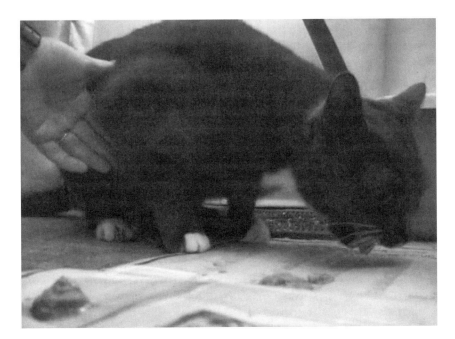

Figure 2.1
Kathy High, *Domestic Vigilancia*, from *Everyday Problems of the Living*, 2005. Video SD by Kathy High with Ernie Cat and Lily Dog. Photo from video by Kathy High. Courtesy of the artist.

cat's mouth from which this voice emerges, and I am, as Brandon LaBelle says, attracted and repelled at the same time (LaBelle 2014, 2). I feel this attraction and repulsion in my own gagging mouth: I feel it coming up from my gut, which is undulating in tune with the cat's gut. It's a gut feeling, an affect, an intense movement, in his and my body. A mimetic responsiveness, as Anna Gibbs would remind me—"a mimetic responsiveness to a vitality that is not fixed in any single body but which rather *traverses* bodies and forges new relations between them" (Gibbs 2015, 7).

I want to think through these responses in this chapter as I listen to the voices of animals, the voices of/in animal voicetracks. How do the nonlinguistic voices of animals—gasping, gulping, squawking, barking, humming—speak of and to affect in my and their bodies? What aesthetics, affects, and ethics do these voices literally and metaphorically provoke? How do they move between bodies, speaking of and within assemblages? As I listen to them, feel them, how do these nonlinguistic voices of animals point to a voice that is not about the symbolic—that does not privilege language over matter in the way that worries so many new materialist thinkers?[1]

High's work speaks noisily of the assemblages between people, animals, machines, life, and death. Her cat speaks within and of this assemblage. The connection between mouths and cats, along with telephones and death, of which Kitty and her kitty spoke, is not surprising if we have read Avital Ronell's *The Telephone Book*. In a chapter entitled "Birth of the Telephone: Watson—Dead Cats," Ronell anticipates the undead unvoice (to which I turn in chapter 5) as she conjures up Thomas Watson, poet, spiritualist, inventor, electrician, and collaborator with the better-known Alexander Graham Bell (Ronell 1989, 229, 240). Watson produced the "electrically carried ghost of a twang" which Bell made into the first electric telephone machine. To do so, Watson claimed to have worked with the fur from his beloved childhood cat, which his mourning family had had stuffed—using the fur, he said, "as an exciter" (Ronell 1989, 239). Literally and metaphorically, I would say. Mourning and excitation, fear and creativity, and a cat at the center of it all—all find echo in High's video work, as it is out of the mouth of both cats that an affect-borne creativity speaks. And no surprise that the voice speaks a gut feeling. For, as Ronell says, it was the mouth of that dead stuffed animal that had been particularly frightening to Watson, and we might hear it coming back to speak to him,

to spur him along, to haunt him, and, indeed, perhaps to haunt the very telephone itself: "The telephone makes you swallow what is not there. ... At the same time, you spill out a part of you that contains the other; in this way, it is a vomitorium" (Ronell 1989, 238, 341–342). And so, indeed, says Kathy's cat, in not so many words, but with a voice strangled by a gut-wrenching mouthful.

Domestic Vigilancia also evokes the telephone's long-established role in film—the way a telephone contaminates a scene, disruptively setting some action in motion, spreading life-and-death news (in film as in real life, as I know too well).[2] Kathy's cat reminds me that the telephone is a relay point, both of connection and transfer, but also, and as such, possibly a site of emotional and affective blockage or breakdown—the call that may not be answered, or is left hanging. And, even more than just a relay point, the telephone can be an active player in an assemblage, 'flirtingly' saying something for itself (in a way I'll return to in chapter 4):

The telephone ... is to be plugged in somewhere between science, poesy and thinking. In as much as it belongs in its simplest register, to the order of the mechanical and the technical, it is already on the side of death. However, the telephone cannot be regarded as a 'machine' in the strict sense of classic philosophy, for it is at times 'live'. ... The telephone flirts with the opposition life/death by means of the same ruse through which it stretches apart receiver and transmitter or makes the infinite connection that touches the rim of finitude. (Ronell 1989, 84)

It is not surprising that High's video opens to death with a life-and-death phone call that at first does not get through—a moment of upsetting anxiety—and is then left hanging. Kathy's cat's mouthful is more than a gut-wrenching scream ... more like pure gut-wrenching. What has turned his stomach into a vomitorium, which erupts through his mouth into a most noisy and moist voice, is a relay between Kathy's not quite dead voice and the medium's mechanized, telephonic voice. Like the famous RCA Victor talking dog, which faithfully attested to the power of a technologized voice, Kathy's cat testifies to the intensity of a technologized voice within the assemblage: "What could be more 'human' (or at least anthropomorphic) than this 'talking dog'?" (Taussig 1993, 223; see also 212–225). Or this vomiting cat? I am called back to Ronell, whose telephone emerged from "a mysterious coupling of art and occult" (Ronell 1989, 366). And so I listen to the voices of Kathy and the medium and the cat, once again entangled with and through art and the occult.

Or I could tune into this 'mysterious coupling' as a sort of *contamination* circulating through the bodies of kitty and Kitty and the telephones, animating their voices. Again, the RCA Victor talking dog speaks up, testifying, Michael Taussig tells us, to a mimetic fusion of sympathy and contagion, of sensuousness with imitation (Taussig 1993, 220). Listening to the video's voicetrack, I sense the stunning intensity with which this work inflects the movements of contagion which Deleuze and Guattari figured as 'becoming-animal.' But it does so in a gesture and voice that speak just as certainly to Donna Haraway's concerns (in response to this figure) for "the old, female, small, dog- and cat-loving: these are who and what must be vomited out by those who will become-animal" (Haraway 2008, 30). In High's work there is certainly no quiet swallowing of the ordinary and affectional, to which Haraway is keen to attend. And so Kathy's cat, bringing forth his own and Kathy's affect from his guts, speaks from a situated encounter, an entanglement of bodies (Haraway 2008, 26), contaminating me, too, with his vocal emissions. Vocal emission, spewing from the gut, through the mouth, in a movement that connects to me viscerally, reminding me, too, of the importance of the mouth in his voice and his voice in the mouth: "The mouth affords entry onto the complicated weave of language and assemblage where breath and spit, food and vomit, desire and angst, for instance, all stage their particular events to ultimately surround, interrupt, flavor, and support forms of agency and communion" (LaBelle 2014, 2). The voice that pours forth from Kathy's cat's gut and mouth produces a gut reaction in me, which, as Terry Eagleton has argued, is after all the original aesthetic response, 'in the body' (cited in Buck-Morss 1993, 125).

Becoming-animal and attunement

As I have listened to Kathy's cat's very visceral and present, and in another and important way ordinary, voice, it helps me think about the problems that Donna Haraway has with Deleuze and Guattari's becomings, including becoming-animal. Having started, in a way, from the middle of that debate, let me step aside from Kathy High's work for a minute to expand on this discussion. Two of the key figures used by those thinking about what an animal *does* are *becoming-animal* and *attunement*—the first owing much, of course, to Deleuze and Guattari and Brian Massumi, and the second being more in tune with Haraway, Despret, and Latour.

Becoming-animal is one of Deleuze and Guattari's becomings,[3] with which they sought to move beyond a philosophical ontological focus on being. Like many of their concepts, it is (purposely) difficult to tie down or restrict. To me, it reads as not quite a literal concept, even though it is avowedly nonmetaphoric. They figured 'becoming-animal' as movements by contagion, as a way of thinking movements that are not about the more familiar relations of pity, identification, analogy, imitation, representation, resemblance, or reproduction (Deleuze and Guattari 1987, 258, 272–273, 305–306; Massumi 2014, 62). Contagion here is invoked to suggest "a proximity 'that makes it impossible to say where the boundary between the human and the animal lies'" (Deleuze and Guattari 1987, 273). For Christof Cox, becoming-animal is being "drawn into a 'zone'"—it is about unlearning old habits and learning anew—to experience common capacities with animals rather than imitating their forms. It is about entering a shared affective and productive *zone*. And in this movement, one experiences new physicalities, new emotions, and new relations with others and with the world (Cox 2005, 23).

While the concept of unlearning is crucial here, as I will return to below with Catherine Clover's work, I would also say that in some ways I respond to becoming-animal more as a passionate invitation than as a description. And yet, I must admit, I also remember a story that disturbed any easy distinction between invitation and description, not to mention capacities and forms. It was a story that a friend from Liberia told me when I was making a radiophonic work, *Esprit de Corps: Oscillating with Emotions*. It was the story of his mother back home going off into the bushes at night and transforming into a goat at times when she was disturbed. He spoke of "crying voices … disoriented … making all kinds of noise in the dark." It was an unsettling story of disorientation, of border crossings, of borders always/already crossed—a story of his mother and of others who transformed into animals—a story that calls out to be told again here.

Most of these things happen at night, these transformations take place at night. … I noticed with my mother she sometimes used to go for days without eating, she would be depressed, she'd just go quiet, she'd feel so tired, she'd feel sick afterwards, her muscles all aching. Sometimes we asked, "How long does it take you to change in and out? Do you change your clothes or do you get out of clothes?" She said "no," she doesn't—they don't—change clothes, they just walk into the bushes and then they walk out. There's no struggle involved.

It happens at night. They walk in places in the dark that they know no-one is there so they will never be seen in or out when they are ready to transform from being a human being or from being an animal back to their original state. Because she was a goat basically she would just roam around in the bushes until she's ready to come back home. Nothing out of the ordinary she would have done.

If you're just an ordinary person that you don't have that ability to change from being a person to an animal, you just treat all animals to be animals. These people, they become so close to certain animals, like my mother, she never used to be afraid of any animal.

And I said, "But what happened when you have changed back to being **you**, what comes to your mind first?" She says, "Oh the first thing that comes to my mind is, I hope no one is watching me."

At first I never believed it. I had so many arguments with my mother; so many times. I said, "Well it doesn't happen, you shouldn't believe it. It won't happen, if you don't believe it, it won't happen." She said, "Well I don't want to believe it myself but it does happen, so that's how it is." [And it's better than some people who turn into a python terrorizing the villages in the night.]

It's embarrassing for a family member to say "my mother or my father or my brother changes from being a human being to an animal" because in Africa, in my part of Africa, it's linked with evil, it's linked with witchcraft, it's linked with trying to destroy people.

But I think it's more emotional, because my mother, when she used to get angry, you can notice that something is coming up on her. Or if something is disturbing her ... then you see her behavior is starting to change. We used to ask then, "Well why, if you change, why do you come back?" She used to say, "It's like you've got two brains operating, you got one is telling you don't do it, one is telling you do it, and then you've got this extraordinary power that just comes and takes over, and just does it."[4]

My friend's distinctive soft voice, somewhere between everyday description and incredulity (though I'm not sure if it's his own incredulity or what he imagines is the listener's), disturbs my sense of just what becoming-animal might be, once again telling me how porous is the border of metaphorical and literal. It's a story and a voice that has stayed with me, haunting me and provoking my thinking here.

Deleuze and Guattari's becoming-animal is not without convincing critics, including Donna Haraway, who worries about an abstractness of the *animal* within the figure of *becoming-animal*—"a scorn for all that is mundane and ordinary and the profound absence of curiosity about or respect for and with actual animals. ... This is a philosophy of the sublime, not the earthly, not the mud; becoming-animal is an autre-mondialisation" (Haraway 2008, 27–28).

Leaving Haraway's important criticisms to the side for just a moment—and hoping that Kathy's cat has offered another, more situated way of thinking it—at a poetic level, and as an expression of a desire to get away from fixity, becoming-animal has been productive for the arts. This was responded to and exemplified by the eponymous exhibition at MASS MoCA in North Adams, Massachusetts from 2005 to 2006. Curated by Nato Thompson, the exhibition featured works from artists including Kathy High, Natalie Jeremijenko, Patricia Piccinini, and Mark Dion, among others. The exhibition explored how, when it is actualized in art, becoming-animal can be energized, moving from the realms of abstraction; and, in turn, the works in the exhibition brought to life the way that becoming-animal can offer an energizing concept for artists. As the exhibition also demonstrated, artworks like Kathy High's can give force to Deleuze and Guattari's evocations of contagions and intensities, going beyond the limiting and recognizable boundaries between human and animal, and the fixities of both, as they provoke us to see and listen, to feel and sense, differently. Artworks can focus us not on what *is* human and what *is* animal but, as becomings, on what can be possible, on what bodies can *do*, separately and together. Energizing the imagination, they can disturb what we know and expect. In response to Haraway's important concerns, artworks have the potential to move beyond Deleuze and Guattari's "disdain for the daily, the ordinary, the affectional rather than the sublime" (Haraway 2008, 29).

Attunement, empathy, and sympathy

Attunement is another way of coming at some of the same concerns of becoming-animal. Vinciane Despret, for instance, figures human-animal relations as a mutual attunement—a passionate, bodily with-ness. And even though she is writing about science, I sense that Despret's attunement can also happen through media and artworks that performatively *make* relations, rather than merely displaying them. Relations of attunement depend on the *availability* of the bodies to each other, to practices that transform both, to affects that move them. In these relations of attunement, it is affect that articulates bodies, that creates and is created: that is, attunement is how affect shapes the bodies in relationships, activating them (Despret 2004). Attunement expands on Despret's understanding of

emotion and affect, which I discussed in the previous chapter. As Bruno Latour says, following Despret's argument, it happens through "body talk": "the many ways in which the body is engaged in accounts about what it does" (Latour 2004a, 206). While Latour is probably emphasizing body here, for me *talk* speaks just as loudly.

Working in the framework of attunement with the figure of empathy, Despret understands the encounters between humans and animals as a blurring of knowing and known bodies, because of the way bodies of both enact 'embodied empathy' in these encounters (Despret 2013b, 69). Empathy is a key figure here for Despret as for Donna Haraway, describing a movement of response, of co-response—*corresponding* "*with* each other." "Empathy, in this case, is not feeling what the other feels, it is rather making the body available for the response of another being" (Despret 2013b, 70). Embodied empathy is not about humans feeling what animals feel (or vice versa), but feeling *with* them, thinking *with* them, an "embodied communication" (Despret 2013b, 71).

In his provocative text *What Animals Teach Us about Politics*, Brian Massumi prefers corporeality to embodiment, because, he explains, "corporeality is not separable from the action, or from the action's dynamic form of expression which is vitality affect." Massumi also works with the figure of sympathy rather than empathy (Massumi 2014, 29, 86). Nonetheless, coming at this from outside of philosophical debates, I read Despret's embodied empathy and her understanding of affect and emotion and attunement as in tune with what Massumi is arguing about corporeality, "thinking-feelings a-doing" and mutual inclusions in the "ethico-aesthetic of animal politics" (Massumi 2014, 43, 47, 49, 86–87). Responding to Massumi's ludic work, I engage with Despret's concepts in interplay with his own.

Ethics and politics

As many in animal studies move from thinking about what an animal *is* to what an animal *does*—in itself and reciprocally in response and attunement with other bodies (Bussolini 2015)—listening to voice, with its affect and performative and intersubjective force, has much to offer not only to new materialism but also to conversations with animal studies. So what does Kathy's cat have to say about all this? Or rather, in his voicing of his bodily response, in attunement with Kathy, what does he have to teach me about

politics and ethics? The assemblage that *is* Kitty and kitty's work speaks of ethics as well as aesthetics and affect. It is the very ethics that new material-ism attends to—an ethics that is neither human-centered, nor language-centered. Cary Wolfe—who followed Derrida, who followed his own cat (away from the tracks mislaid by Levinas and Heiddeger, he tells us)—retunes ethics away from concerns with "giving speech back to animals." Focusing on their responses rather than their reactions, Wolfe's ethics addresses the question of whether animals can suffer (Wolfe 2003, 10, 67, 71–74). With Donna Haraway, I want to follow Wolfe's turning to animals' *responses*, but I would add that in a way there is actually no need to worry about 'giving speech back'; animals already have a lot to say from and about an assemblage, as Kitty's kitty has asserted, straight talking from his gut and his mouth, in his intense and noisy voice. In response to this artful invita-tion, I can and must listen with curiosity to what Kathy's cat has to say as I attend to what he is doing (Haraway 2008, 19–25, 42). And this call and response between Kathy and her cat and me speaks of ethics. And, inciden-tally, it also speaks of companionship—I sense the cat's uncomfortable 'sharing' of his food as reverberating, albeit in an uncomfortable way, with Donna Haraway's sense that it is with food (*cum panis*) that *companion* relations between human and animal species begin (Despret 2013b, 62; Haraway 2008, 17).

Kathy's cat also speaks of the sort of ethics that Anat Pick calls "crea-turely." I will return to the complexities of Pick's creaturely ethics and aes-thetics in chapter 5, but I would like to mention her ethics here, because of the way that the creaturely resonates with the relationship of vulnerability and the materiality of care in the encounter between Kathy and her cat in this video. For Pick, it is such material obligations and shared bodily vulnerabilities that characterize the creaturely commonality and "point of encounter between human and animal" (Pick 2011a, 155, 187, 193).[5] This creaturely vulnerability—his own and Kathy's—is what her cat speaks to and with.

I have called him kitty, but let's be clear: this is not a generic kitty cat. It is Kathy's cat, or Kitty's kitty as I hear him, emotionally and physically con-nected to her, in life and fear of death. It is a cat in its full particularity and "specificity" (Wolfe 2003, 6). Only such a kitty would be contaminated by Kitty with her existential and emotional anxiety. So Kitty contaminates kitty through her voice, via the medium of the telephone, via the medium

on the telephone—and sickens me, via the medium of video. But what disturbs me here is not just an almost unconscious, somatic, sensual sympathy of vomiting voice to uneasy stomach, but the visceral ethical reminder of how close are people and animals, how affectively connected, and how tenuous is 'humanness' in face of the animal that it sacrifices for its speciesism (Wolfe 2003, 6).

Against a politics of speciesism, Kathy and her cat speak of care, the Derridean *gift* of caring (Wolfe 2003, 63). In the video I see her cat's voice gently ushered, attended, by Kathy. Her hand plays an important, creaturely role in this assemblage; and in one way, I apprehend it as the hand of which, to which the cat speaks. It is an everyday gesture that speaks concretely of care, affection, and responsibility (Haraway 2008, 36). Watching Kathy's hand and listening to her cat's response, I am reminded, too, of Rosi Braidotti's insight that there are important ethical implications when we replace the metaphoric animal with the affective, literal being: "The animal … is … taken in its radical immanence as a body that can do a great deal, as a field of forces, a quantity of speed and intensity, and a cluster of capabilities. This is posthuman bodily materialism laying the ground for bioegalitarian ethics" (Braidotti 2009, 528).

In short, as Braidotti reminds us, "we humans and animals are in this together," affectively and ethically connected by care and relationships of care (Braidotti 2009, 528–531). As Kathy's cat's voice reverberates literally and metaphorically through the video's assemblage of people, animals, technology, speaking it, speaking from it, I do sense just such a relationship of care. From a humanist reading, it might seem that only Kathy has the Heideggerian hand that thinks, that gives, that cares, that makes us 'human.' Yet listening again with new materialist ears to her cat's voice, and rethinking Heidegger with new materialist ethics that understands that we "are in this together," I can sense Kathy's cat's 'handling' care too, as the cat takes her anxiety into himself, taking responsibility for her, contagiously, poltergeist-like. And I can sense this through the whole assemblage that is the work of art (Wolfe 2003, 61; Bolt 2011, 17). In this assemblage, or *agencement*, in which I am entangled, there is a flow of forces between Kathy and her cat: "the one who makes the other do, the one who makes others move, the one who inspires others to be inspired, and the one who is therefore induced, mobilized, and moreover, put in motion, *activated*" (Despret 2013a, 40–41). And the one who is transformed, if we can learn

to wait for animals to show their ways and listen to what they have to say (Buchanan 2015). This is the gentle waiting that I sense from Kathy High's work.

In her *Animal Films* series, High continues her work *together* with animals, as a 'facilitator' and 'collaborator' with animals. The series includes the work *Voices from the Other Side*, a collaboration with Ernie Cat (who was, in fact, the very cat I encountered in *Domestic Vigilancia*). This work exemplifies, for me, what Matthew Fuller has described as an ethically important but rare thing—art made *by* animals, not *about* them (Fuller 2007). As High puts it in the video: "Working with facilitator, Kathy High, this is the second video made by Ernie, the cat. In this sensual meditation Ernie explores the ways cats speak to each other about dying: thoughts are exchanged from those still living to the 'other side' through a strange language of cat howling. It is a language of pre-death, preparing for dying, of the aging." Ernie's voice here, like his voice as Kitty's kitty, comes from deep in the guts—this time a howling. Where Derrida's cat was silent—not called upon to speak perhaps or maybe not in the mood—Ernie bellows out in the face of death, voicing a new materialist knowledge that goes beyond human language and the symbolic.

In the previous chapter I discussed how Karen Barad pointed to the problems of the metaphoric, privileging language over matter in terms of "agency and historicity" (Barad 2003, 801); but once animals' voices enter the scene, the relationship between language and knowledge and voice becomes even more complicated. And the literal and metaphoric find new points of intertwining. In Kathy High's video artworks, I hear animal voices that travel on voicetracks which cross-cut the metaphoric and literal divide. And in so doing, they speak their own particular carnal knowledge.

Gut, ventre, ventriloquism

Coming from the gut as it does, Kathy's cat's voice speaks his carnal knowledge with a sort of ventriloquism, ventriloquizing the gut. Gut, ventre, ventriloquism. Ventriloquism, as Steven Connor explores, comes from the Latin translation of the Greek word *engastrimythos*—word or speech from or in stomach (Connor 2000, 50). In a wonderfully titled opening chapter, "What I Say Goes," Connor elaborates his important cultural historical understanding of voice, and its movements and powers, through a study of

ventriloquism. For Connor, ventriloquism quintessentially tells us of the uncertainty of the position and source of the voice, as it speaks "from some other place, reorganizing the economy of the senses, and embodying illegitimate forms of power" (Connor 2000, 43). Speaking from that other place of his own gut, ventriloquizing Kathy's anxious gut, her cat embodies the (illegitimate?) power of new materialism, where we and animals "are in this together." From Brandon LaBelle's oral point of view, the power of ventriloquism is also the power of the mouth—drawing us to the inanimate thing or machine that speaks—to its *body* (LaBelle 2014, 7). In High's work this would not only be the telephone but also her cat—indeed the assemblage that the cat and telephone and Kathy and the medium and video—and I—form together.

Ventriloquist voices also remind me of the intimate connection of affect and organs. When Connor points out that the (Western) voice comes from the sternum, home of the heart, that connection is clear (Connor 2000, 3). Emotions start with affects that move human and animal bodies. I feel anxiety start as an affective wrench of my guts, the ventre inhabited by ventriloquism. Affects and emotions move not just individual bodies but also between bodies—human and animal bodies and machines. Understanding emotion as expression of the movement of embodied affect—within and between bodies—has engaged numerous theorists in the "affective turn," as I discussed in the previous chapter.[6] But it is something that animals have plenty to speak about too—like Kathy's cats, and dogs, speaking from the gut. But perhaps also by way of the heart?[7] Her cat's care for Kathy, feeling her anxiety, speaking her anxiety when Kathy's own voice is strangled and flattened—speaks a noisy carnal knowledge from the heart and from the gut in a voice wracked and wrought by both anxiety and care.

Before turning to my next examples, I would like to mention that the new materialist refigurings of human-animal relations, activities, politics, and ethics (through becoming-animal, attunement, and Haraway's important concept of natureculture) are not the only places that important rethinking of nature has occurred. Once again there has been Don Ihde's early attention to animals' voices as an "expression of action and emotion" (Ihde 2007, 192). A lesser-known and more controversial approach is that of Rupert Sheldrake, whose work has long intrigued me. What particularly drew me to Sheldrake's work and what speaks to this project is the way he reconceptualizes and draws attention to *memory* in the relations between

humans, animals, and plants. Sheldrake comes to this rethinking not as an artist nor as a philosopher of science but as a biologist, one who questions a mechanistic paradigm of biology. His understanding seems more in harmony with the new vitalism and animism that transect new materialism than with the mainstream of biology.

It is Sheldrake's concept of *morphic resonance* that speaks particularly to my project, as it posits a collective memory that is outside the individual (person's, animal's, plant's) memory, involving "spatio-temporal patterns of vibratory or rhythmic activity" (Sheldrake n.d.). While Sheldrake's theories are not generally accepted within biology circles, there is something conceptually and poetically appealing to me about his sonic figure of resonance and his evocations of the "vibratory and rhythmic activity" of memory (Sheldrake 1981 and 1988). While the poetic exuberances of Deleuze and Guattari have ignited new materialist thinking, so far those of Rupert Sheldrake seem to be largely ignored there. Yet there is something promising about the emphasis on time and memory in his unusual nature-culture move, where he replaces what he sees as the anthropomorphic figure of 'laws' of nature with the less human-centered 'habits' of nature. It reminds me of becoming-animal's attention to learning and unlearning habits. And it could, in my view, offer something valuable to thinking about animals and art and the ways that human-plant-animal assemblages work.

I would note, finally, that during Sheldrake's investigation of animal-human communication, he developed an interest in telepathy.[8] This reverberates with Kathy High's work, which not only plays around with telepathy and mediums but in which Kathy and her cat might also be understood to occupy a shared *morphic field*. Morphic fields resonate for me particularly because of Sheldrake's recognition that there is more to the organization of life than genes and because of the more fluid, vibratory, social, holistic, and relational approach that they express. And so, attuned by Sheldrake to the way that birds can be apprehended as sharing morphic fields, I listen next to the work of Catherine Clover.

AKKKKK—the birds—noisy voices we learn to hear

Catherine Clover has been making works for and with noisy, wild urban birds for many years—listening, recording, translating, transcribing, reading to them, performing for and with and after them, making books and

performances and installations. Like some of the scientists that Vinciane Despret discussed (2004, 2013a and b), Clover seeks artistic practices and ways to develop relationships of attunement with the birds. Her choice of urban gulls and pigeons is deliberately not sentimental; instead of 'beautiful' and mellifluous or even sublime birds, calling to us from the 'wild,' she works in a sort of minor mode (Ngai 2007; see also Manning 2016) with despised and everyday species. These are birds with whom we share urban space but often without noticing them, unless to bemoan their presence. These are birds whose groupings we name as deadly and dirty—a murder of crows, *a filth of starlings*, as the title of one of Clover's works reminds me (Clover 2012).

Clover's practice is multidisciplinary, working with voice, sound, language, visual art, installation, performance, and public art. Besides her experiments with voice, she also works visually in a range of creative ways, from the texts themselves, to overhead projections, to signage. Clover's mode is collaborative—with human performers and with avian collaborators. Her human collaborators perform and improvise the written word, which includes her own translations and transcriptions of birds' voices. Her oeuvre is a tribute to the importance of learning anew, learning new habits of listening and voice in interspecies relations—bringing new understandings, and practices of listening and voice—folding this listening back upon itself through the field recordings and transcriptions and translations and performances. Inspired particularly by Salomé Voegelin, Clover works with listening as a way of becoming aware of "sharing space" and intertwining lives and voices in urban spaces—becoming aware of what we have in common with cohabitants in urban contexts. As Clover says of her work, her concern is to "unlearn" her old ways of listening in order to hear the birds' calls "not as pleasant musical sounds, nor even as the sound of a species, but as distinct communication between individuals living their lives in close proximity to mine" (Clover 2015b, 33).

I first encountered Clover's work in 2014 in a local festival on the Upfield Bike Path in Melbourne, Australia. The artist was standing in front of a foldout table underneath a densely spreading tree. It was a particularly unromantic, grotty inner-city setting between a railway line and a car park and behind a particularly unglamorous shopping center. On the table were various bird guides. The work was called *Reading The Birds* and that is literally what it was—a reading of Daphne Du Maurier's *The Birds*. When I saw the

promotional material about the work, I thought it would be a sort of Hitch-cockian reenactment,[9] with the birds arriving later in the evening to play their creepy part. Instead, it actually felt more like a call to the birds to come to hear their bedtime story—a story for noisy critters who refuse to go to sleep! I remember my pleasure in coming upon it and how fitting it seemed for the public art event—so carefully located in its place, so unex-pected in one way, but so felicitous in another. I was delighted (and delight is often the experience of Clover's work) by the idea and the novel (in every sense) relation between birds, reader, audiences, text that was taking place, delighted with reading the birds as an assemblage, a "provisional and infor-mal coming-together" and a doing-together of artist, birds, audience, tree, place (Baker 2000, 64, 136).

Clover's sense that birds' voices mark a 'shared proximate space' impels her to record and work with their voices in a way that disturbs the usual approach to animals' voices in soundscapes, where birds are *authentic* or typical *objects* of closely focused sound recordings, as if to downplay their embeddedness. In his "Four Objections to the Concept of Soundscape," Tim Ingold objects to such soundscapes, to all 'scaping in fact, which, he says, problematically "slices up" the environment differently from how we experience it, from the way we experience sound as part of our "immersion in, and commingling" with it. As I discussed in the previous chapter, Ingold invokes instead the ensounded quality of singing, humming, whistling, and speaking—which, I noted, are voices (Ingold 2011, 137–139). It is this sense of the birds' ensounded bodies voicing their embeddedness within their environment that Clover's works evoke, managing to do so even when located in galleries.

To think more about this, and to continue to move beyond the sound-scape model, it is useful to turn to the 1934 work of Jakob von Uexküll, who has made quite a reappearance with new materialist thinking. His work speaks to the way Clover understands and listens to birds' voices in shared environments. As a biologist, von Uexküll investigated nonhuman percep-tions, the perceptions of nonhuman beings in their environments. His con-cept of *Umwelt* describes those perceptual lifeworlds as distinctive to each species—so that an object for one species will work differently, and there-fore have a different meaning, for another species in an overlapping physi-cal space. As recent commentators have noted, this is a welcome and democratic difference from Heidegger's abyss between (a superior) human

Dasein speaking/thinking being in the world and a lesser animal being in the world.[10] For von Uexküll, "All animal subjects, from the simplest to the most complex, are inserted into their environments to the same degree of perfection" (von Uexküll 2010, 50). Animals, and plants, are each the subject in their own particular environment in which they are enmeshed— as Tim Ingold would have it—in their own dwelling-world which they perceive/act in according to their own particular sensory spectrums (Ingold 2011, 77, 63–65; von Uexküll 2010, 70, 139, 150, 197; Baker 2000, 93). Von Uexküll's biological elaborations were accompanied by compelling visual imagery; but it is in Clover's work that I can *listen* to his concern with questions about the ways animals' worlds exist and their sensibilities (Ingold 2011, 79). For me, Clover's work provokes a disruptive and new materialist sense of subject and subjectivity as it opens onto a number of important questions: How can birds be the *subject*? What is the voice of an animal subject? How does an animal voice its subjectivity? How does this voicing speak to new materialist thinking which replaces the (Cartesian) subject in the sense of a fixed identity (Baker 2000, 77, 93–95, 102–103, 120, 125)? How is this avian vocal subject unique and relational—extending Cavarero's understanding in a new materialist direction (Cavarero 2005, 5–10)? And, going further or in a somewhat different direction, what happens to the human listener to that voice—and what does this tell us about the animals' voices in conversations with the artist and me as audience? Is this a moment of becoming-animal?

Clover's response to such questions is provocative, coming from her own practice and her reading of Tim Ingold, for whom *subject* is problematic. She writes that she has been brought by her encounters with birds to recognize them, with Ingold, as neither subjects nor objects, but as "occurring," and their voice as "languaging language" (cited in Clover 2015b, 80). In this way I listen to their voices in her work as troubling the shackling of voice to human language and a human-centered sense of subjecthood or way of understanding (Despret 2008, 133). Instead, with René ten Bos, Clover listens to these voices speak of the potentials for cross-species interaction and for exchange between humans and birds as an exchange between beings:

When I listen to the birds I hear them as users of language. I hear their sounds and I do not understand them, yet I understand that intelligent exchange is taking place. I recognize the birds as speaking beings (Bos 2009) where "one experiences more

Figure 2.2
Catherine Clover, *Shooting the Breeze*, 2015. Mixed-media performance by Catherine Clover with Viv Corringham and Vanessa Chapple. Courtesy of the artist, photo by Catherine Clover.

than just sounds—in this sense, this is an experience of language—but one is not able to make sense of it: one does not know what is being signified by what one hears." (Clover 2015b, 64)

This is particularly evident in Clover's work *Shooting the Breeze* (2015). This work has a very different feel from *Reading The Birds*, as it is located in a small gallery space high above Flinders Street station in the center of downtown Melbourne.[11] I am immediately surprised by the texts Clover has placed on the windows, transcribing the calls of the very birds I am now drawn to watch through those windows. The urge to speak them/speak to them is strong, and being alone in the space at the time, I succumb. The presence of recorded ambient outside sounds urge me on. *Co roo coo coo, rackity coo.* On the wall, too, are texts in which English words intermingle with the birds' transcribed voices (these texts have been performed in the live performance which unfortunately I was unable to attend but which left its memory in the space itself and in the recording that I listen to). I put on

headphones and watch the birds outside (with field glasses that Clover has provided)—birds who are of course always there. Yet I somehow never really engaged with them before when looking out of windows in this building (an old building full of artists' spaces and galleries). I admire and play with the field glasses, a simple and delightful stimulation not just to sight but also for thinking about sight inflected by voice. The field guide next to them guides me to "Birds of South Eastern Australia Urban Areas"—silver gulls. I have an uncanny feeling as I look closely through the glasses at a man crossing Flinders street at the same time as I serendipitously hear in my headphones the words "footsteps." A vivid and deceptively simple reminder of the enfolding of the two spaces of the work—the spaces where the sounds were recorded and the space in which I am listening to them, while watching that other space. It is humorous and serious and I am enthralled. As with all Clover's works, there is a lot of room for the audience—clearly certain things are going on for her, but she doesn't force me into the same response, leaving me the opportunity to share the spaces, inside and out, as she does with the birds. For me, this work manages beautifully to avoid the worries Ingold raises about soundscapes. While here inside the gallery there are the recorded sound of the birds' voices and textual transcriptions that are performed by human performers, these do not undermine the sense of the birds in their environment. Instead, as a memory device, they point me to a live encounter with the birds as they fly by the window, embedded in their environment.

In this work, as in all Clover's works, no animals are harmed. None are brought into the gallery to meekly serve her artistic goals. They are there but through memory, through their recorded and transcribed voices, which invite us to attend to them outside in their own *Umwelt*. There is a folding of the spaces but not at the physical or psychic expense of the birds themselves. Clover even prefers not to *represent* the birds visually. They are not presented or represented in the gallery except in guidebooks—they are left to come and go as they will outside the gallery. But what of the voice in these works; might it be heard somehow as a representation or imitation? I sense not, for when Clover works with voice—her own and those of her collaborating performers, who include both the artists who speak during the performances and the birds themselves—it is as part of an intersubjective conversation.[12] "Rather than only thinking *about* the birds, I started to think through the birds, to waver around them … to use Baker's

open-ended and highly enabling term" (Clover 2015b, 59). And so the voices that speak bird sounds are strange—neither the birds' own voices nor simply imitations by the human performers. This happens because, rather than trying to represent or mimic the birds directly, these performers speak Clover's translations, performing written texts. As Steve Baker might have it, their voices are figural rather than figuring, bodies doing, becoming, a conversation with the birds rather than echoing or representing or corresponding to birds outside (Baker 2000, 140–141, 148). There is something enchantingly uncanny here that offers an uncertain communication at the same time as troubling it.

Mediated by text on a wall, mediating a translation, mediating a sound recording, mediating an 'original' encounter, the performance plays between the familiarities of mediation and the strangeness of what LaBelle figures as "reversed ventriloquism" with its reverberating, echoing, haunting of the space of the performance (LaBelle 2014, 165–171). A reminder of the fundamental location and dislocation of voice. And I wonder, as I sit here writing, remembering the experience of reading and listening to Clover's work, where the desire to perform animal sounds comes from, in daily life (as I meeow to the cat sitting on my lap while I type) and in art. Perhaps it is an affective, tender sense of the animal as a being, as other,[13] that calls forth my own imitative voice in my everyday life, as in my audience response to Clover's work? Mimicry in her work operates as a way to enter dialogue with a work. As Derrida understood, if we put the animal first, as the desire to mimic its voice does, we are sidestepping the anthropocentrism that has dogged Western philosophy. Steven Connor speaks of (Merleau-Ponty's) "singing the world" and the imitation of the voices of things (and I would add animals) which is "more than mere imitation. When one vocalizes a sound, one gives it to one's own voice, in order to give it *its* own voice" (Connor 2000, 10).

For Clover, like Connor, the question of mimicry is complex, and she's not as willing to reject it as Deleuze and Guattari might seem to invite. In this sense, as Ansa Lønstrup has importantly pointed out, artistic exploration of voice is ahead of philosophy and able to explore voice in a more open way (Lønstrup 2014, 4). In Clover's work mimicry is not necessarily something to be feared as philosophically unacceptable. In her work it seems not so different from becoming-animal; indeed, it can be a way of becoming-animal, troubling an essentialist abyss between human and

animals. Clover's work effectively inflects and intensifies becoming-animal and mimicry through her mediations. And so I listen to Catherine Clover actually working in Deleuze and Guattari's "zone of proximity, indiscernibility, or indifferentiation"; and in doing so, she affords an experience of "a kind of temporary affiliation with an animal ... [where] perhaps a connection is made" (Clover 2015b, 92).

The birds and the bees—humming, vibrating, morphing

The voice of these connections and affiliations across humans, animals, and things could well be humming. Or so Michael Taussig suggests. He, too, disturbs a simple subject/object division in the voices of humans and animals—and machines. His "Humming" piece buzzes around this in a Nietzschean and poetic register: "Humming is connecting, not just the connections between insides and outsides, animal and human, machines and human, but the mediating medium that connections of any kind require" (Taussig 2010, 309).

It's not surprising that it is an anthropologist who hears voice in this way, given his familiarity with cultures where relations between humans, animals, plants, and things operate on a plane of nonhierarchical relations. Taussig points to voicings in Indigenous peoples in the United States, in the world of the Iroquois, for example, quoting J. N. B. Hewitt:

The speech and utterance of birds and beasts, the soughing of the wind, the voices of the night, the moaning of the tempest, the rumble and crash of the thunder, the startling roar of the tornado, the wild creaking and cracking of wind-rocked and frost-riven trees, lakes, and rivers, and the multiple other sounds and noises in nature, were conceived to be the chanting—the dirges and songs—of various bodies thus giving forth voice and words of beastlike or birdlike speech in the use and exercise of their mystic potence. (Taussig 2010, 308)

Taussig cites this text as part of his deployment of *humming* to evoke "the density and intimacy" of becoming, connection, vibration—across and within human, animal, machine (Taussig 2010, 313). For Taussig, humming is becoming and thinking; it is the thing you are doing while humming—walking, working, whatever. As such it is an intimate connection with things in the world. This resonates with Indigenous Australians' relations to country that I discussed in the previous chapter and presages a discussion of the voices of things and assemblages in the following chapter.

It is also a reminder of the way voice, and voicing, trouble humanist subjectivity while opening onto a different sort of subject and ways of relating: becoming, connection, vibration.

Vibration: The vibration of a bird's voice, in tune with a violin's voice—the vibration of each, and through them and between them the vibration of the assemblage that they form—this is what we can listen to in the radio-work of violinist, composer, performer, and radiomaker Jon Rose. His 2007 radio artwork *Syd and George* (Rose n.d.) explores "the story of a 20-year-long interspecies relationship between Syd Curtis, a member of Homo sapiens and George, an Albert's Lyrebird or Menura alberti, who lives in Lamington National Park, Australia. In parts of the composition, both species tend to morph into each other" (Rose 2012b). Lyrebirds are famous for an elaborate mating dance, in which the male lyrebird in full throat calls to his sexual other with a voice dense with virtuosic sonic mimicry. He mimics not only other bird (and animal) sounds but also machines, such as chainsaws and lawnmowers. I hear his particular voice as calling across, or at least affectively disturbing, the boundaries between species as well as between animate and inanimate.

Rose's work opens with Syd describing his recording of George's vocal and dance performance, admiring somewhat warily George's very powerful voice, as Rose's violin plucks a lyrebird's pecking voice. The program quickly explodes into a polyphony of violin, lyrebird, and Syd's fragmented commentary; at times it's difficult to tell what is the violin's voice and what is George's. "George does three beats to the bar." Describing George's performances—"in a manner of speaking"—Syd tells of the way that some people consider that lyrebirds are mimicking dogs' barking with their "peculiar" low-frequency "gronking song"—to which Rose's violin gronks in response (or is it George?) and in anticipation. Syd's repetition of "in a manner of speaking" leaves me in no doubt that all of these—Syd, George, violin—are voices that are speaking.

Through the voicings of Rose's violin, I listen to how Syd and George, man and bird, started to shape-shift and morph into each other over their long interspecies relationship (Rose n.d.). A musical boundary disturbance vibrates in *Syd and George*, where, "in a manner of speaking" (a regular refrain in the work), Syd, George, and Jon Rose/his violin morph into each other—a sort of vocal morphism. This resonates with the morphism that for Jane Bennett and Bruno Latour undoes sharp distinctions, such as

between nature and culture, and brings forth recognition instead of the hybridity or "crossings" as "an essential component of an ethical, ecologically aware life" (Bennett 2001, 99, 96–98). Interestingly, speaking of Bennett, the excerpt on Rose's website—the only version available to me— ends abruptly, mid-sentence, with the words, "and you wonder why ..." And so by chance, or deliberately, the work refuses to simply dispel the puzzles about the being and becoming of voice between human and animal and things—leaving me in enchanted wonderment.

Syd and George, and the radio work assemblage in which and of which they speak, are altogether both playful and enchanting, in ways that tell of the singularity of their relationship. Playfulness, as Brian Massumi explores, is one of the key things that animals can teach us about politics. As a person perceives an animal, they are suddenly reinvigorated, reanimated and transformed (Massumi 2014, 83–87). This "child's play" is "transformation-in-place":

> The child immediately sets about, not imitating the tiger's substantial form as he saw it, but rather giving it life—giving it more life. The child plays the tiger in situations in which the child has never seen a tiger. More than that, it plays the tiger in situations no *tiger* has ever seen, in which no earthly tiger has ever set paw. The child immediately launches itself into a movement of surpassing the given, remaining remarkably faithful to the *theme* of the tiger, not in its conventionality but from the angle of its processual potentiality. (Massumi 2014, 83)

Such play, which is at the heart of so much of Rose's work, is doubled and redoubled in *Syd and George*, as Syd plays George and George plays Syd and Rose plays his violin to play both. Just as Massumi sees children playing "tigritude," I listen to Rose playing lyrebirditude, relationally transposing the movements, the vibrations of their voices into his own (Massumi 2014, 84). It is an affective gesture and resonates in an enchanting work.

As musicians themselves, Jon Rose and his collaborator Hollis Taylor come to their understandings of birds' voices through music; and in turn, they understand music anew through this encounter, moving beyond a definition of music that "routinely, and often haphazardly, endorses human exceptionalism and the nature/culture divide" (Taylor 2014, 12). It is interesting that musicality is a key metaphor for von Uexküll as well as for Deleuze and Guattari. But for Hollis Taylor, studying the Australian pied butcherbird in natureculture, it is a literal musicality, where every mature

bird has a different song. She has researched in depth the way they engage in mimicry much as humans do, as the most basic part of music making (Taylor 2014). "I discovered the pied butcherbird on our first fence trip.[14] ... This was an epiphany for me. ... Originality, creativity, genius—these are eighteenth century concepts that are overdue for a rethink, along with human exceptionalism, which is currently being disproven in a number of parameters" (cited in Neumark 2015b, 139).

While musicality is important here, for me, as for Taylor, it is the musicality of voice in natureculture, rather than voice as conventional music, that I listen to in Rose's work and in his collaborations with Taylor. I will return to this in the following chapter.

Moving (with) animals

Donna Haraway's vital figure of natureculture provokes valuable understandings of animal-human relations, as we track them through affect, intensities, and events. I sense this intensely in David Chesworth and Sonia Leber's work *The Way You Move Me*. The title already alerts me to affect as movement and a relationship. I encounter Chesworth and Leber's two-channel video in a small gallery in Melbourne in 2012 and find myself mesmerized—moving around the room to watch each screen separately and then across both as they meet in a corner. The beautiful yet somehow disturbing or confusing sound ensures that I can't passively flow along with the captivating imagery. The work, according to the artists, "follows the movements of sheep and cattle across the Western Australian wheat belt, capturing the internal dynamics and rhythmic ebbs and flows of herds. These shifting lines and shapes are accompanied by a wordless soundscape that both mimics and enhances this sense of motion. At this juncture of chaos and order is an examination of the forces and connections that exist between humans and animals" (Leber and Chesworth n.d.).

An important concern for Chesworth and Leber is to explore interspecies rhythms and movements. Having read about movements of crowds in Elias Canetti's *Crowds and Power*, the artists are thinking about the dynamics of motion of animal herds—or mobs as they are known in Australia. It's interesting, by the way, that Aboriginal people easily extended the colonial settlers' term *mob* from sheep to people—speaking of "us mob" and "you

mob." The title of the work, *The Way You Move Me*, evokes for me the connection of physical motion and emotion at the point of interspecies relationships—who is the "you" moving "me"? From whose point of view is the title, and the work, speaking?

Through the duration of the work, visual and sound rhythms intensify and deintensify together—in harmony and in counterpoint. While the installation's soundtrack does the work of holding the room together, with its two screens, the sound also does the work of disturbing my place in the room and in the piece. It is both diegetic and nondiegetic at the same time, yet even when diegetic, there are other sounds and sound is othered—it is not quite the sound of what I see. Partly this happens because much sound has been removed and much has been amplified—adding a subtle uncanniness to this work. The most significant removal in the soundtrack is the human voice—which somehow for me nevertheless haunts the work—but in its relative *absence* (except for the voice of a woman on a quad bike which practically sounds like it is mimicking an animal voice as she calls "comeonnnnn" and the occasional man's background "hupping" and "heeping" the sheep) it allows and invites unexpected exploration of interspecies relations.

The panting sound of the dogs' *breath*—the ground zero of voice—is one of the voices that are amplified in the sound design. The panting breath, foregrounded in shots of individual dogs after a rounding up, conveys a continued bodily motion—a *vitality*—even in a moment of deintensification of movement. And even in this moment of deintensified motion, there is still motion—an *afterward* moment of *as if* "stillness"—though again a haunted moment, a moment haunted by the movement that preceded it, the traces of which, the afterlife of which, I sense in the panting of breath. I hear it and feel it and see it, too, in the buzzing voice of the flies—which the cows' flapping ears and flicking tails try endlessly to escape. And in the mooing and breathing and panting voices of the herded cattle.

I mention the dogs in particular because they play a key role throughout—intermediaries between sheep and cattle and humans; other to both, but essential to both and to their relationship. And they do so, too, in the voicetrack where their barking is the main voice. By removing most of the sounds of people and amplifying the barking of dogs, on and off camera, the artists bring into relief this crucial interspecies nodal point. As they do also when they linger on the cow's slurping tongue, that quintessential *organ* of

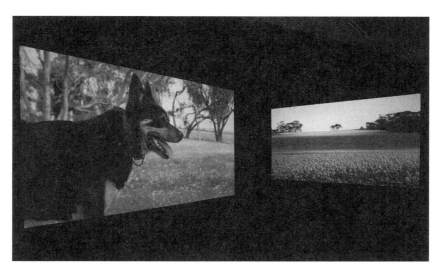

Figure 2.3
Sonia Leber and David Chesworth, *The Way You Move Me*, 2011. Two-channel video, 5.1-channel audio, 10.5 minutes (installation view). Courtesy of the artists, photo by Sonia Leber.

speech, speaking soundlessly here (from my vantage point) of their relationship with the farmer. The movements of the animals, their mooing and bahhing, hooves on the land or water, become voices of the assemblages of people, animals, country.

These assemblages of relations between people, animals, and country, explored through motion visually and aurally through voice, are of course very different from the relations between these actors before white settlement of Australia. Yet while absent at first viewing and audition, these earlier relations somehow still inhabit the work—ever present in country's memory—in the voices of its endangered carnaby cockatoos and the wind in the grass and in the scramblings of its busy ants on the rocks. For me, all this is actually rendered sensible and complex by the relative silence of the voices of white pastoralists, even when they are in frame, and the noise of the birds' voices, even when they are out of frame.

There is an interesting scene in this work that I'd like to bring into the conversation about training that's going on in animal studies. This conversation often begins with the famous aphorism by Wittgenstein: "If a lion could talk, we could not understand him."[15] To which the reply from and

about trainers and philosophers—from Vicky Hearne to Vinciane Despret, from René ten Bos to Cary Wolfe—is that lions do talk and that an understanding is already there. The problem, they propose, if there is one, is more one for humans than for the lions (Despret 2008, 123–124; Ten Bos 2009; Wolfe 2003, 45, chapter 2). In this scene in *The Way You Move Me*, the camera follows a trainer with her horse. The horses' hooves voice the changing speeds and regularities of movements in an assemblage, where the hand of the trainer on the reins and whip creates the rhythm I hear in the hooves, as they voice the assemblage that they compose. What does this scene have to say about the understanding between trainer and horse? It is that, if we attune to voice in the broad way I've been developing, as the voice of the assemblage, then in this scene it's possible to apprehend the 'unimaginable' understanding between trainer and horse—to listen to that understanding in the voice of the hooves as they pound the ground, both making and erasing their tracks as they move (Wolfe 2003, 74).

How to talk to a parrot and listen to a mussels' singalong

I want to end this chapter with two works that speak of the challenges and possibilities of conversations with animals. In the first, I listen to a parrot who talks in what we usually hear as a voice that mimics the human. But as it turns out, despite the common acceptance that parrots do talk, the way we understand them, and they us, is still somewhat elusive. And radio, as it turns out once again, is an ideal medium to play with ambiguous performances of conversations with animals. This time I'm listening to a work of radio artist Sherre DeLys, *Long Ago, Parrot in an Interior* (2004). Speaking and reading to her parrot, Ajax, DeLys remembers living 'alone' for a year in a village in Belgium in 2002. Speaking of Belgium, I serendipitously listen to the program shortly after reading Belgian philosopher of science Vinciane Despret, who, remembering Donna Haraway, describes a relationship of "inextricable affinities" between species, going beyond imitation or mimicry. "It is to call for a response and to respond. ... *It is becoming with* them and (starting) from them" (Despret 2013a, 36, her italics). Attuned by Despret and Haraway, I wonder as I listen: Who is the "you" that DeLys is talking to?—Ajax the parrot, or me the listener? "Hello," we say to each other. Or do we somehow, interpolated by her speech, become each other? "What are you doing?" Do I somehow sense what a parrot might sense,

when it speaks but does not get an answer or the answer it wants? At times DeLys and Ajax speak at cross purposes, with Ajax regularly asking, "what are you doing? wanna a cup of coffee?" He sometimes provokes her response, or a chuckle, but at other times they simply ignore each other in mutual monologues. *Ahh*, she says, *ahh* he returns. *Ahh*, I respond as I slurp my own coffee, thinking ahead to chapter 4, where things will speak. And as I do, right on cue, DeLys tells me, "In the end one remembers by becoming the thing remembered. Isn't that how it works, Ajax?" Not for Ajax, it would seem. "Bye, see ya later." Trying to go out together with the song "Edelweiss," DeLys repeats its title, hoping Ajax will do the same. He refuses to cooperate, of course; he's not ready to go out, with a song or otherwise, as he lets me know in his crying voice. But then, wait, is it actually his voice after all? Well, it is a parrot voice, yes, but is it his? With a final spanner in the works of voice and authenticity, after the program finishes the announcer tells us that Ajax's lines were in fact spoken by other parrots—Coco, Buddy, and Dugal—performing Ajax for me and for DeLys. And even though Ajax (alias Coco and Buddy and Dugal—or is it the other way around?) is the most domestic of birds, there is something delightfully feral about the aesthetics he provokes in DeLys, reminiscent of Jon Rose's response to George. Both of their radio works blur the line between authentic and performed, as they bring out a sense of the performativity of both the birds' and the humans' (and things') voices. And while both works are inhabited by birds' voices that are palpable and vital, the birds themselves remain, become, also elusive—refusing to be fully known or understood.

Even more elusive for me than DeLys's parrot(s) are environmental artist Natalie Jeremijenko's mussels. Her mussel choir is a work that I keep reading about but haven't been able to access live or in documentation. Yet the concept is wonderfully alluring, and its potential makes it a fine work with which to end this chapter. The mussels in the choir, hooked up to sensors and audio software, sing the quality of the water that they filter. The work has had a number of installations, including at the 2012 Venice Biennale, and was planned, though in the end not realized, for Melbourne, Australia:

One mussel can filter as much as 6–9 litres of water/hour. By instrumenting mussels with hall effect sensors, which indicate the opening and closing of their shells, and by giving them each a voice, converting the data into sound, the artwork uses the

behaviour of the organisms themselves as a biologically meaningful measure of pollutant exposure in order to produce a public spectacle.

Storm water run-off, local weather, and seasons will have evident effects on the Choir's performances. The songs will map parameters such as water depth to sound pitch, presence of pollutants to sound timbre, and the rate of the opening and closing of mussel shells to sound tempo, for example. The mussels will become rock stars. (Carbon Arts n.d.)

For the moment, I have to be content with imagining the unimaginable voices of these rock star mussels, in all their bivalve potential.

I find myself assisted in these imaginings by Sophia Roosth's intriguingly titled text "Screaming Yeast: Sonocytology, Cytoplasmic Milieus, and Cellular Subjectivities," which speaks of a vibrational animal voice at its most cellular level. Roosth describes the inaudible vibrations—voice—of yeast being amplified so that scientists can listen to them: "By amplifying the vibrations of cells, researchers are essentially 'turning up the volume' on cellular vibrations" (Roosth 2009, 333). She asks, "What are the conditions that enable scientists to describe cells as actors capable of 'speaking' or 'screaming,' and how might listening to cellular sounds eventually change how scientist think about cells?" (Roosth 2009, 333). Roosth, however, questions the very notion of "project[ing] cultural notions of what it means to be human, to be subjective and have agency, and even for something to be meaningful, into a cellular milieu. Perhaps sonocytology is a mode of imperialism, seizing a cellular colony and asking that its epistemology resonate with our own" (Roosth 2009, 350).

I understand Roosth's concern, but perhaps it might also be apprehended as a reversal of the humanist tendency of science. She describes Gimzewski hearing yeast cells scream when inundated with alcohol: "It screams. It doesn't like it" (Roosth 2009, 339). I wonder, though, whether this might be heard not as the hubris of speaking *for* cells but as a humility of listening to cells speak, even though I do also sense a certain hubristic cruelty in inundating those cells with alcohol. Clearly yeast suffered in the making of this experiment. It may be science, but it can also be listened to with an artist's ears to attune us to animal voices at a cellular level.[16]

Enchanted terrains ... to follow

In this chapter I have traversed an enchanted terrain in which animal voices speak themselves and speak a variety of relationships with people,

animals, and things, in and out of assemblages. These voices in media and artworks speak to and with animal studies and new materialism, bringing forth understandings that are enchanting, engaging, disturbing, and curious. It will be to the way that *place* marks this new terrain—onto which animal voices have tossed us—that I turn in the following chapter. So to finish, and to anticipate, I return to Jane Bennett's figure of enchantment, which embraces the affects, aesthetics, and ethics that animate the projects I have encountered here: "Enchantment consists in a mixed bodily state of joy and disturbance, a transitory sensuous condition, dense and intense enough to stop you in your tracks and toss you onto new terrain, to move you from the actual world to its virtual possibilities" (Bennett 2001, 111).

3 Ears to the Ground: Voicing Place

My Aboriginal teachers in the Northern Territory rarely picked up after themselves, but more to the point they did not seek to erase themselves. When they go fishing they call out to the ancestors and Dreamings saying, "Give us food, the children are hungry, we got kids here!" When they get food, they cook it on the spot. The remains of the dinner camps tell the stories of how they went to that place and called out to country, and how country fed them. The remains of people's action in country tell an implicit story of knowledgeable action: these people knew where they were, they knew how to get the food that is there in the country. (Deborah Bird Rose cited in Hawkins 2006, 89)

As Aboriginal people tell us, things voice place as they tell stories—voicing themselves and the place, and their relations. To speak of place, I return to Tim Ingold. In the spirit of radiophonic essays, which have been so important to my own media arts practice, I begin this chapter with repetition, repeating a passage from Ingold that I cited in the introduction—knowing as I do that the repetition is always different depending on its place in the text. "The ground we walk, the ever-changing skies, mountains and rivers, rocks and trees, the houses we inhabit and the tools we use, not to mention the innumerable companions, both non-human animals and fellow humans, with which and with whom we share our lives ... are constantly inspiring us, challenging us, telling us things" (Ingold 2011, xii).

Listening to this *telling us things* depends on *being alive* in a place, on wayfaring, for Ingold. Wayfaring is not a passive or fixed emplacement, any more than it is 'placeless' or 'place-bound;' rather it is about 'place-*making*' and its attunements (Ingold 2007, 101). As I introduced in earlier chapters, in his provocative essay "Four Objections to the Concept of Soundscape," Ingold intoned the need to be attentive to how we think sound and the environment, and not to separate the two. Since sound is a *medium* and a phenomenon of experience for him, Ingold objected to the practice and

concept of soundscapes: when we are in an environment, he argues, it is not a *soundscape* that we hear (Ingold 2011, 137–138).

At first reading, Ingold's essay (and others of his works) may seem tricky for a new materialist approach to voice in media and the arts. But I would suggest that by understanding sound as a medium, Ingold is not dematerializing it so much as proposing a materiality, in which we are immersed and through which we experience the voices of place telling us things. And while his work may seem to abjure media arts, I will try to bring the two into conversation, by focusing on the experiences of place that listening to the voicetracks of media and the arts affords. This is both an immediate—if mediated—experience and one that, through memory and imagination sparking an enchanted audition, also infuses the more direct experiences of which Ingold speaks.

Telling us things. One of the things that the voices of the ground we walk and the houses we inhabit, the rivers and the skies we share tell us about is place. At the intersection of physical space, personal emotional response, and individual and cultural memory and imagination, place has long been a concern for creative arts practices as well as for cultural studies, sociology, and philosophy. From site to site specificity, from psychogeography to locative media, artists have engaged with place as their subject and their material as well as providing a location for their work. Many have worked with sound to reach an even deeper intimacy with and immersion in place. And when it is voice that ensounds place, something else happens that can locate the audience and the place differently, speaking its life and giving it life anew. In this chapter I'll be encountering works that voice place in ways that speak to new materialism—following lines and plucking strings, ears to the ground and listening to walls, walking and hearing the voices of things in place and the places of things. I'll attune to the particular sense of place that artful voice calls forth, as it shifts our attention to what we don't normally see or hear in a place. Voice reframes our attention to and apprehension of place—reorienting our senses and the way they are inscribed in and by a place. Through new materialism, I will listen to these voices as they enliven a place, "telling us things," as Ingold put it. And in turn, I will attend to how they can give new, artful life to new materialism.

Vibration and transperception

"Transperception," as Douglas Kahn proposes in his groundbreaking *Earth Sound Earth Signal*, evokes the way sound sounds not just its source but all that it moves through, from source to hearing ears, including the environmental spaces and atmospheres and body of the listener (Kahn 2013, 170–171). Kahn is energetically attuned, for instance, to how Henry David Thoreau[1] sensed his beloved Walden through transperception, listening to the distant church bells tolling through, and with, the "vibrating" atmosphere. Thoreau hears them, Kahn points out, as having "conversed with every leaf and needle of the woods. It is by no means the sound of the bell as heard near at hand … but its vibrating echoes, that portion of the sound which the elements take up and modulate—a sound which is very much modified, sifted, and refined before it reaches my ear" (cited in Kahn 2013, 170).

While Thoreau and Kahn are more directly concerned here with sound than with voice, the figure of *conversing* speaks of voice to me, as the bells and the atmosphere and the woods *converse* on their way to Thoreau's listening ears. Indeed, Kahn goes on to point out that for Thoreau the echo of his voice in the woods was "not merely a repetition of my voice, but it is in some measure the voice of the wood" (cited in Kahn 2013, 171). Resonating with Tim Ingold's approach, this figure of transperception usefully brings together vibration, environment, mediation, and listening in a way that reminds us that listening to voice in place is always the voice of place. With transperception, I will attune to vibrations for a sense of how they enliven our sense of place.[2]

Things vibrating (in) place

In *The Fences Project*, Jon Rose and his collaborator Hollis Taylor have traveled the Australian continent, listening to, playing, and playing with the voices of the ubiquitous barbed wire fences that transect country. Rose, whose radio work I discussed in the previous chapter, is also an installation artist and instrument builder who, over the years, has been adding more and more strings to stranger and stranger instruments. At times he turned whole gallery spaces into stringed instruments:

In the sense that Paul Klee described the process of drawing as "taking a line for a walk," so it was for me with a string. ... By 1983 I was using fence wire to string up whole gallery spaces. Two years later, the penny dropped. Why was I making string installations when the continent that I was living on was covered with strings? That became the conceit: Australia was not mapped out with millions of miles of fences; it was hooked up to millions of miles of string instruments. (Rose 2012a, 197)

The fences in this project are not passive objects.[3] For Rose, they have voices waiting to be performatively brought forth, and as they sound, the places they are located in are also ensounded. Each fence's voice is different, unique. As Taylor tells me: "We assumed that the fences all have a different voice—that was the premise for why we had to stop and play so many. If they were the same or similar, we would have stayed in town and saved our energy" (Neumark 2015a, 138).[4]

The artists bring these voices forth in enchanting and virtuosic *play* with the fence wires and posts—bowing and banging, twisting and twanging,

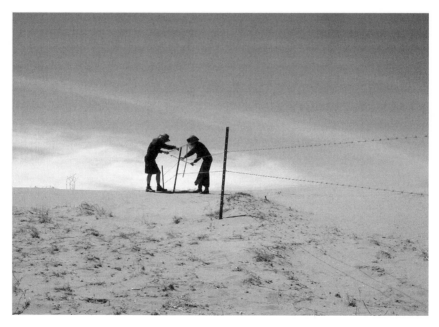

Figure 3.1
Jon Rose and Hollis Taylor, *Bowing a Dune Fence in the Strzelecki Desert, S.A.*, 2007. Courtesy of the artists, photo by Jon Rose.

vibrating and thumping—at times bowing almost conventionally, at other times banging with hammers and mallets. The voices they bring forth speak sometimes rhythmically, sometimes eerily, sometimes softly, sometimes disturbingly—but they always open a listening for the artists, and their audiences, to perceive, to be in country differently. Both the fences and the artists play at the borders of natureculture, as Donna Haraway would have it: "Inherent in everything we do," says Taylor, "is the natureculture continuum. We don't mind the gap. Fences reset our perception. To have a voice is to be sung into existence" (Neumark 2015a, 138).

To have a voice is to be sung into existence. I hear in the voices of the fences a 'musical' relationship to a thing, to a fence, inflected by new materialism. The fence is no longer some generalized thing that could be anywhere, nor is it a simple instrument waiting somehow to be mastered. Rather it is particular, unique, and in and of the place of which its voice sings. Each fence is sung into existence by the playing, and so, too, is the place. As musicians, Rose and Taylor relate to the fences firmly in their place; their work bespeaks the entanglements of the place, the elements, the fences, and the performers themselves—an assemblage to which they are performatively giving voice. As Rose told me: "Sometimes in the outback, the wind is playing the fence (aeolian), so it is a question of joining the performance, or holding back and listening to the show as an audience member. … Although after decades of playing fences, you get a sense of how one might sound by looking at it, but then there are surprises" (Neumark 2015a, 138).

In their work I get the sense of the wind and the weather joining the performance, "enwinding it" as Ingold might have it (Ingold 2011, 139). For Taylor fences speak the weather, speaking a kind of *weather report*:

Fences, unlike violins, can suddenly turn on you. Weather affects them much more than their smaller cousins. Fences are a type of weather report. I found them frustrating, coming from the violin. On a violin, the notes are where they are, and you can be confident in a performance that you can replicate your rehearsal. Not so for a fence. Fences gave me (forced onto me) the opportunity to improvise in a way I never would have on a violin. Playing a fence is like interviewing a stranger; you have to be ready for just about anything and can't afford to take too strong a stance until you get your bearings. (Neumark 2015a, 139)

What I hear in Taylor's commentary is a quite specific call and response between the musicians and each unique fence—a relational 'duet' of the

sort that is inherent in voice and listening, according to Adriana Cavarero, as I discussed in the introduction. Cavarero's sense of the uniqueness of each subject, which is expressed in the duet of voice (Cavarero 2005, 5), reverberates with Taylor and Rose's sense of the uniqueness of each fence and its voice. And so, even though Cavarero is concerned with the human voice, what I listen to here is still a (new materialist) duet of sorts in the way Rose and Taylor listen to each fence as they respond to its call. And, even more, I myself feel called to listen to this voicing as a duet with place, with the places that are Australia, where country has been covered by fences since colonial times. Indeed, *The Fences Project* gives me a different sense of the fences that I had known as ubiquitous in Australia but that I had thought of only as sort of dumb obstacles, interfering with movement— stopping dingoes or rabbits in their tracks, say. This work affords the fences a more nuanced voice, a voice that for locals may already be easier to hear. As Taylor explained to me, "the outback folks made me think twice. Many had already given their fences a tug. To them, fences mean the local music of place, the voice of their paddock, rather than an experimental music session" (Neumark 2015a, 138–139).

While these fences may have been intended by their builders as obstacles, the life of country is not to be silenced, and its voices too reverberate with and through them. The fences voice not just themselves and a relationship with the artists, but also country. Indeed, for Rose, *The Fences Project* is also a response to Indigenous Australian culture and the understandings of fluid relations between animate and inanimate that it provides:

As with so many of the Aboriginal notions of fluidity between the animate and inanimate, between the living and the dead, between history, myth, and the present moment—we just shift states a little. ... The world is inherently musical and, as a musician, it is our job to reveal what is there and maybe convey or share it with other voices from other species and indeed—even other objects that may be in a current state of silence. (Neumark 2015a, 139–140)

To me, this silence does not speak an absence but rather a memory waiting to be listened to. To listen to these memories through playing the fences, wherever they could, Rose and Taylor worked with local Aboriginal people and their "performative tradition where they more often *did* things than *made* things" (Taylor 2007, 238). Taylor cites an instance at one fence with three posts where

several women approach Jon with a concern.
You can't play music with these. Them posts dead ones. We gotta bring 'em back to
life. We paint 'em up.
Really? Yes, please.
Bernadette Tjingiling, Marita Sambono-Diyini, and Christina Yambeing have never
painted together before. Sharing a pie plate of yellow, red, green, blue, white, black,
and magenta acrylics, they sit on the ground around a post and communally cover
one at a time. The first has turtles, fish, snakes, and other animals climbing a pale
blue post. The second features the bush yam with soft brushwork. The third is cram-
full of bright flowers and dragonflies. It's the time of year that dragonflies come out;
they herald the beginning of the Dry, although they are late this year due to the
weather.
There's magic with 'em, we're told.
The three women work late into the night. ... Every available space on the vibrant
posts celebrates some living thing. (Taylor 2007, 239)

The ways that Rose and Taylor listen to the voices of fences, performa-
tively bringing them forth, also recalls Don Ihde's "duets of contact and
motion" where the "voices of things ... bespeak ... their natures" and also
tell of their relations within the environment and lifeworld (Ihde 2007,
191–192, 23). These voices speak from the world, telling us about them-
selves and the world and, in so doing, bringing themselves to life or, even
more, speaking of the life that is already there (Ihde 2007, 23). As I listen to
the extraordinary in the ordinary in *The Fences Project,* I recall Barbara Bolt
and Jane Bennett and sense how artful voice has the poetic and performa-
tive potential to reveal, to make the always/already enchantment of the
modern world audible.

Remembering place

Voice is always/already situated or grounded. As I attune transperceptually
to voice—in place and of place—I can hear how it vibrates and performa-
tively in/forms the space it traverses. And so voice connects speaking and
listening bodies and things physically and affectively with each other as
well as and through the spaces and places they share. And in this moment
of connection, memory speaks. Memory is vital to our relationship to
place—we know place through memory. In a layered and complex way,
memory haunts place and the art engaged with place—through the sensual,
gestural, proprioceptive memories in the audience's bodies and in the
things that comprise the place. I've always found uncanny the way I can be

physically in a place, 'directly' experiencing it through my senses (smell, touch, hearing, seeing) and movements, but at the same time can 'know' it through my own or someone else's memories, including through media—books, films, radio, or music. This is a haunted disjuncture, where I experience other people's memory of a place as my own and my own memory as 'other.' And with it, the materiality of the current moment is disturbed, layered by memories of another, past moment with different modal materialities. This makes me think of Karen Barad's sense of memory where the past is always/already with us. Barad's memory is one of "quantum entanglements" that speak of being in two places at once, the "superposition of times," as each moment of time contains all times and hauntings are not immaterial and moments don't die (Barad 2015). "Memory is not a matter of past," she says, "but recreates the past each time it is invoked" (Barad in Dolphijn and van der Tuin 2012, 67).

Continuing down this new materialist track, I have also been thinking of memory and place in terms of the *place's* memory—for instance, thinking about *place* as *having* memory—memory that can be voiced in an artwork's voicetrack. In these voicetracks, I sense an 'otherness' calling out to me, provoking desire and curiosity about my relations with the others emplaced there. And so I sense the flow of memory between myself and places as a mesh of complex relations, which through artworks I can hear voiced and which, through the memory of artworks, I can hear anew when I again encounter those places.

Locational singer Susan Philipsz performatively works her voice in just this way to evoke the entanglement of memory and place—enabling the audience to emotionally inhabit a place by evoking its memories. In 2008 I encountered her work *The Internationale*, which she installed in Turbine Hall on Cockatoo Island, Sydney, as part of the 2008 Biennale of Sydney. The work had first been sited in a pedestrian underpass in Ljubljana, Slovenia, during the 1999 European Biennial, Manifesta 3. Watching documentation of that first installation, I sense how the work spoke quite differently on Cockatoo Island. Cockatoo Island is a location resonant with a complex and varied history—from fishing by the Eora people on what they called Waremah to a prison in convict times, then dockyards and large industrial shipbuilding yards from the 1850s to 1990s, and lately given over to tourism, including an art and event site. One of its central buildings, Turbine Hall, is a huge, labyrinthine, empty, abandoned-feeling industrial space.

Philipsz's singing of the "Internationale" unexpectedly calls me deeper into this space as I approach. The lone and lonely unaccompanied voice that I hear is palpably untrained. It is evidently recorded without 'professional' production or postproduction. Nor is there any attention to sophisticated speakers, so the voice sounds frail and thin as it reverberates round the large empty space. It emerges from a single old speaker high up on the wall, "in the place of a loud-speaker, which would have been used as a warning siren in the ... industrial space (or, perhaps later, public announcements?) ... so there's a long history of sound involved in the gesture."[5] At first I hear the singing as a melancholy lament for the revolutionary workers' song of hope and intention, but bespeaking too the fragility and bravery of the artist. The more I listen, the more Philipsz's voice feels like it is tapping into, channeling, Turbine Hall's physical industrial memory, and I begin to feel the space differently—sensing its proud workers' history reverberating in my body (I have gooseflesh, my hair stands on end). Philipsz's voice reanimates the space for me as if with workers' memories—it feels as if those memories haunt her voice, making it tremulous, as if those memories haunt those enormous spaces, 'as if' I am overhearing them in that place, as the voice of the place.

This work is typical of Philipsz's locational singing practice—she records her singing of existing songs with little or no professional postproduction, and then has them played back in particular public locations on very ordinary speakers. For curator Carolyn Christov-Bakargiev, these repetitions perform a particular sense of memory and loss: "Repeating rather than inventing a song is a form of re-enactment that instantiates two different times—a past moment of an 'original' song and the present one of her repetition. Repetition is a form of distancing, a deferral yet an affirmation of loss, separation and death" (Christov-Bakargiev 2014, 96).

Christov-Bakargiev goes on to suggest that Philipsz's repetitions evoke a particular kind of bodily vocal identification, not only with the singer but also between listeners, present and absent (Christov-Bakargiev 2014, 96). What's all the more powerful in this work for me is the sense that in this very place, Turbine Hall, the "Internationale" was indeed once sung and listened to.

For Steven Connor, what is also 'absent' in Philipsz's voice is the performance of heightened affect. This has an effect on the listener's body, calling for *it* to produce that embodied affect (Connor 2014, 140). Which I

certainly do. For Philipsz herself, the frailty of her voice gives listeners the possibility of relating to her nonprofessional voice and *imagining* it as their own voice, and thus provides a new way for them to engage with their surroundings (Philipsz 2011). As she puts it in conversation with Manuel Segade:

Hearing [the songs] stripped of their usual accompaniment gives the effect of listening to something quite private, as you say, and that can have the effect of making the listener more aware of themselves in the space. There is a kind of tension between the sentiment of the songs, the way I choose to sing them and the environment into which they are being played, which stops you from entering into any kind of state of reverie. ... What I hope the work does is engage you with your surroundings, not the opposite. When I make the recordings, it is important to keep the breaths and pauses in between, so that the song sounds natural and intimate. The idea is that when you hear a voice taken out of context in this way, your own sense of self becomes heightened while at the same time, you begin to experience your surroundings in a new way. ... A lot of my work deals with absence or loss in one way or another. (Segade 2007)

As Philipsz's singing taps into Turbine Hall's physical, affective and emotional memory and I feel myself and the place differently, I am also reminded again of the way places are always/already haunted by voices of the past which artworks can make audible. Philipsz's voice works performatively not so much to reanimate the Hall as to give access to an animation, an enchantment, always/already there. It sings the voicetrack of an assemblage that entangles Turbine Hall, the loudspeaker, Philipsz's and my own embodied selves, workers' memories, and the reverberating memory of other listeners (and singers) past and present. Within and through this assemblage, I experience in her singing voice what Estelle Barrett understands as a "more radically transgressive performativity" (Barrett 2013, 68). This is a performative voice that calls for a listening animated by and conveying the very aesthetic and affective qualities that new materialism foregrounds.

When a house speaks for itself

Susan Philipsz's voice speaks of the way that memories of affect and emotion can inhabit a building, and how voice can attune us to this—calling us to wonder at both place and memory themselves. In 2014 in London, I attend a sound work by Saskia Olde Wolbers that involves listening to the

memory of a building. This work, *Yes, These Eyes Are the Windows*, is set in the terrace house in Brixton, London, where Vincent van Gogh lived for a year in his youth (1873–1874). Having been allotted a specific time when I booked online, I arrive at the address and wait obediently with five other audience members; at our appointed time, I press the doorbell. The bell rings out the house's readiness, and the door opens by itself, because, as it turns out, there is no one there, except those other five audience members and me. Inside the house, there are two rooms on each floor, some with their ceilings held up by metal supports, some with exposed walls, all with scrappy old furniture. In short, it is a dilapidated mess with no place to sit, so I stand in each room, listening, and then move around, impelled by and following the invitational call of the not quite discernable voices and sounds. The speaking plays at the border between the metaphoric and the literal; at times the voicetrack, with the roar of gushing water and other voices, is so loud that it vibrates the building—literally shaking the crumbling walls, ceilings, and floors. As the voices and the building itself move in this noisy assemblage, so do I—and so am I, too, as part of it, moved. I find myself animated physically and affectively by this voicetrack where some of the voices turn out to be the building's own charged memories, which it speaks in the first person from speakers mostly hidden in its recesses. As Olde Wolbers said, "It's a story. One in which the house speaks for itself" (Coomer 2014).

Waiting

Olde Wolbers worked with location and memory to shift our understanding and our affective and emotional relation to the house. Later I encounter another house which speaks its memories, closer to home. In the country town of Avoca, Victoria, Australia is Watford House, the heart of artist Lyndal Jones's *The Avoca Project* (TAP). Watford House is a wooden house, prefabricated in Sweden in 1850 and imported to gold rush Victoria via Hamburg, Germany. Since 2005 it has been the site of *The Avoca Project*, an extraordinary durational environmental art project. This project is both local, regional, and international, as the artist Lyndal Jones has involved local and international artists and community members in various art events housed there. Many of these center on the house not as site but as part of the artwork, indeed often as the artwork itself, as Jones and others

take care of it, repairing the house and gardens—listening to its voices as they do so. I have been intrigued by TAP for many years but first encounter it directly in 2015 when I go up for a two-day event, *Uncle Vanya in Avoca*, directed by Bagryana Popov.[6] I am keen to listen to the house, as I always respond to a house that has a lot to say—and a house that speaks three languages is particularly alluring. On the weekend of the performance, the house converses with the small audience convened for this location-specific, live-time (two-day) version of Anton Chekhov's *Uncle Vanya*. The production culminates a two-year durational process, working with Jones and *The Avoca Project*.[7] I arrive somewhat uncertain about what lies ahead, but I am welcomed by the house, which speaks its creaking greeting to me, reminding me of its (and my own!) age, as I join the forty-member audience crowded inside its rooms and spread round its gardens. The reverberations of the voices within the small rooms speak to me of the times before expansive open plans when rooms in modest houses needed fireplaces to warm them and they shaped the voices that moved intimately within them. Over the four acts, Watford House's Swedish-speaking walls and Australian-speaking gardens enter a conversation with an Australian English version of Chekhov's Russian—in a duet evoking their layered histories. The listening on that weekend whets my ears for more, for the opportunity to listen to the house in a quieter setting, and so I return a few months later with my collaborator to stay in the house and talk to Jones about the project. We want to take the time to sense the voicetrack of this house that is a unique art project. As we wander through the house and gardens together and stand and listen, Jones tells us about the way that, when you care for a house, the house cares for you. This reminds me of the aesthetics and ethics of care that I listened to with animal voices and now, attuned by Jones's own listening, can attend to here in her house and garden. As we follow in Jones's voicetracks, I too listen to an artwork that is not *about* a house but *is* a house, whose voices have not always been easy to hear. Jones explains that it has been essential to let the work unfold, to *wait* to let these voices speak—a waiting of the project's ten years' duration by 2015. Waiting—an art practice in itself for Jones, who has engaged in a number of 5-to-10-year projects—has involved here an attentiveness to silence. In this moment in Avoca, I apprehend waiting through Don Ihde's giving voice to silence: "Waiting is a 'letting be' which allows that which continuously 'is given' into space and time to be noted. Auditorily this is a

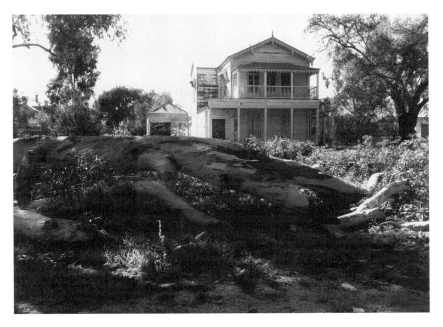

Figure 3.2
Lyndal Jones, *Escape from Certain Harm*, 2013. Digital still image. Courtesy of the artist, photo by Lyndal Jones.

listening to silence which surrounds sound. 'Silence is the sound of time passing'" (Ihde 2007, 111).[8]

To attend to the materiality of voices in and of silence, we must first be able to wait, to attune our time, our ears, our sensibilities. In a way, this is a listening that is attentive to environment, a "becoming earth," as Jones puts it to me on that day. And entering the gift economy with which Jones's wider project works, I am given the gift of a different sort of listening to voices speaking through the silence. And so to encounter the voicetrack of this assemblage—an art project that is a house and a garden and water tanks and all the more-than-human beings and things that are there—I have to slow down to listen to the time-lapse-like voices of plants growing, of walls speaking their memories, and of water tanks echoing the bounty of water in a drought-stricken country. I have to remember, with Jones, the thud-ding voice of the magnificent gum tree as it fell over due to flooding and salinity in the land, speaking what she alluringly calls "insistences of the ground" (Jones 2016). As Jones "thinks through materials" in this

project—watching and listening, making audible and visible what is there—she, and the others who sense it and learn from it, are perhaps engaged in an enchanting process of becoming-house.

Wondering and wandering through riceworks

When artful voices affect us, evoking memories of emotion, memories that inhabit a building, we sense how voice and sound might attune us to this—calling us to wonder about both place and memory themselves. When buildings come alive with memory and affect, there is a sense of wonder, a sense of the wonder that is there, but we rely on art to sense it again. Vic McEwan and Cad Factory's *A Night of Wonder* (September 21, 2013) recalls the wonder that Jane Bennett tells us is already in the world, if we can just apprehend it. It reminds me of art's *work* in doing this affective and aesthetic and ethical work. For Bennett, as I've discussed, it is affect and its aesthetics that make us feel ethical investments and attachments.

These are the affective attachments that are provoked and voiced in *A Night of Wonder*, an evening of installation and performances at the SunRice Mill in Coleambally, New South Wales, Australia. Artists Vic McEwan, Mayu Kanamori, and Shigeaki Iwai are in residence at the rice mill for three weeks prior to the event. When the audience gathers, the artists take them on a shared rice journey through the industrial site of the mill, following the traces of the rice's own path through that place. I listen to this work's voice-track through documentation, encountering it as a duet, with the artists responding to the call of the rice and the rice responding to the call of the artists. The event opens as a number of people are invited to address the rice, calling it into relations with themselves and the community. It begins with the welcoming address from Stan Grant, a local Aboriginal elder, an invocation which echoes his earlier welcome to country outside the mill: "Good-day. My name is Stan Grant and I'm Wiradjuri. Rice, I need to speak to you. You are not originally from this land. You were brought here from far away, from across the sea, many, many years ago. You were then brought to Wiradjuri land by people who were not Wiradjuri but by people who would see you in the future."

A rice grower next intones: "Rice, rice all very nice, I'm proud to grow you and to prosper with you. You feed the world. I feed the world. I suppose this is part of who I am and what I am." For the Japanese-born artist, Mayu

Kanamori, it is important to tell the rice that "we know spring has arrived because we can smell the burning stubble. For generations now we have fed our young from your rebirth." I listen to these voices ceremonially calling the rice into a new materialist conversation—evoking the possibility of conversations between people and things and resonating with the way *duet*, for Don Ihde and Adriana Cavarero, is quintessential to voice. And the rice answers in its own manifold voices. Released from containers high on the walls, the rice responds to these calls in whooshing tones as it curtains to the floor, revealing its own artful voice. And, reminding me of its ongoing presence in the place, a bed of rice husks responds in a quietly crunching voice to the tactile weight of people walking on top of them. And in this "duet of things which lend each other a voice" (Ihde 2007, 67) and speak the event's voicetrack, it is not just the rice that tells of this place, but the building itself. McEwan artfully calls forth the building's voices in his per-formance with its many ladders—ladders that the workers climbed daily to move between the levels of the mill. Reminding me of Rose and Taylor with their fences, McEwan plays the ladders, running a bow and fingernails across them, calling upon them to give voice to their memories of the rice workers who constantly climbed up and down upon them.

Figure 3.3
Vic McEwan, Iwai Shigeaki, and Mayu Kanamori, *SunRice—A Night of Wonder*, 2013. Video documentation from *Sunrice—A Night of Wonder*, a project as part of the Cad Factory and SunRice Contemporary Arts Partnership. Photo still image taken from documentation video by Sam James, courtesy of Realtime Magazine.

Stemning—voicing atmospheres

In *A Night of Wonder*, as in the works discussed in the previous section, I am reminded of the point made by sound artist and composer Marie Højlund about the Danish word for voice, *stemme*.[9] *Stemme*, she points out, is also used when describing the atmosphere in a room, for example as the room's *stemning* (voicing). This connection (which Højlund works with in her own practice), like Olde Wolbers's proposition that the building speaks for itself, recalls Gernot Böhme's concept of *atmosphere*. The various works I've discussed so far have voiced the atmosphere of the rooms and buildings they played with—in Böhme's sense of atmosphere, where atmosphere speaks to the life of an environment and helps us understand *place* in a performative and entangled way. Böhme understands atmosphere through what he calls "new aesthetics." New aesthetics moves beyond a 'normative' aesthetics of judgment, which ignores sensuousness and wrongly, he argues, approaches art as communication of meaning. At the heart of Böhme's new aesthetics— both for audiences and for artists—is (trans)perception, which happens through bodily presence, including that of people, objects, and physical environments (Böhme 1993, 115–116).

Atmospheres, Böhme says, are an intermediate phenomenon between subject and object (Böhme 2013, 3). Attuned by new materialism, I would suggest that they disturb the difference between subject and object, or at least make it porous. Atmospheres, he tells us, are spaces *tinctured* through the presences of persons, who sense through their bodily presence, and things, which articulate their presence through various qualities which he calls *ecstasies* (Böhme 1993, 116, 122). To the various makers of atmospheres that Böhme signals, including set designers, garden makers, and town planners, I would add event curators and installation makers. And in this, the ecstatic work of Vic McEwan and the SunRice project is exemplary.

Voice, as Højlund's insight suggests, is particularly evocative of atmosphere—speaking of it and from it and within it. Thinking about voice through atmosphere offers another way into the apprehension of an assemblage and the relationships it involves, from the point of view of the perception of the assemblage for the maker and the audience. Böhme's atmospheres inflect what Tim Ingold says about air, that most material and literal of atmospheres. As he did with sound, Ingold understands air as "the

medium" of the inhabited environment (rather than an object)—a medium which "allows us to move about—to do things, make things and touch things. It also transmits radiant energy and mechanical vibration so that we can see and hear" (Ingold 2011, 22). And, for me, more than that and less transparently in a way, air—as the atmosphere of a place—tinctures and is tinctured by voice.

Ears to the ground

Elle-Mie Ejdrup Hansen usually makes installations to be sited in a location, working with lines and drawings, voice and sound to engage with place, in a way in which it is the listening that brings the audience into the work. However, in her online work *The Sound of ...*, Hansen brings the location of Ringkøbing-Skjern, Denmark, to me digitally, as she places a still photograph and moving video image side by side in the nine small pieces that comprise the work.[10] This work is not a documentation of a locational installation work but an exploration of how we can engage with place online, through photography and video, through sound and voice. In the work's nine pairs of moving and still images, the moving image is a version of the still, transformed into sound waves—playing with, voicing I would say, the "tension between photography and video."[11] This gives me a sense of listening to the image, hearing the voice that is there, the voice that is both still in the still image and animated as it animates the moving image. The work recalls *In-betweenness*, Hansen's earlier project with a seismograph in Iceland (1997), which conveyed the movement of the earth (Hansen 2013a). As I engage with this work online, I set the moving images in motion and the earth erupts, volcano-like. It feels like the motion that is always/already there within the still image, a liveness there if we could but sense it. It is as if the still image is being deconstructed by the sound and voice, so that I sense the 'something more' that is there in the still image and the stillness immanent in the noisy/vibrating one. In one sequence it feels like the waves of a still image of the shore become the moving waves in the video, as they move from still to moving and back in a constant ebb and flow. I sense in this flowing over between still and moving image both a very small, intimate moment and the horizons where we can listen to voice as it is *"given"*—"comes-into-presence" (Ihde 2007, 109, his italics).

Figure 3.4
Elle-Mie Ejdrup Hansen, *The Sound of ...*, 2009. Online digital work. Courtesy of the artist, photo by Elle-Mie Ejdrup Hansen.

I think about the way my hand on the cursor plays (with) Hansen's work, provoked by the voicetracks and evoking the voicetracks. How is my hand invited to respond by the work? How is the voicetrack affected and effected by the material forces of my actions? Perhaps this is a good moment to turn to what Erin Manning proposes as the *minor gesture*, "activating new modes of perception ... reorient[ing] experience." For Manning, this activating gesture is "singularly connected to the event *at hand*, immanent to the *in-act*" (Manning 2016, 2, my italics). I wonder: Is my hand playing the cursor a minor moment of minor gesture? In any case, the new modes of (trans)perception at hand and with hand here— particular for me, located in Melbourne—reorient my relation not just to the place of Hansen's work but also to my own local place. And with that they speak also to the potentials of online media art to animate and be animated by a sense of place.[12]

Perhaps, too, this is a good moment to return to Don Ihde's postphenomenological concept (after Heidegger) of *giving voice*, to ask, How might *giving voice* speak to this moment of play? In one reading, *giving voice* may seem all too human-centered—as phenomenology sometimes does. Yet I read something more complex in Ihde's figure, reading it, as I have been, through his relational (rather than human-centered) figure of duet. In this way, with Ihde, I sense my actions as calls and responses that imbricate me in the work and its voicetrack. And so I sense my hand on the cursor as part of an assemblage in which the voices erupt, pushing up from center to edge

and horizon. Some of the pieces are more gentle in their movements and voices, some more vigorous, some are more silent, others more cacophonous. But all call and respond to my hand, eye, and ear as they become part of these assemblages.

The voicetrack of eruption itself provokes and is evoked by the motions of the visual lines in the work. As in others of Hansen's works (where she works with a line that points off into the horizon), in *The Sound of ...* the lines both point to an end and are endless. In some of the nine pieces it feels like the still image is flowing into the moving, and in others this feels reversed. But in all, I experience a simultaneous sense of both a wave and a particle, still and moving—somehow one always includes the other, remembers the other, is a version of the other. The vibration here is literal and metaphoric, like the vibration Hansen usually plays with in her drawings— and they make we wonder, are they sound or light or the voicing of both? Later when I return to the piece after listening to a lecture by Erin Manning, I sense the infrathin exemplified here, the infrathin difference between the still and moving image. Marcel Duchamp used examples of *infrathin* to evoke the separation between two things that are the 'same' but not. I sense this in Hansen's work, in the infrathin difference between the still and moving image of the 'same' place. Manning thinks Duchamp's figure of the infrathin (to which I return in the final chapter) through Alfred North Whitehead's philosophy of process and her own process-driven art practice. She understands the infrathin as the "threshold between force and form." She revels in the way Duchamp's infrathin is exemplary and eludes definition. For Manning, the infrathin speaks of the way the actual is always replete with the virtual (Manning 2015). Experiencing Hansen's work, I am moved by and with its voicetrack as I hover on the threshold between the still and moving images. The force and form of each and both, and the virtuality replete in the still image—all speak to me of the infrathin moments of voicetracks.

In all the nine pieces that make up Hansen's *The Sound of ...*, the voices call us to enter the movement, the vibration and flux of the image, to "find our being" and move through, as Tim Ingold would say (Ingold 2011, 138). I imagine that Ingold might feel uneasy about my speaking this way about an online work, but I have to say that I am not worried about mediation per se. And, even while agreeing with his qualms about soundscapes, I don't

assume that all media art working with voice, sound, and place do so in the ways he criticizes. Indeed, I experience this very different way of working in the nine compelling pieces in Hansen's work, as I "find my being in them and move through them"—invited and invoked by the work's voicetrack that speaks its still and animated quality. As I move through the work, I listen with it and within it to the voice of the world as it speaks, as it comes into speaking. The voices in Hansen's work enmesh me in eddying waves that we listen to "within" (Ingold 2011, 138).

As I look and listen, I wonder what experience of the place this work evokes and how, getting down to particulars, the voices of the birds and sea work here. What I sense is neither landscape nor soundscape but a sense of place vibrating with lines of light and sound that take me into its depths and beyond its horizons. The voices of the sea, the larks, the swans and geese are their own voices, speaking an emplacement I can't see but can feel as an enlivenment. But they also voice the environment itself. As the voices erupt—like the waves, as waves, with the waves—they evoke a sense of the movement within the stillness—they speak of both immersion and erup-tion. In some of the pieces the voice erupts as if pushing up from the center out to its edges, volcano-like, its lava flow going to both edges, where, on one side, it meets the still image, taking my eye and ears with it. In other pieces it feels like the waves have come up out of the still image and are pushing against and ebbing and flowing into the moving image where they speak a voice that was in the still image but silent, waiting—voicing what Ihde calls "the enigma of *silence* ... [as] a *dimension* of the horizon" (Ihde 2007, 109).

In the *Sound of ...*, Hansen works an assemblage that voices the land and the sea, the ground and its inhabitants, making perceptible not just living organisms that I cannot see but the very world I can sense in the vibrations of the air, the flows of the sea, the wind in the grass. While this is an online work, not an installation, nonetheless it affords me an opportunity to fol-low the voice, "to listen and wander the same path," as Ingold put it (Ingold 2011, 139). And, in many ways, in this (as in others of Hansen's works),[13] voice and light work in a multisensorial way that bypasses another of the pitfalls of soundscapes: here "the environment that we experience, know, and move around in is not sliced up along the lines of the sensory pathways by which we enter into it" (Ingold 2011, 136).

Voice, breath, and place

Breath speaks to us of place and its relation to the humans and more-than-humans who shape and are shaped by it. This is the voice of air that enables us to sense this medium, in Tim Ingold's sense, and it is also the voice of atmosphere in Gernot Böhme's sense. Perhaps one of the best-known artists to work with breath and place is Canadian sound and installation artist Janet Cardiff. Conceptually and phenomenologically, her work has many things to tell about voice and place. The seminal audio walks that first brought her to prominence create an uncanny play between walking, memory, media, affect, emotion, voice, and place, where the voicetrack, tinctured by her voice and breath, immerses us extraordinarily and palpably in a place. To construct her walks, in which voice is the crucial element, Cardiff works in between script and impromptu, speaking the relation to the place she's traversing through a distinctive performance and recording of voice. As you put on your headphones and accompany her on her walks, you're in her head and she's in yours—such is the effect of binaural recordings of voice.

There is a dizzying *mise-en-abyme* in Cardiff's audio walks—as you walk in her footsteps, you listen to stories within stories, dreams within dreams, memories within memories. This makes the experience of the places where she stages them particularly strange and intense, orienting and disorienting. Cardiff's evocations of memories of places are intensely and intimately poetic but also elliptical, as cinematic memories suddenly intervene—in one way constituting her memory and in another disrupting it (texturally). The intermixing of Cardiff's archive of embodied memories (of being in a place) with the place's own archive (both mediated and 'historical') makes her work pleasurable and endlessly engaging and surprising.

This pleasure and engagement are amplified by the palpable sense of bodily materiality in Cardiff's voice; it is breathy in my ears—breathy and breath-taking. As she sniffs and breathes and hesitates, I feel it in my own body; I walk with her, feeling the strain, for instance, of her walking a steep path. But since it is Cardiff's human voice that is foregrounded, I wonder what the work can tell us here about nonhuman voice and new materialism. What is Cardiff voicing, breathing? Is it just her own memories or also the memories in the place that vibrate through her, inflecting her voice, catching her breath? As I listen, I sense her voice reverberating with the

things she engages with, in such a way that they speak through her. Again she is like a medium, for memories in media and in things—which together animate the places I traverse with her. She does not try to absent herself from the work, to let a place speak for itself, as it were (Kim-Cohen 2009, 109–115). Instead she is clearly bodily present in works that commingle the voice of the place with her own body and voice—her own making and doing—vibrating together and mediating both through media and memories.

In 2012 at Documenta 13 in Kassel, I experience one of the audiovisual walks that Cardiff has made recently with George Bures Miller, *Alter Bahnhof Video Walk*. I come to this work still reeling from another of their Documenta works, *Forest (for a Thousand Years)*, which I came upon somewhat unexpectedly as I was peacefully walking among various Documenta works in Kassel's Karlsaue Park. I was suddenly disoriented and drawn off the path and into the woods by sounds and voices—screams, marching soldiers, artillery shots, bombs, and planes. As I arrived in the clearing, the stridency of these voices and sounds was all the more jarring as they were framed by moments of sudden quiet. As I joined a group of people standing and sitting on logs—they turned out to be the stunned audience— it was as if the memories of the war in those woods had come alive, reverberating, bombarding—evoking the forest's own memories of the wartime experiences it had witnessed, indeed experienced, and now staged. Suddenly it was as if I'd actually stumbled back into World War II or a World War II film set, complete with an assortment of dazed extras not sure what would happen next. This work took immersive to a whole new and different level. Evoking visceral terror, the voicetrack of this assemblage spoke of time and memory and war and media, of forests and noise and quiet and ravens and trees. … And as with so many of their works, this twenty-eight-minute audio installation in the woods in Kassel affectively evoked place and memory in a way that was both locating and dislocating. As I heard the voices of things, humans, animals, and other living beings—the leaves speaking in duet with footsteps, birds singing and screeching, for instance—I was uncertain whether they came through the speakers, from the same place at another time, or were happening live. And later, as I watched documentation on line, I once again saw people looking around with the same uncertainty—riveted and disoriented simultaneously.

I go from this to Kassel railway station for *Alter Bahnhof Video Walk.*[14] This work once again plunges me into the complexity of time and layers of memory in the station whose walls and floors, platforms and recesses speak the memory of the Jews who were deported to death camps from that very place. And it awakens my own memories of earlier audio walks where I listened to Cardiff's voice—now both familiarly intimate but strangely different, too, as it is playing against an image track. Disturbing my sense of time even further, Cardiff speaks both from the past, when she was there making the work, and from the present, when she guides me through the space. As she voices the disorientation of time with memory, I feel it in my own body—walking with her and listening to her compelling voice, not sure if it, she, is with me here now, or was it then? In this voicetrack, mediation is both pressing and elusive, present and absent at the same time.

As I start the video on my iPod, Cardiff in my earphones calls upon me to align my movements—and I would say, my affects—with hers. As ever with her works, I find that the 'instructions' that she gives me are alluring, more an invitation to enter a zone of intimacy with her than an injunction, even when the words are directives, like "stop." But her voice reverberates so intensely inside my head that I feel as if it is my body itself directing me, that it feels an inner urge to stop moving. Unlike her audio walks, there is an extra layer here, a visual *mise-en-abyme*, with the video that I hold up in the 'same' place that the camera shot it. A disarming repetition, the same but different, an echo and memory rather than a documentation. It feels live and present, yet not. And so I walk around the railway station, looking at the iPod in front of me and finding myself looking around confusedly to see where the brass band in the video are—are they just out of sight, behind that pillar? And what of the dancing girl, the elusive figure in red pulling a suitcase, the bird, the dog, the people rushing? What is then and what is now, I wonder, and what was eighty years ago? Hearing them in my headphones, seeing them on the iPod, I can't believe they aren't just out of sight. Or that the people I see around me and whose voices I hear won't suddenly appear in the video.

And in the assemblage of this work, it is Cardiff's voice and voicetrack that hinge across the multiple times of the 'same' place—speaking of this assemblage that is place, technology, and memory—and her, and my, body. It's so live that I find myself expecting, as her voice enjoins me, to see in the

railway station today the same events I am watching in the video. I feel dizzy at times, relieved when she enjoins me to stop or sit down. And while Cardiff asks me to follow the image—as if what's happening in the video is happening now—for me it is her voice that leads me on, anchoring me in this visual confusion while luring me ever deeper into it. I literally feel the disorientation of the memories she, and others, are talking about. And if you watch the YouTube video documentation of the work, as I do to remind myself, there is yet another layer to navigate and plunge into.

One of Cardiff's most famous works is her early audio walk in the streets, laneways, and buildings of London's East End. From its very title, *The Missing Voice: (Case Study B)*, the work calls to me, luring me in. Once again I encounter the way Cardiff's voice brings a place—London's East End—alive in an uncanny way, animating it and disturbing it with her strange and disjointed narratives, drifting between fact and fiction, dream and reality, between locatedness and dislocatedness, playing between media and within media. "I dreamt I was dreaming," she says softly in my ear. Meanwhile the smooth cobblestones of those old streets beneath my own walking feet voice their duet with the footsteps that I hear in my headphones—making the voice of those cobblestones I am walking on more palpable, as they blur together. At one point, after meandering through old tiny laneways and across traffic-laden modern thoroughfares, I arrive at a small garden of flowers. I follow Cardiff's instructions to enter a local church. The smell of incense inside and the singing voices (it is a Sunday) are intensified by the recordings of singing and by Cardiff's verbal description of incense. The church reverberates literally and poetically with these echoing voices, sounds, and smells. And throughout, the intimacy and immediacy of her breathing, her hesitations, her silences, so close in my ear, tincture and contour my emotional and sensual experience of the places she invites me to experience with her.[15]

Fragile ground

Walking as a way of engaging with place has since become a growing practice for artists, many of whom are inspired by Cardiff.[16] Listening in these walking works to the voices of things, humans, animals, and assemblages reframes our attention to and apprehension of place—reorienting our senses and the way they are inscribed in and by a place. A recent exhibition

that focused on walking and place is part of the Palimpsest Biennale in Mildura, in regional Australia (2015). I experience a number of the works in a gallery after a day at the extraordinary, ancient, and now dry and fragile Lake Mungo, which is one of the places that the Palimpsest artists work in. I am already alerted by the premise of the Biennale to listen for and to the voice of footsteps, speaking of place and movement, as I move from installation to installation in the Mildura Arts Centre. A few rooms in, my ears, cushioned in headphones, prick up as I listen first to sound artist Daniel Browning's radiophonic work *The Crucible*. Serendipitously, I come into the looping work just as he is speaking the words "those footprints speak," about "the world's largest collection of ice age human footprints, etched unconsciously into the claypan" (per the wall signage). Sensitive to the voice of footprints and trees through his own Indigenous knowledge, Browning's work is a listening to the voices of both. Removing my headphones, but with my ears well attuned to voices of Lake Mungo, I walk through a small corridor covered with eggshells by artist Mishka Hennies. Crunching under my feet, unsettling my footsteps, they tell me of a ground's fragility and the destructive impact of my walking feet that I normally don't notice. They remind me of the fragility of country at Lake Mungo and the care that the Indigenous people give as they listen to its voices.

And then, more shells, as the corridor opens onto a strikingly beautiful and somewhat elusive work by another contemporary Indigenous artist, Julie Gough—*Holding Pattern*. It is an assemblage of seashells, orange and white traffic cones, and videos, which again, serendipitously, show feet walking when I enter the room. The traffic cones recall the holding patterns of the airports that figure largely in the videos. The conch shells, which hang from the ceiling on strings, move slowly, gently—are they agitated by the affect of their own listening and their desire to speak back what they hear and what they know? Are they performing their voices as speakers or microphones, I wonder—a question to which I'll return in the following chapter.

These works remind me of another work that speaks of the fragility of place. In *The Life of Claisebrook*, artist Nola Farman engages with water under pressure—water bursting with the desire to speak, to speak back, and to tell of a repressed Aboriginal history embedded in a wetland's waterways, birds, and trees. Farman makes the sound-sculptural work in an East Perth

(Western Australian) wetland, an important heritage site for Aboriginal tra-
ditional owners that has been once again interfered with and flattened for
redevelopment and a second 'Europeanizing' in the 1980s and 1990s. While
the redevelopers strive to control and "tame" Claisebrook, Farman listens
to the voice of the water system, still alive but "repressed," as she puts it,
"out of control," in order to make the work, in which water speaks in a
sometimes gushing, sometimes relaxed voice. In this place-specific work,
the repressed voices of Aboriginal history and country return, spurting out
through the rocks, the water speaking its life with a voice that modernizing,
Europeanizing colonial culture has failed to silence. I notice that Farman
prefers the term "place-specific" to "site-specific" for her work, because it
expresses the way place relays knowledge, holds knowledge, speaks knowl-
edge, including the knowledge of what she listens to as "repressed voices of
a place," especially places that have been tampered with in efforts to con-
trol and master their energies.[17]

Spanning environments

My final two examples bridge from this chapter to the next. They are works
that evoke both place, on which this chapter has focused, and things,
which speak in the following chapter. They are literally bridges. Bridges,
which are structures, are also places, as they hinge two pieces of land and
speak of that land, the connection, and their human and more-than-
human 'load.' Bridges are places that are especially vocal about their ener-
gies, for sound artists like Bill Fontana and Jodi Rose, who call upon them
to speak eloquently of themselves and of place. In Fontana's work I hear
their distinctive voices, evoking not just an inner musical being but also
the very places they span and contour. His *Harmonic Bridge* (2006) "explores
the musicality of sounds hidden within the structure of the London Mil-
lennium Bridge. This bridge is alive with vibrations caused by its responses
to the collective energy of footsteps, load and wind." These vibrations
shudder along the voicetracks of the work, evoking those footsteps, bodily
and mechanical pressures, and wind that the bridge bears. To make this
voicetrack, Fontana uses a network of live vibration sensors to bring the
voice forth to our hearing. And it is a particular voice speaking of the
bridge, its life, and its emplacement between the shores: "I create a

dialogue between one place and another place," says Fontana. "It is never random." This *dialogue* evokes the voice of conversations within and between places and the things assembled there. Yet another place enters the dialogue as he remakes the work for the vast space of the Turbine Hall in Tate Modern, London. For Fontana, *Harmonic Bridge* is a mapping of a "hidden musical life," which he then "translated into a living acoustic sculpture by carefully rendering sounds from this listening network into a spatial matrix of loudspeakers, in the Turbine Hall of Tate Modern" (Fontana 2009). To my ears, however, this is not so much the voice of those loudspeakers, nor even music per se, but the vibrating musical voice of place and the bridge speaking its response to place, to people and weather. Indeed, as Fontana explains in relation to a desert work, "The sound of thousands and millions of grains of sand shifting and moving over these vibration sensors produced a sound that was very much like the sound of the sea. That was the *voice* of the desert I was looking for" (Fontana 2014, my italics).

Sound artist Jodi Rose similarly tunes in to bridges' vibrations, listening for their singing and working with the sounds musically, often orchestrally. What she hears in these vibrations, she tells us, are the structures' voices, even though they do speak musically to her and with her—speaking of the bridge and its place, the lands it spans, the water it overlooks, the events that occur on it. By 2011, Rose had already listened to more than 48 bridges through contact microphones on their cables, "listening to the *voice* of the structure as wind, traffic and tension create vibrations. … More than the acoustic properties or harmonics in the wires, the sound is also the *voice* of the bridge, released through the vibration that travels along the cables and reaches out across the globe" (Rose 2011b, my italics).

While both artists tend to focus on sound and music, their significant references to voice tell me how sound and musical works in and of place can be listened to for their voice, their voicing of place, both by the artists and the audience. With these works I listen to the vibrations of the bridges that speak of their location within a particular environment, a voicetrack of that assemblage. And it is listening, tuning in to their singing, as Rose puts it—their singing voice, I would emphasize—that lies at the heart of these works for the artists too (Rose 2011a).

And to follow

Voices tell us of place in all sorts of ways, vibrating and moving through and with the ground and through and with our feet and bodies—vibrating, too, through and with the air and atmosphere as well as the flora and fauna. In this chapter bridges have spoken of place, the places in which they are located; with a different attunement, however, bridges could also be called upon to speak differently, voicing their most metallic selves. From that vantage point, we could listen to their metal structures speaking themselves, in the ways that I turn to in the following chapter.

4 Technology and Machines Speak (for) Themselves

In the previous three chapters, I have been listening to how new materialism opens up an understanding of voice beyond the human and helps us attend to the relationships of voice as not necessarily between humans. It invites a listening to art and media voicetracks that include flora and fauna, places and things. In turn, I've proposed that listening to these voicetracks troubles presumptions of human-centered agency and subjectivity and contributes to the new materialist conversation. In this chapter I turn my attention to things as they voice themselves. I will focus on mechanical and technological voices speaking (for) themselves—rather than mediating or carrying voices of others, in the way in which we typically listen to them. While technology did often play an enabling role in the voicings of place in the artists' works I listened to in previous chapters, here I will be listening differently, to different voices. I will be listening to insistent thingly voices that I cannot ignore. I think I first became particularly attuned to these voices through stories. There was a friend who told me of hearing the explosive voice of a gasket blowing in her car (a very loud breath, indeed), telling her of her own explosive state. And another who heard the cracking voice of light bulbs bursting as she hit the switch, speaking of her own eruptive emotions. Yet another spoke of the quiet death groan of her computer as she bored it to death writing her thesis. And then there is Steen's story, to which I'll return at the end. But I don't want to spoil the ending—mine or his—so I'll simply say now that as these voices call out strangely, in their own ways, they speak of the enchantment that is always/already there in the things and our relationships with them.

I begin by attending to technology that itself speaks, speaks itself, voicing its own curious essence. No longer content to be an almost inaudible bearer of others' voices, it brings its own voice forcibly into the

conversation. I listen here to loudspeakers and microphones that no longer humbly and quietly enable or transmit other voices, but voice themselves at the same time. In the next part of the chapter I engage with works of sonification, a curious case of 'as if' a thing or force of nature is speaking but, to my ears, one that's more about the voice of technology. Finally I listen directly to machines, from robots to toys to tattoo machines, and attend to what they have to say about politics and economics as they speak of and for themselves. But first,

A transitional piece

In 1969 artist and composer Alvin Lucier made a famous work called *I Am Sitting in a Room*. As he said, his stuttering was part of the motivation for the piece, in which he performatively spoke a paragraph about sitting in the room, recording the text as he spoke it, then played the recording back in the room through loudspeakers, re-recording over and over until his stuttering voice turned into 'music.' In Lucier's work, the ambiguity of the voice, its move between signification and sonority (from sound speech to noise), moved the work forward and into a liminal, transitional zone. In some ways we might listen to this as technology's enabling and demonstrating this quality of voice, and as a comment on the tape recorder and a play at the edge of voice, sound, and ultimately music. In some ways, we might listen to it as the voice of the place, the room. And, in other ways, we might listen to it as the voice of the tape recorder. Let me elaborate.

Lucier was interested in the way rooms have characteristic resonances and the way certain frequencies are "emphasized" as they resonate in a room so that "eventually the words become unintelligible, replaced by the pure resonant harmonies and tones of the room itself" (Lucier n.d.). In that sense, I sometimes listen to Lucier's work as the voice of the room, and could have placed it in the previous chapter. This seems to accord with the approach taken by Jonathan Sterne and Mitchell Akiyama, who apprehend the work as a sonification of the "acoustic characteristics of a room" (Sterne and Akiyama 2012, 552). Leaving for later the question of sonification, I have to say that I would be uneasy with this as the only way of listening to Lucier's work. For in so many ways this work is ambiguous— not just troubling voice's relation to space, to place and time, and to human subjectivity, but also troubling the way we listen to voice and

technology or technological voices. I would like to suggest that there is also a tension audible here between the artist's voice and technology's voice, a play or even morphing between them; the voice of technology is set off by the artist's, but eventually, over time and in a space, it asserts itself, even takes over. This is something that I sense only when I actually listen to the full, long piece and experience it in its slowness. As my attention drifts in and out, I experience a certain ambiguity—whose voice is it? Is it Lucier's voice transforming through technology, or does the loudspeaker itself begin to speak? As I listen to this piece as it reverberates from the previous chapter into this one—transitional between the voices of place and the voices of technology—it characteristically eludes easy placement in either.

Loudspeakers, loud speakers

We use the term "loudspeaker" or "speakers" so casually that the sense that these objects are 'speakers,' that they are *speaking*, has been lost. Why do we call them speakers if not to convey a sense that they are indeed speaking, not just playing back or amplifying? And, if they are speaking, what is their voice? Is it simply the voice that has been recorded or is being amplified live, for which they are transparent devices of recording and playback (van Eck 2013, 157),[1] or do *they* perhaps have something to say? I'd say that it depends on how and where you listen. I first started to think about this in relation to works by Brandon LaBelle, in which he places loudspeakers among the audience. This simple placement can subtly disturb the sense that these are simply playback devices and can foreground the 'speaking' quality of speakers themselves.

In one of LaBelle's recent works, *A Rehearsal for the People's Microphone* (2015),[2] I notice that if I stand in front of them, the speakers sound like traditional playback devices for recorded voices. But if I stand to the side, I still hear voices but cannot ascertain their source or who, indeed, is speaking here—I keep looking around in confusion. In this listening askew, it is as if the loudspeakers in this rehearsal speak otherwise, daring to take over. In a way, what the work also tells of is relationality and voice—not only the importance of the listener's position and disposition, but also of the voice itself that speaks to the listener and the always/already embodiment of the so-called disembodied voices of recording and playback.[3] What I am

hearing is the speakers as uncannily live—voicing their own voice? Because as hard as I listen, there on the sidelines, I cannot sense the voices as simply long ago recorded and now playing back. I wonder at first whether there are actual people there, speaking, but as I look carefully I see there are only the speakers. I begin to have the uncanny sense that the speakers have somehow taken over and are speaking themselves with an as-if-human voice. Who or what is inhabiting whom or what? Whose or what's voices are speaking? What I find myself listening to is something more than a work about echo and repetition—perhaps more a rehearsal for a reversal—where the speakers' own voices *become* the human voices that inhabit them, rather than a transparent transmitting. I feel like the RCA Victor dog in a new materialist enchanted zone. Just as the People's Microphone in the Occupy movement plays with repetition and alters our apprehension of microphone technology, so this work disrupts my sensed understanding of speaker technology as simply communicative/transmissional. Are the speakers voicing the way they are occupied by the people, just as the People's Microphone voices a different sort of occupation of public space?

Speakers … again and again and again …

While LaBelle's work disturbs the taken-for-granted sense of the voice which speaks in a loudspeaker, it does this by playing with *human* voices. In so doing, it provokes a sensed understanding of the uncanniness of speakers and the repetitions of voices they speak. Another work with speakers that plays with repetition in a way that enables them to speak is a sound sculpture by Pe Lang and Marianthi Papalexandri-Alexandri, *Untitled V*, installed at Kunsthal Aarhus, Denmark, in May 2014. The repetition in this work is literally embodied by the speakers themselves, their speaking bodies, lined up on the wall one after another. They are tenuously connected by a thin nylon thread which rubs against a motorized wheel, causing the friction that sets it all in speaking motion (Lang and Papalexandri-Alexandri 2014). Each speaker is small and delicate and softly spoken on its own, but as an assemblage their rhythmic multiplicity evokes something more, a moving and mesmerizing experience.

The wall signage invites me to "listen to the sound of the speakers and not to the sounds produced by the speakers." And so I do, but even more, I

Figure 4.1
Pe Lang and Marianthi Papalexandri-Alexandri, *Untitled V*, 2014. Site-specific sound installation with motors, nylon line, steel, loudspeakers, and aluminum. Exhibited at Kunsthal Aarhus, Denmark, and commissioned by SPOR festival 2014 (May 8–11, 2014). Supported by The Danish Arts Foundation and Swiss Arts Council Pro Helvetia. Courtesy of the artists, photo by Pe Lang.

listen to these sounds as voice. To me, they are voices rather than sounds, because they speak insistently (of) the speakers' desire to be heard. Their clicking, and bouncing, little bodies express the effort of voicing, quivering across the membrane of the speaker, quivering with desire. Together they form an organism that voices not just their analog past and relations with each other but also, most importantly, a lively, vibrating desire to be listened to. There is affect forcefully at play here—I am moved as the membranes of the speakers move, listening to them not so much as music or even sound, despite its sonic rhythms, but as something more—the otherness of these speakers repeating and repeatedly calling out to be listened to. I'm reminded of Julie Gough's speaker/microphone shells, which I discussed in the previous chapter—shells that listen to the room, the audience, and the video images and are literally, I feel, moved by their desire to speak and listen.

In her extensive study of microphones and loudspeakers from a musical perspective,[4] composer Cathy van Eck discusses how loudspeakers and microphones can be apprehended as instruments, as "active" devices (van Eck 2013, 114). Discussing Dick Raaijamakers and his work *Drie Ideofonen*, van Eck notes how he seeks to explore the "distinctive voice" of loudspeakers by letting them talk to themselves. As Raaijamakers himself puts it, "for once the gaping loudspeaker should turn inwards and listen to itself: in short, the loudspeaker should be made to hear the sound of its own loud voice" (cited in van Eck 2013, 115). In this way, for van Eck, "the loudspeaker has indeed become a sound producer instead of a reproducer" (van Eck 2013, 115). And, as I listen myself to *Ideofoon 1* online, I am reminded of Lang and Papalexandri-Alexandri's work, which attuned me to the "distinctive voice" of speakers—their repetitive vibrations and insistent clackings.

Sonification

For years I have been puzzling about my ambivalent response to sonification—when artists, or scientists, translate nonsonic data into sound. Something about the disingenuous arbitrariness of the sounds that are assigned to data always makes me uneasy, even though an artist's desire to move listeners does have its appeal as an aesthetic gesture. When I think about artworks that sonify storms, for example, I find myself wondering: If a storm does more than sound, if it *tells* us about the weather, what is *its* voice? And my persistent sense is that I can actually listen to the storm's voice in its noisy wind and raindrops dropping and the creaking wooden structures it disturbs and the rustling leaves it stirs in the trees. (In my agitation as I write this, I have an etymological moment, scanning various online dictionaries and finding provocative connections in German and Italian between storm, stir, commotion, and making a noise.)

Troubled by sonification's disregard of these voices, I turn first to Jonathan Sterne and Mitchell Akiyama. In an important essay, they elaborate on the way sonification's aesthetic and deeply arbitrary *representation* misleadingly calls us to experience it as a causal, indexical relationship between sound and data. In doing this, sonification also, they note, feeds into a worrying romanticizing of sound—as if the ear is somehow affectively superior to other sense organs. This romanticizing recalls what

Alexandra Supper identifies as the experience of an "auditory sublime" sought after by scientists and most art-science sonifications (Sterne and Akiyama 2012, 549–551; Supper 2014). Steven Connor, too, is disturbed by the implications of sonification. He questions what is going on culturally as well as aesthetically when an artist uses software to sonify storms and other meteorological events. While Connor acknowledges the desire that this speaks to—to hear the inaudible—he worries about the underlying urge to turn the world's noise into signal, to "make it over into our terms ... *for us*" (Connor 2010, 32, his italics).

In our terms ... for us ... yet again an assertion of the human as central. As Connor alerts us, sonification does not invite or require us to bend to hear the voice of others, things, events, but instead bends them to speak in a voice we prefer to hear, a voice we are accustomed to listening to. It is as if we need to sonify in order to hear the voices of objects, rather than attuning ourselves differently: "The press, the presence, the intractable demand on us of sound is being diminished, as the realm of the inhuman has been contracted to the human" (Connor 2010, 32–33). To my ears, this is a refusal of the call not just of sound but also of voice—a refusal to engage with its "press [and] intractable demand" to be listened to.

So what are we listening to in sonification? For Sterne and Akiyama, sonification is part of a move "to make data sensible" and meaningful (Sterne and Akiyama 2012, 548, 552; Bjørnsten 2015).[5] In this sense I find myself wondering whether sonification is more the voice of the data itself—data speaking itself—than of the 'original' event. It might seem obvious, inevitable, and unproblematic that sonification speaks data and not the event, if we follow Friedrich Kittler's argument that sound technologies "deprivileged" the voice since "'frequencies are frequencies' regardless of their source" (Sterne and Akiyama 2012, 357).

As a bit of an aside here, I am wary of going too far down this road with Kittler, as I am mindful of Seth Kim-Cohen's arguments (in another context) against "sound in itself." Although Kim-Cohen is not discussing sonification here, he nonetheless makes a relevant point: "The problem lies in the acceptance of value in the exposition and translation into sound of electromagnetic fields. These sounds, and the way they are presented, decline to engage the rich cultural, technical, social, ontological implications of their origins" (Kim-Cohen 2009, 115). This contention moves us beyond or beside that of Kittler. While Kittler's argument is compelling and

self-evident at one level, and answers the Derridean concern with voice as privileged self-presence, it also risks reductiveness and refusal of the importance of difference and otherness and relationality to which voice can open us. Kittler's work has certainly been important in media studies in encouraging attention to machinic processes, and indeed its attention to technology might seem sympathetic to my purposes here. However, I would suggest that perhaps with a new materialist approach, we can bring back voice without losing his important attention to the machinic and technology. That is, we can listen to machines voicing themselves. Before I elaborate on that, let me return to the question of voices of code and data, but in examples where, unlike with sonification, data's voice forthrightly asserts itself.

Code and data speak differently

In previous works I have written about artist Igor Štromajer's Internet operas in the context of human voice performance.[6] I'd like to return to his work now because I think it plays with data in a way that importantly contrasts to sonification. I'm also interested in how, through new materialist ears, I can listen to this work in new ways.[7]

In his intense and intimate *Oppera Teorettikka Internettikka,* Štromajer performs live for over half an hour—performing an opera whose libretto is HTML and Java, which he sings in English and Slovenian (Štromajer n.d. (b)).[8] The video documentation, which I watch online, begins with Štromajer entering a fairly empty stage (a chair, a computer, a lectern) and moving around, with a headset microphone into which he gasps for breath, pants, groans, stutters. It's unclear whether it's his voice that is driving the uncontrolled and dramatic movements within his body and around the stage, or whether his voice is enacting his bodily movements. Or perhaps both express the affect of a ventriloquized HTML code, which he starts singing in a sort of Artaudian and *mise-en-abyme* gesture. Or perhaps all three are at play, as throughout the event Štromajer's voice and improvisations are on the move, ranging from falsetto singing to dronelike chanting to raspy shouting out of something between singing and speech. At some points his voice dramatically breaks into stuttering and at other times it exudes classic operatic emotion. Periodically during the voicetrack of the performance, Štromajer's voice mixes with a range

of sounds, including other voices, more or less processed or synthesized, one of which is a contrasting female BBC type dryly informing me about nuclear reactors, nuclear cores, navigational satellites, and the like. Štromajer's 'own' voice, too, is sometimes processed—distorted, pitch-shifted, speed-altered.

There are powerful affects and strong emotions at play as Štromajer's body and voice are driven into motion and expression. As I engage with the work, I am moved within the assemblage that is voiced here—of data and bodies, of microphone and lecture, of synthesizers and processors—as Štromajer tracks the code and the code tracks him. During his extraordinary performance—whether he is standing at the lectern reading the printed libretto (which is the HTML code) or ranging across the stage, whether he is stuttering into the headset or speaking/singing into a handheld microphone—I too am affected as he voices "HTML source code, text-to-speech software, Java scripts and applets"—or they voice him (Štromajer n.d. (b)). Previously when I encountered Štromajer's *Oppera Teorettikka Internettikka,* I listened to his stuttered speech as speaking the gap between the digital's 1s and 0s and wondered if the emotions were a performative enactment of the code or somehow embedded in the code itself. Now, through new materialism, my listening is particularly attuned to the latter, to Štromajer's voice as affectively channeling the code. I find that I am listening to his performance as a ventriloquism of the network and the code speaking, insistently, through him, with 'his' voice.

I also apprehend the "cruelty" in Štromajer's stuttering and singing—in the Artaudian sense. As theater scholar Laura Cull puts it, Artaud "break[s] with the habitual use of the voice as an organ of communication, and … reconfigures[s] the relationships between lips, tongue, palate, breath and vocal chords in order to produce as yet unheard sounds" (Cull 2012, 72). In Štromajer's work, the sound comes not so much from within him as *through* him, as he is inhabited by the messy, noisy network connection that makes his body and voice stutter and sing in a voicetrack that throws its rails into disarray. In this ventriloquial moment, just what is being thrown and by whom or what is up in the air. And so, as Štromajer sings the code, I have a sense that the medium is speaking through him, effecting his improvisations. Indeed, from the opening performance, Štromajer is as if a medium for the medium—both performing the medium and performed by the medium. And with his *minor gestures*, as Cull might have it—with his

speaking/singing HTML code—he throws not just his voice but humanist apperceptions of performance, body, and voice itself into the air.

This speaking of/by the medium has also been explored in Mark Hansen and Ben Rubin's renowned installation work *Listening Post* (2001), a work which, again, I have discussed before, but now engage anew through new materialism (though this time through memory and documentation).[9] Before Web 2.0, the main Internet sites of real-time and text-based sociality and networking were chat rooms, bulletin boards, lists, and other public forums, to which *Listening Post* listened. *Listening Post* worked as a listening and sucking machine to pull voices out of the Internet by "cull[ing] text fragments in real time from thousands of unrestricted Internet chat rooms, bulletin boards and other public forums. The texts are read (or sung) by a voice synthesizer, and simultaneously displayed across a suspended grid of more than two hundred small electronic screens" (Hansen and Rubin 2009).

When I first encountered *Listening Post* live at the Whitney Museum of American Art in 2003, the installation space was darkened and theatrical, though instead of a single screen (as it sometimes seems), it comprised 11 rows and 21 columns of small screens suspended before us in the proscenium space. Recalling the clackety-clack of typing fingers, the installation spoke with a clackety-clack as it shuffled text between sections, framing the voice and screen text that emerged from it.[10] Along with the clackety-clacking voice, the detached fragments of Internet text came to me in a detached vocalization by a detached, British-accented synthesized voice. As with Štromajer's work, I return now with new materialist ears to this work and listen to it not just as conveying the voices of the humans who typed their inputs, but also as channeling and speaking the Internet's own, more-than-human energy. It is the energy of the Internet's vast multiplicity of data that *Listening Post* vocalizes: in this sense, the Internet itself speaks *Listening Post*, as a site, through which energies flow, animating the work's voice.

There is a strangely nourishing quality to the voices in this work, speaking real-time data feeds. I listen to them as responding to a call to sense the materiality and diversity of the Internet—a call from within the very flow of the Internet itself, and myself in its audience. While some might listen to this as a work of 'sonification,' I experience it differently, as forcefully voicing data flows rather than sonifying them. I sense in *Listening Post*'s

vocalizing data none of sonification's indexical link to some other 'natural' event. For me it neither expresses sonification's abstract aesthetics nor directly serves to make politics or science 'accessible.' Rather *Listening Post* openly and strangely voices the chattering Internet, calling on me to apprehend it anew.

Opaque voices

It's not just the Internet that speaks in a chattering voice. Analog machines can chatter too. This is something I listen to in the work of Morten Riis, whose approach is informed by Timothy Morton's object-oriented ontology (OOO) and Wolfgang Ernst's German media archaeology. Riis says his project aims to attend to the operational technology in process in artistic performance, in order to understand both the media object's perspective as an "active 'archaeologist of knowledge'"—what it knows, how it hears—as well as the aesthetic event of interactions, or intra-actions (following Karen Barad), between humans and media objects (Riis 2015). Riis asks, "What do you hear when you listen to the wind in the trees? Do you hear the wind or the trees? What do you hear when you listen to a recording of your voice on tape? Do you hear the voice of the tape? In both cases you are hearing two objects as they relate to one another ... a modulation of voice through tape" (Riis 2015).

Riis's questions intrigue me, and even though I don't share his OOO perspective, I do note that like new materialism it also attends to the voices of things in our posthumanist era. While Riis himself does not put it this way, his approach resonates with the duets and conversations that I have been listening to, as he apprehends both the tape and voice speaking to each other, relating to each other. Riis's theoretical and artistic work concerns itself with what media objects "care about," what they are "interested in," what they hear. I, too, respond to these concerns but also listen to his work with slightly differently attuned ears, attending to how it speaks as much as how it hears. Like other of Riis's works, his *Opaque Sounding,* which I encounter in Aarhus, Denmark, in 2014, works with analog, machinic technologies, including media technologies. It fills the small, dark installation room with an intense assemblage of moving machines and projections that busily communicate with each other in ways I can't quite fathom or enter into—I just go with the flow. As Riis explains, the work evokes the

Figure 4.2
Morten Riis, *Opaque Sounding*, 2014. Slide projectors, perforated paper strips, Meccano parts, electronics. Courtesy of the artist, photo by Kasper Hemme.

dramas of the machines themselves, rather than staging human dramas; it is "a performance where the instability and fragility of the physical mechanical is going to appear like a key focal point in a constant dialogue between performer and machine" (Riis 2014).

Riis is focusing on the drama of music-making machines themselves, that is, from their perspective, with a concern for how the objects involved hear. What also calls out to me in *Opaque Sounding* is the voicetrack of this staging, with its *voicing* of a machinic assemblage where some of its parts are moved by the desire to speak in a musical voice and others squeak, clack, bang, and buzz their noisy connections. I encounter his work as not only visually opaque but also, enchantingly, vocally opaque. What is this voice speaking of so dramatically? I listen with it to the frailty and also the wondrousness of machines, which normally hide their innards and silence their affective voices.[11]

Vociferous robotic assemblages

Speaking of old technologies speaking in artworks, I'm reminded of some classic robot artworks from the 1990s.[12] I have to admit that robot art never really spoke to me until I encountered Louis-Philippe Demers and

Bill Vorn's *La Cour des Miracles* (1997)—a sort of robot freak show, figured via the sensory imaginary of a Hollywood apocalyptic, postindustrial future. In a dark, smoke-filled room, this controversial piece was the loudest and most intense at ISEA 97 (International Symposium of Electronic Art) in Chicago, where I experienced it. There were six different characters in this assemblage—Harassing Machine, Begging Machine, Limping Machine, Heretic Machine, Crawling Machine, and Convulsive Machine—each, as its name evoked, with its own particular look, movement, voice; each with its own persona and affections. In voicing their own pain and ambiguities, the miraculous, horrific, ugly-beautiful, simple and strange machines/animals/ freaks spoke to me of an alienation from the smooth high-tech control-desire of the computer world, as well as of an impossibility of escape. There was something about these metallic skeletal pieces, caught in cages, chained to walls, freakishly dismembered, screaming and writhing in agony— frantically responding to sensors—that engaged me despite my resistance. *Sensors*—a wonderfully ambivalent term—did they sense you or did you sense (through) them? Or did emotion relay back and forth through them as they sensed *your* movement and presence, and you sensed their effect/ affect? In short, I wondered: What is voiced here? Like loudspeakers, sensors' very name reverberates with a certain 'agency,' but it's so familiar that we don't necessarily notice it.

Remembering this work now (and watching video documentation online), I sense that the robots voice their emotions in ways that recall Deleuze's sense of a 'disorganizing' voice—with their "stammering, whispering, mumbling and howling" (Cull 2012, 58). Evoking a disturbing border state of affect, their voices disturb my sense of human voice and affect—as they speak of and with machinic voice and affect. Voicing themselves in the way they do, the robots in this work disturb any easy sense of what is human and what is not; and, what's more, they refuse a simple invitation to easily project human emotions onto them in a human-centered way. For me, *La Cour des Miracles* instead plays at an edge of human-animal-machine, speaking from this edge with its whispering, howling, groaning voices.

Besides the individual voices of each robot, the work also includes a vociferous robotic assemblage, whose voicetrack trembles and vibrates, voicing its irreducible intensity of affection through its 'howl-words' (Deleuze, cited in Cull 2012, 66). The voicetrack calls me into a sort of

becoming-robot, following a reverberating insistent desire, an oscillation of affect and emotion, that seems to go nowhere and everywhere at once— drawing me into its vortex. And with it I sense people, animals, robotic machines all swept away in that relay/tionship of becoming. Apprehending the voicetrack, I experience this becoming-robot as "the perception or affection of one body by another, without the need to pass through process of imitation or representation" (Cull 2012, 69). While the assemblage is of course spectacular in one way, in another way, more profoundly, it works through a minor use of voice, where it is the "material force" of the voice, rather than signifying sounds, that is so affective and thought-provoking. The becoming-robot voices what is happening both to me and to the robots, as we listen to each other: its ways of speaking produce all our bodies and selves. Again I am reminded of Deleuze, for whom "it is not that the subject expresses him- or herself through the voice, but rather that 'the subject is the effect of voice'" (Claire Colebrook cited in Cull 2012, 74–75).

The way in which robot voices speak with a material force is also particularly sensible in Kenneth Rinaldo's 2000 installation *Autopoiesis*.[13] As I first encountered *Autopoiesis*, I was called into a room where a series of open, delicate sculptural robotic 'arms' hung from the ceiling and attracted me to walk among them. Their open structure invited and tinctured the affect-filled atmosphere that flowed through them. The arms moved and spoke in response to audience members' movement and proximity and to each other: as Rinaldo puts it, they "talk to each other … respond to each other" (Rinaldo 2013). And, I would add, to me. I was enthralled by their movements, physical and affective, and their voices. They spoke what Rinaldo calls a "group consciousness … where what is said by one affects what is said by others" (Rinaldo 2013). Now, returning to *Autopoiesis* years later, I attune to it not so much as a group *consciousness* but as a *swarm*—in which agency is distributed across and through its coordinated, collective body. As a swarm, the work mimetically and palpably, as Anna Gibbs would have it, imbricates me in the "non-cognitive, sensory and affective modes of knowing" of its movements (Gibbs 2015, 11).

And *palpable* it certainly is. *Autopoiesis* creates a multiplicity of moments of oscillation of affect among its robot arms and within the audience, of which I am part, all part of a vibrating, swarming assemblage. And in the immersed moment of encounter the work speaks its swarmed body in a varied clanking metallic voice, speaking what Rinaldo calls "a musical

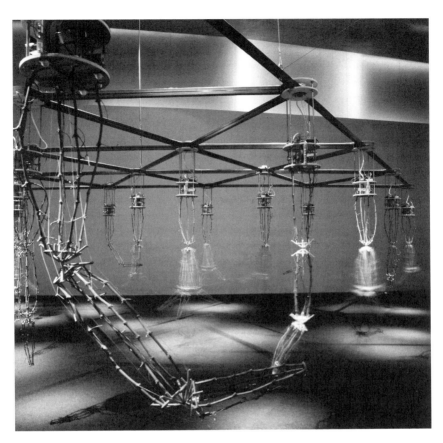

Figure 4.3
Ken Rinaldo, *Autopoiesis*, 2000. Artificial life interactive robotics series. Commissioned by the Kiasma Museum in Helsinki, Finland, curated by Erkki Huhtamo; photo by Yehia Eweis. Courtesy of the artist.

language." From the outside I do listen to it as sound or music, but moving inside I listen to the voicetrack—I hear the voices. In this sense, and now through new materialist listening, I sense the work actually exceeding itself, speaking of more than autopoietic systems with an observer at the center—rather speaking affectively as an assemblage or swarm. Like Vorn and Demers, Rinaldo uses sensors not for direct cause-effect interactivity, which so often has the regressive effect of recentering the subject in control. Instead in *Autopoiesis*, the sensors transmit and amplify the affective voice speaking the assemblage including the audience and the robot arms. As

partial objects, these arms—pathetic reminders of war-torn and severed limbs?—speak of their own life, and in so doing paradoxically also somehow become my arms as mine become theirs, as the affect oscillates between me and them. Again, I sense a resonance with the partially severed bodies of *La Cour des Miracles*.

Robots softly spoken

More recently, another robot media artwork (an interactive, autokinetic work made within the art-science collaboration paradigm) that I find particularly affective is Mari Velonaki's *Fish-Bird Project* (2006). In this work two empty wheelchairs, one named Bird and the other Fish, wander quietly, almost silently around the room, guided by sensors in response to the audience, and communicating with each other in words printed out from each of their (not really visible) mini thermal printers. They move differently but they form an assemblage, as the hyphen in the work's title would assert. The empty chairs—which look just like the most basic wheelchairs—animate and are animated by a sparse and lonely voicetrack, empty and full of lonely silences. The voicetrack is composed of audience responses, the rubbery voice of the wheels tracking across the floor and over the scraps of paper from their printers, which increasingly litter it over time, and the softly squealing voice of the printers as they print out and eject their words. Like mouths, they emit their words and sounds, nearly silently, nearly silenced by the sadness of unrequited love and loneliness. And so the emptiness and silences of the voicetrack express and echo the lonely empty chairs wandering around within it. As I remember, the signage tells us that the two robots have fallen in love—an impossible love like that of a fish and a bird—but cannot be together due to "technical difficulties." I laugh, but I am overcome with sadness. Perhaps it is because I encounter this work when my elderly mother has just become frail, lonely, and wheelchair-bound, but I find it almost unbearably poignant as the chairs move as if aimlessly and speak softly of and into the silence.

Static movement ... voicing the static

Igor Štromajer has made recent works with robots that I find equally, though differently, irresistible and poignant. They, too, speak of an uncanny

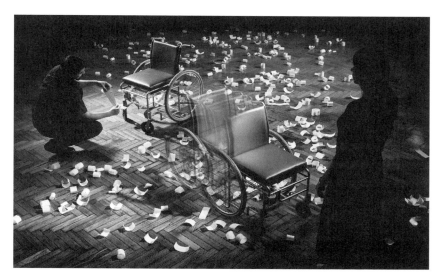

Figure 4.4
Mari Velonaki, *Fish-Bird: Circle B—Movement B,* 2004–. Robotic interactive installation. Mari Velonaki in collaboration with David Rye, Steve Scheding, and Stefan Williams. Courtesy of the artist, photo by Paul Gosney.

intimacy of robots at the same time as they return me to the affective and emotional voice of the Internet. In a conversation in 2013, Štromajer expressed what I hear as a new materialist sense of intimacy and emotions, which underpins his approach to voice and to robots: "emotions are not the privilege of living beings, nor of the art only. Even businessmen, supermarkets, political propaganda, cellular phones, satellite technology, multinational corporations, medical equipment and stock exchanges could be and are full of emotions. That is how I understand intimacy" (Neumark and Štromajer 2013, 143).

And it is the voicing of those intimate emotions through his work that particularly draws my attention here. In Štromajer's *Ballettikka* works I sense voice speaking intimately of and from human-machine assemblages. *Ballettikka Internettikka: Stattikka,* for example, which he made with Brane Zorman, plays with the public and private space of the Internet and through the Internet—once more letting the Internet itself speak (Štromajer n.d. (a)). One of the key players in its voicetrack is a robot. This is a strange work that I have experienced only through documentation and responses on the

Internet. It involves the lonely robot poignantly caught mid-step on a rooftop in Hong Kong—a ballet so slow it is virtually static as it speaks a moment of shared vulnerability. Performed live in Hong Kong for a festival in Dresden, Germany, *Ballettikka Internettikka: Stattikka* is quickly documented on the Internet (November 2007). Watching this documentation, attending to the robot's animated body, I wonder whose voice is animating it and who its voice is animating. Johannes Birringer describes his experience of watching the work as it is sent live to Dresden from Hong Kong:

Somehow this event challenged almost all available "theatrical" conventions: nothing happened, nothing moved. We listened to a still image … but this is not true, of course. The live transmission was alive, there was constant motion, the sound and music, the voices, the flickering lights of the city, the steady rhythmic blinking of the little robot's electrical eyes—a kind of electric heart-beat and a comic allusion to "liveness" in the sense of this machinic/machinimatic doll's being or realness which, magnified into a huge projection hovering on the Dresden Festspielhaus-floor, more and more looked like Armstrong or Gagarin stepping onto the Moon and (frozen moment of transmission from the planet) being momentarily arrested: a suspended stepping, over the edge. (Birringer 2007b)[14]

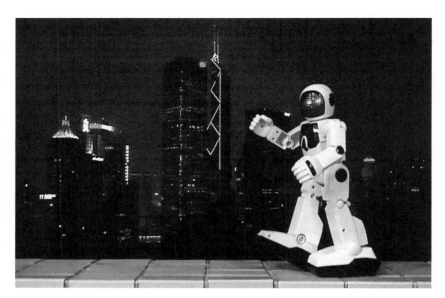

Figure 4.5
Igor Štromajer and Brane Zorman, *Ballettikka Internettikka Stattikka*, 2007. Live Internet broadcast/stream. Courtesy of the artists, photo by Igor Štromajer.

My own attention is drawn to the poised foot and raised arms—evocative and with a quite palpable sense of precariousness. As the title reference to *Static* suggests, there is a virtuality here, a potential of movement, but also of sound—evoking and invoking the voice in and the voice of the noisy static. Perhaps the robot is transfixed by the voices coming out of the static? I sense an uncanniness in this work, as in other works by Štromajer—the voices give a sense both of the voice of connection and also of the Internet itself—as somehow also speaking to/through the robot.

Dirty voices: toying with technologies

When I was trying to think about voice and the politics of neoliberalism—a form of late capitalism different from the *laissez-faire* in which I grew up—I turned to political theorist William E. Connolly. Connolly is a keen analyst of the politics and affects of neoliberalism—in addition to being well attuned to new materialism and the "fragility of things" (Connolly 2013). I found a particularly provocative suggestion in his work when he was discussing how late capitalism and neoliberalism are instantiated through the law and the courts in the United States, where "court policies … treat money as a mode of speech to be protected by the state" (Connolly 2013, 21). Money as a "mode of speech," speaking the views of those in control of the state. It gets me thinking: What is the neoliberal voice of money, the dirty voice of dirty money? And, how do contemporary art and media art play with this voice, make it audible to us?

These questions brought to mind artful voices that toy not just with technologies but also with the political economy that produces them. I'd like to call them "dirty" voices. This is not because they talk dirty but because their technological talking dirties the everydayness of neoliberal understandings. So with its own particular dirty voices, art can bring to the fore the ways that, in a distortion of new materialist thinking, voice is being attributed to all sorts of things for neoliberal political-economic ends. And, in so doing, art's dirty voices question this politics. This is politics speaking, but not in the usual sense of political voice, giving voice to people. These are the voices of the hacked technologies of Toydeath and The Yes Men's ®™ark.

The dirty voices in their works toy with the taken-for-granted voices of neoliberalism. In so doing they take the notion of political voice beyond

the usual sense of direct 'representation' in political life and discourse. They remind me that contemporary art and media art can also voice political situations and events in ways where there is room for open-endedness and uncertainty. Whether it's through the eruptive surprise of laughter or screamingly painful affect, these works not only speak about politics, they speak about the voice of money and political normality, the dirty voice of dirty money. They make them audible and remind me of what's at stake with listening to voice anew.

Toydeath is an Australian experimental electro rock group that toys with technology's voices. They *bend* the circuitry of cheap commercial dolls and other objects and toys,[15] so they can crank up and distort the toys' vocal performances during their own excessive and playful and noisy musical performances. The dolls whose voices they mess with include Barbie, Jesus, and George W. Bush. According to artist Natalie Jeremijenko, herself highly attuned to new materialist vocalizations, children's toys are one of the most widespread users of voice chips. She argues that when voice chips produce voices that speak from a product, they not only add "functionality" but in so doing commodify both voice and interaction. When Toydeath bends the voices of the dolls to their will, they distort their normal performance and make me aware of the usual *static* dynamics of such commodified quotidian human-machine interactions, which remain the same no matter what, no matter where, as Jeremijenko says (Jeremijenko 2004, 264, 266–268, 277). Toydeath's dolls and toys also speak a welcome antidote to moves within artificial intelligence to build functional, emotive talking robots.

If I can listen to the dirty money of commodity culture voicing itself in Toydeath's circuit-bent toys, I can attune to the dirty money of commodified gender speaking through the 1993 intervention of the Barbie Liberation Organization (BLO)—an early escapade of RTMark (®TMark), aka the Yes Men. ®TMark contrived to exchange the voice boxes between three hundred Barbies and G.I. Joes by channeling "$8000 from a military veterans' group to the Barbie Liberation Organization" (RTMark 2000a). This gender surgery involved cutting out and exchanging the voice mechanisms of the two toys in the factory. Barbie and G.I. Joe thus voice the doing and undoing of gendered voice—and with it of their own speaking bodies.

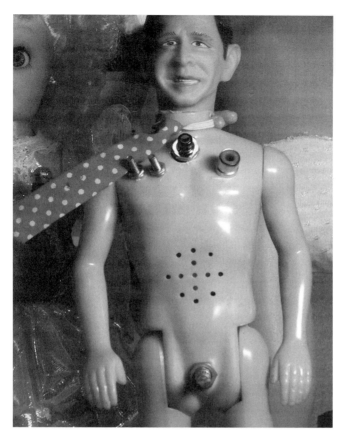

Figure 4.6
Toydeath, *George Dubya and friends*, 2014. Performance/music. Courtesy of the artists, www.toydeath.com.

In this circuit-bending, gender-bending art intervention, I listen to humorous and deadly serious political interest in toys' voices. In an assemblage of commodity toy culture, factory practices, interventionist art practices, girl and boy toys, Mattel politics and economics, toy-making and dismantling tools, and voice technology, the dolls literally and disruptively voice the taken-for-granted gender politics and economics of commodity culture. A revoiced G.I. Joe now speaks Barbie's famous interpellations, such as, "Wanna go shopping?" As technologically reenhanced Barbie explains, through this gender "corrective surgery she speaks for the BLO, an

international group of children's toys revolting against the company that made her and Joe" (RTMark 2000b). And what makes this gender surgery particularly provocative is that it excises only the voice box, producing a sharp, disruptive confrontation between voice and body that unsettles any acceptance of conventional masculinity and femininity. Paradoxically, while clearly it is the voice box that is speaking in and through these surgically enhanced dolls, what I listen to with them is the (new) materially performative connection of voice and gender in a political and economic assemblage.

Ratatattating tattoos

In his work titled *and Counting ...*, Iraqi-born American artist Wafaa Bilal unleashes on his own naked back the relentless and painful voice of a tattoo machine—ratatattat tattooing. For me, what makes the machine's performance particularly painful and affective is not just its relentless inscribing of its will on the artist's back throughout the performance, but also the way it speaks in the work's voicetrack in counterpoint to the warmer, but in a way even more horrifying, human voice of a woman who meanwhile reads out the names of the dead. In this twenty-four-hour live tattooing performance at the Elizabeth Foundation for the Arts gallery in New York in 2010, Bilal's back is tattooed with one red dot for each of the 5,000 dead American soldiers and one green UV ink dot for each of the 100,000 Iraqi casualties, only visible under black light. Bilal's concern in this work is memory, the politics of memory. He asks, "And how do you remember a human being that's been killed by an aggression? And what I wanted to do, I wanted to create that monument, when I could carry it with me" (Bilal, Goodman, and Kamat 2010). And this he did with a tattoo and its machine as a "medium" to make visible—and audible—those appalling numbers, to give them a physical palpability for people, in a three-stage work:

Stage one, I lay down the Iraqi cities, Iraqi map with no border. Then I am putting 100,000 dots, one dot for each Iraqi, in an invisible ink. It's not going to be visible unless you have a UV light. And stage three is the 5,000 American deaths going to be on top of the 100,000. So, at the first glance, on my back, you are going to see the Iraqi cities in Arabic and the 5,000 dots that represent American death. And there are different circumstances when you have a UV light. You are going to see the 100,000

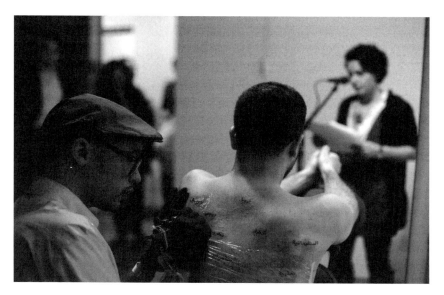

Figure 4.7
Wafaa Bilal, *and Counting* …, 2010. Performance. Courtesy of Driscoll Babcock Galleries, photo by Brad Farwell.

dots come to life. And that is examining the issue of Iraqi death is not being visible, is not being acknowledged. And the number, it's so high we cannot even comprehend. (Bilal, Goodman, and Kamat 2010)

This is what I see, and it is also what I hear through the unrelenting and cruel voice of the tattoo machine, punctuating the voicetrack. The machine voices an imprinting and expression of personal and cultural memory on Bilal's body: "I have a family who have been under bombardment for so many years. And I think they deserve other people to hear their voice" (cited in Pellegrinelli 2010). For me this voice is not (just) metaphorical, it is literally the voice of the tattoo machine.

I am reminded of an inspiring talk by New Zealanders Te Kawehau Hoskins and Alison Jones, where, by the way, the old/new materialism of Indigenous culture emerges once again, as the energy of that materialism animates their own voices and gestures. Hoskins and Jones discuss Maori facial carving, the *ta moko*, as expressing a memory, a cultural identity and inner spirituality—family and tribal belonging and social standing (Hoskins and Jones 2015). The *ta moko* speaks to me of a sense of

something inside insisting on being seen (and heard) marking itself on the skin—as distinct from the more decorative tattoos that now predominate in the West. This is the process that I listen to in the voice of Bilal's tattoo machine, which not only makes the invisible visible but also makes (the memory) of its process audible. Although I encounter this work only in documentation, it is still so painful that I wonder how I would have coped in real life with that cruel voice—relentless in the particular way that a mechanical voice can be.

Repetition and memory

Before I return to questions of encountering works through documentation, I would like to mention another work with which Bilal's *and Counting* … resonates for me. It is Angela Tiatia's *Edging and Seaming* (2013), which I encounter at the Eighth Asia Pacific Triennial of Contemporary Art (APT 8) in Brisbane, Australia. A less painful work certainly, but there are nonetheless pain and memory etched into the voicetrack here too, though voiced more softly by a sewing machine rather than a tattoo machine. In Tiatia's two-channel video work, I listen to the voicetrack through headphones, realizing soon that it is the track of only one channel, the one on which I see her mother, Lusi, alone, edging and seaming. On the other channel is a workshop in Guangzhou, China, where the outwork her mother does in Auckland, New Zealand, will soon be relocated, a silent threat/promise whose voice I am left to imagine. "Lusi's grandmother was a Chinese immigrant to Samoa, and Lusi herself was part of a generation of Pacific peoples who were encouraged to migrate to New Zealand in the 1950s and 60s to bolster a growing economy. Tiatia's video shows her mother completing a final order before the company she works for outsources the labour, highlighting the ramifications of globalization for local communities" (Tiatia 2015).

The imagery on both screens is of repetitive hand and body gestures, from cutting to sewing. The voicetrack echoes, speaks the repetition with the sewing machine—buzzing needle and squeaking foot pedals—accompanied occasionally by the voices and music of whirling fans, unreeling thread and a Radiola radio in the background. As I stand in the gallery engaging with *Edging and Seaming*, voices from a nearby work intrude on my listening—seeping into my listening ears, past the cushions of my

Figure 4.8
Angela Tiatia, *Edging and Seaming*, 2013. Two-channel high-definition video, 12 minutes in duration. Still image from digital moving image. Courtesy of the artist, photo by Angela Tiatia.

headphones, complicating the voicetrack. This is a commonplace experience in listening to work in galleries, and one that is usually annoying. But in this case, while annoying at first, it becomes interesting, as chanting Maori voices and accompanying voices of drums insert themselves in my experience of Tiatia's work. What I am hearing/overhearing, entangled with Tiatia's voicetrack, is the distant voicetrack from Rosanna Raymond's *SaVage K'lub* in the adjacent room. In Raymond's work, there is a video that includes documentation of tattooed performers wandering through the gallery in an earlier performance—no doubt wandering past the very work I am watching—with their chanting punctuated by the rhythmic, repetitive, and insistent voices of sticks and horns and drumming. In an uncanny way these drumming voices remind me of Tiatia's other mesmerizing work in the Triennial (*Heels*, 2014), where I watch her upper thigh, with its Samoan familial tattoo, insistently express itself through the tapping voice of her high-heel shoes on the wall. The memory of *Heels*, enmeshed with the voices and memories of Raymond's work, all become for me, in that moment, on that day, part of the very assemblage that is voiced in Tiatia's work—globalized and local economics, globalized and local media (radio), colonial histories in the Pacific, sewing machines, piles of cloth and clothing, factory and domestic workroom spaces and atmospheres, and bodily

gestures. With both Bilal's and Tiatia's works, I hear voicetracks of memory and politics: the machines that speak of war in Bilal's work's and of labor in Tiatia's also speak, repetitively, of the repetitions of memory.

Speaking of documentation encounters

Of the works I have discussed, there are a number that I have only encountered through documentation. I have taken this mediated encounter somewhat for granted so far, but now I would like to elaborate on this practice, about which there is some controversy. This seems particularly pressing in this chapter in which technology's voice is foregrounded, thus complicating the question of what voice it is that speaks in documentation.

There is a debate in performance studies between those who argue that you can only discuss a performance that you have attended live and those who argue that you can critically engage through documentation. This debate is taken further by Philip Auslander, who not only validates engagement through documentation but argues that documentation itself is performative in a way that *makes* an event: "the act of documenting an event as a performance is what constitutes it as such" (Auslander 2006, 5). For Auslander the documenting document then becomes something other, something more—not "an indexical access point to a past event but ... itself ... *a performance* that directly reflects an artist's aesthetic project or sensibility and for which we are the present audience" (Auslander 2006, 9). In a way, documentation is haunted or shadowed by the performance, and the elusive performance is haunted by the documentation which will 'follow' it—a practice of *différance*.

Related to these uncanny hauntings of performativity, Monica Ross offers a concept of untimeliness, which provides another useful way to approach disagreements about documentation and performance and memory. For Ross, the *untimely* points to the way performance and its documentation trouble our sense both of time and of the 'original.' She argues that performance is in fact always/already untimely because of its uncanniness, ephemerality, and premonition of absence (Ross 2007a, b, and c). She critiques an auratic reading of documenting which places a performance work as a "cult object" in "an inaccessible past" (Ross 2007c, 106). Ross proffers instead documentation of performance as inviting you "to be at once in the present and elsewhere" (Ross 2007c, 106–107). Ross's concept of the

untimely resonates for me with voice, which is also haunted by ephemerality and premonition of absence. And it speaks to an intimacy of engaging with documentation that I experience and that those who insist on 'live' performance, and/or voice, as 'original' cannot account for.

Are there, I wonder, implications for *memory*—which in a sense documentation both stands for and evokes—in this reading of documentation as performative, especially in the digital era? And how is the memory/documentation relationship particularly inflected by the digital? Perhaps in the digital era, as the 'original' event becomes more and more elusive, there is a sort of nostalgia for memory—as if it were ever reliable or durable. And if there is a nostalgia for bodily memories—a nostalgia fueled and sped up by the digital—it involves a forgetting that bodily memories are also elusive and fragile and mediated. Perhaps what Ross is telling us is that we need to remember that memory, like the documentation to which it is intimately connected, is also performative and untimely.

Impelled by questions about memory, documentation, and performativity, I set myself the task of listening to the voicetrack of an installation work where the documentation is not video taken at the time of the installation but is pieced together years later through conversation with the artist remembering the work, along with a few images and an audiotape. I want, through this, to think about documentation as such as well as the particular work. Somehow the documentation being in pieces seems appropriate for this work, *Carsick*, by Nola Farman, which itself is in pieces, pieces of wrecked cars.[16] In this work, it is the car that speaks, its broken pieces speaking of its sickness. The installation comprises a dashboard, a fender, a car trunk, a car door with mirror, and headphones hanging in the middle of the room under a spotlight. Throughout the room there is a colliding of sound, of voices, a voicetrack of collision in this assemblage of an installation.

The fender emits the screeching voice of brakes as a car approaches and crashes. The dashboard has a car radio and a panic button which if pushed, as it often is, emits white noise, which to my listening evokes its own panic. In and out of this static comes the voice of the car radio with a soundtrack by Anna Gibbs, eponymously entitled *Auto-scan*.[17] *Auto-scan* evokes its process, the process of scanning. And it makes me think about static again, and about radio voices. Is the radio speaking the static through which other voices emerge? Is this static interference—which Douglas

Figure 4.9
Nola Farman, *Carsick*, 1992. Car dashboard, car radio, sound recordings and system, and motion sensor. In collaboration with Anna Gibbs, Brad Clinch, and Helen Britton. Courtesy of the artist, photo by Hans Versluis.

Kahn has chronicled as typical of radio (Kahn 2013, chapter 10)—the voice of radio? I hear talkback and I wonder: Is it the car talking back here, ventriloquized through the radio? The mini-collision of voices in *Auto-scan* mimics and evokes the other collisions in the voicetrack and in the room. One or two particularly call to me, as two young men purr, "Just listen to that engine," their purring voices underscored, at least to my hearing, with a purring cat (I wonder: Is that the cat wandering around the room as Farman talks to me about the work?) It reminds me how much machines always/already speak to those that love them. Later, at home, I listen to the *Auto-scan* tape, an old cassette tape on an old ghetto blaster, and remember the mix tapes we used to make and the inevitable static that spoke of the technology of the making and the playing, a voice of recording, of the tape, and of the player.

Digging out some old slides, Farman points to the headphones in the center of the room and recollects how you could hear in them a disintegrating rusty car, its voice called forth by collaborating sound sculptor Ros

Bandt. I can only imagine this, but through my imagination I listen to a painful but provocative voice, all the more moving as I imagine standing there looking at the car's car/cass, recalling butchered meat, as Farman recalls. I'm also taken back to memories of the car wrecks scattered around in the Australian bush in a series on SBS television in Australia, *Bush Mechanics*, a sort of undoing of every car ad (with which Australian television is particularly replete) and car show I've seen. In the series, young Indigenous men from the remote community of Yuendumu travel around in semi-wrecked cars which they keep on the road with the most inventive mechanics' skills, making use of old wrecks they find lying around as well as various bits of fauna. As Gay Hawkins puts it, "the abandoned wrecks … are part of the collective memory in remote desert spaces" (Hawkins 2006, 87). At the border of human and nonhuman, the wrecked car bodies are a vocal "part of the landscape … *bearing witness* and always available for transformation" (Hawkins 2006, 90). And the bush mechanics find the (still) life in those wrecks, life remembered, life still there, the life—and the 'bearing witness'—that speaks to and with the voices of Ros Bandt's wrecked car.

Farman's description of the work suggests to me how other memories were sparked by the sensors that activated as people walked in front of the front fender—sending the sounds of road movies reverberating through the room: crashing metal, squealing tires. Listening to her remembering them, I hear again these voices of disaster that I remember in my body from media, and from 'real life.' They anticipate the ekphrasis to which I'll turn in the next chapter as the medium of installation relates to the medium of film.

Farman is an artist who works a lot with cracks through which things push and pour out, sometimes a trickling whisper, sometimes screaming their movement. So it's not surprising how much oozing there is in this voicetrack. Here voices ooze from the open car trunk, as if thrown open by the crash and the urgency of the voices to get out, to voice their car sickness. They ooze from the video, in the trunk, of roads flashing by, their broken white lines literally and metaphorically telling of breakage which is spoken in the voices of crashes, sirens, motorcycles rushing by. As Anna Gibbs remembers, "the sound works against the stillness of the chunk of metal in the gallery—not so much animating the dead metal as haunting it, animating the gallery space by activating the listener."[18] As I listen again now, remembering the audiotape and the conversation with the artist,

I am delighted by the sense that this experience of documentation has been in pieces, about a work in pieces, speaking about the inevitable untimeliness and brokenness (each in their own ways) of memory and documentation.

When videotapes silently speak their memories

Fiona Hall's *Slash and Burn* is a work in which videotapes speak silently of their remembered noisy voicetracks. I first encountered this work many years ago, and it remained vividly in my memory until I came upon it again in 2016, in the exhibition "When Silence Falls." I'll return to this exhibition in the final chapter, when I write further about silence, but I want to talk about Hall's work here because it echoes many of the voices of technologies and memory reverberating in this chapter.

In *Slash and Burn* old magnetically recorded videotapes have been pulled from their cassettes—to which they still remain connected—and knitted into severed heads and limbs. The emptied cases on the floor recall the

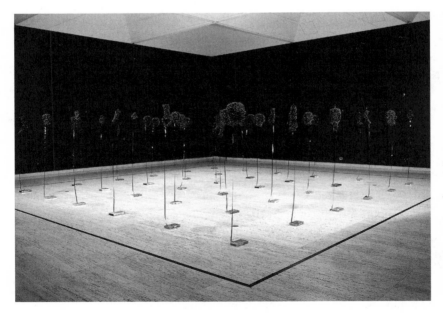

Figure 4.10
Fiona Hall, *Slash and Burn*, 1997. Installation. Courtesy of the artist and Roslyn Oxley 9 Gallery.

movies that had been encased, all of which variously evoked and celebrated violence—from *Apocalypse Now* to *The Last of the Mohicans*, from *Waterloo* to *Courage under Fire* to *Zulu*. The work is visually alluring and confronting, with a fulsome, screaming 'silent' voicetrack—a voicetrack evoked by the tapes that compose the open-mouthed heads and severed limbs. The video-tapes speak of dismemberment insistently, if uncannily, through their own dismembered silence. These are silences resounding with the memory of the voicetracks etched into their surfaces (and with it, the memory of a nearly forgotten analog technology).

Slash and Burn speaks to me through an uncanny voicetrack, ripped from its casings, uncontainable, somehow too much, too loud, too strong in its desire to speak. In a way, the work embodies a strangely literal *mise-en-abyme*—its silent voicetrack is composed of the voicetracks of videotapes ripped from their cases and its dismembered tapes are woven into dismembered body parts. Watching and listening in this silence, to this silence, soundtracks play in my listening memory—I remember watching and listening to many of the violent movies which make up this assemblage. I sense the silent voices etched onto those tapes still—still voices, still speaking of violence. And I sense the whole assemblage evoking a deranged *memento mori*, a presumptive *memento mori* that speaks a desire for the death of a medium that celebrates violence and its technologies.

When a fridge became a cow

I'd like to finish on a lighter note, with a story which I'll call "When a Fridge Became a Cow." It is a story of technological-animal becomings—a cow becoming fridge or perhaps a fridge becoming cow.

When I talk to Danish musicologist Steen Nielsen about what makes a sound a voice and how that affects how we relate to it, he relays a strange story of becoming to me; and although this story about a mechanical object's voice is not an artwork per se, there is an artfully enchanting and poetic quality to both the story and the telling that makes me want to retell it here.

In 2005, we bought a house in one of the suburbs of Aarhus, right on the outskirts of the city … bordering on an open field. And one of the first things I noticed when we moved in was the sort of distant, and slightly muffled, but still quite distinct sound of mooing cows coming from the field. And that brought back some childhood

memories—I spent some time in the countryside when I was a child—and at the same time confirmed that we'd moved almost into the countryside. ... I loved that sound of those calm cows in the field. ... For some reason it never occurred to me that it was pretty strange there were no cows in the field but only horses whenever we went round, anyway. ... I never put my visual experience in contact with my aural experience of those cows. (I should say that our view [of the field] is blocked.) ... And then, one day sometime later, a few months later, I just suddenly realized, quite shockingly actually, that the sound of the mooing cows didn't come from the field, it didn't come from outside the house. It came from the fridge. The fridge actually made these sounds a few times a day. And of course that sound completely changed its character to me. Now it came from an inanimate object. But still it sounded as if that object was trying to express something. But it took on a completely different character, becoming a sort of moaning sound. ... Sometime later, perhaps a year later, the fridge simply stopped working and just died on us. I guess it was moaning for some reason.

This story speaks not just of the desires which we bring to listening but also of the desires that technological objects can voice. And it speaks of strange Deleuzian becomings that are neither imitations nor representations but that voice themselves in uncanny ways, if we can but attune to them. Perhaps in the technological world they also presage the sort of media unvoicing to follow in the next chapter.

5 Unvoice in Media and the Arts: Voice Going off the Rails

In this chapter I want to work with the figure *unvoice* to listen to works where the usual relationship between soundtrack[1] and image track is disturbed and disturbing. In these works, voice goes off the rails, sending soundtracks and image tracks in new directions, sometimes onto collision courses. As unvoicing breaks the usual synchronization and hierarchy of image over sound—so that they speak to each other and speak of each other in strange ways—their very *relationship* comes to the fore, becomes audible. Like Heidegger's famous broken tool, an unvoiced soundtrack and its relation to the image track obstinately demand our attention (Heidegger 1962, 102–104; Bolt 2011, 100).

In my encounters with media and the arts here, I'll be shifting my attention in the first instance away from animals, place, things, and technologies per se, to pull the focus to the media where they speak. However, once unvoicing disturbs the soundtrack's taken-for-granted relation to the image track, we are also open to perceive other things about the whole assemblage: what starts with attention to soundtrack and its relation to image track can open up new perceptions of the media work itself and the human and more-than-human speaking within it.

Why do I introduce the literal and metaphorical figure of *unvoice* to discuss this? What work does it do? Let me preface my answer by saying that I've become fascinated by *un* and its increasing presence in all sorts of places in the last few years. I first became aware of the rich potential of *un* with Maria Miranda's provocative "unsitely aesthetics," as a figure to apprehend the way site specificity is complicated by the Internet as an/other site—with the proliferation of contemporary artworks 'located' both on and off the Internet (Miranda 2013). There is also the ever-surprising voice practice of artist Christof Migone—his own and those he writes about—which he

figures as 'performances of the *unsound* body' (Migone 2012, v and passim). And, too, there is Monica Ross's productive concept of the *untimely* discussed in the previous chapter. To mention just a few!

As a prefix, *un* appeals to me as working in a less binary way than, say, *non*—evoking a more paradoxical and performative relationship with its noun or verb than *non* does. According to an online etymology dictionary (etymonline.com), *un* is actually the most prolific English prefix, and, interestingly, they note its appearance in 1936 in telegrams where it could replace the word 'not' and thus save the cost of a separate word. What an economical little troublemaker! I notice that *un* has come into its own in Melbourne, Australia, where a free and independent art publication has called itself *un Magazine,* audaciously unfixing *un* from its prefixing duties.[2]

The figure *unvoice* also particularly speaks to me because it evokes another *un* quality of voice, its uncanniness—the uncanny voice, which may also be heard as a haunted voice—the return of the *un*dead? As writer and scholar Mark Fisher, aka k-punk, points out, the Derridean figure of haunting and the uncanny (*un*heimlich) resound together: "Haunt is a perfectly uncanny word, since like 'unheimlich' it connotes both the familiar-domestic and its unhomely double. Haunt originally meant 'to provide with a home,' and has also carried the sense of the 'habitual'" (k-punk 2006). In this sense, unvoice literally haunts its media, a reminder of how we habitually used to listen to a relationship that is no longer at ease here—uneasy as well as uncanny.

Unvoice perhaps recalls another Derridean figure, too, that of the supplement, in that unvoice signals works where a voicetrack is not replaced or negated but works differently, where it is undecidable, ambiguous. That is, there is something else, something more, something other, which unvoice performatively brings into play. Playing with and against an image track, unsettling the voicetrack from its anchor to the image track, hinging and unhinging at the very same time, unvoice can be understood as playing between presence and absence.[3]

Recently Brandon LaBelle also fruitfully deployed the figure *unvoice*, to signify an inner voice. The unsettling quality to LaBelle's unvoice resonates with my own take, because unvoice for him is an "oscillation that ... unsettles the fixity of inner and outer." Lurking behind, in the shadows, this unvoice animates and "tempts" the mouth that speaks (LaBelle 2014,

88–89, 100). Although inner voice is not directly my focus here, nevertheless Labelle's inflection of this figure speaks to my own sense of unvoice as performative and paradoxical and animating as it hinges and unhinges across an image track and soundtrack in ways that foreground the usually unnoticed relationship by disturbing it. Here unvoice hovers, forward and backward, refusing to stay in the background.

Off the rails and off the beaten track: medianatures, minor aesthetics, ekphrasis

The works that I will encounter in this chapter range from offbeat subtitling remixes—familiar on YouTube—to artworks with an out-of-sync or otherwise disturbing soundtrack and or voicetrack. In my listening, I want to attend to how unvoice is articulated through media itself, media voicing— and unvoicing—itself. I want to think about how my own bodily state is entangled with the media's bodily state. Jussi Parikka's methodology of *medianatures* suggests to me just such an entangled listening:

New materialism is already present in the way technical media transmits and processes "culture," and engages in its own version of the continuum of *natureculture* (to use Donna Haraway's term) or in this case, medianatures. ... We have to come up with elaborated ways to understand how perception, action, politics, meanings (and, well, non-meanings) are embedded not only in human and animal bodies, but also in much more ephemeral, but as real, things—even non-solid things. (Parikka 2012, 95–96)

Parikka's new materialist approach to media, its attention to media forms and formats, materialities and ephemeralities, helps open media to listening to the unvoice.

With Parikka's medianatures in mind, and body, I turn now to the aesthetics and affects of unvoicing. Many of the works of unvoice that I encounter speak in what Sianne Ngai figures as a minor aesthetics (Ngai 2012; see also Manning 2016). For Ngai, there are three categories of aesthetics that particularly help us understand aesthetic experience in late capitalism: the zany, the cute, and the interesting. In identifying these categories, like Gernot Böhme, Ngai is taking aesthetics beyond the realm of high art into culture in general—asking how ordinary and taken-for-granted works and practices move us in our ordinary lives; how we can think aesthetics not just in relation to styles, say, but to how we make "subjective,

feeling-based judgments" (Ngai 2012, 29). Ngai's insights about aesthetics and affects inform my listening to the unvoicings in many everyday media works on the Internet.

Jane Bennett's attention to the enchantment of lively things in the everyday, particularly the animated ads of commodity culture, resonates with Ngai's minor aesthetics (Bennett 2001, chapter 6). Animation is one of the media forms where unvoicing often plays out. In everyday life, it is common to experience the animating power of the voice behind the fantastic movements in cartoons—so common, in fact, that we don't necessarily pay attention to the role of voice here. But Bennett brings to our attention the enchantments activated and expressed by animations (though her focus is commodity culture) "in which *things* act, *speak*, rise, fall, fly, evolve" (T. Richards cited in Bennett 2001, 111, my italics).

Finally, I will also listen for where unvoicing works as a form of ekphrasis, where the voicetrack works like a rhetorical device in relation to the image track. The concept *ekphrasis* intrigues me, particularly with its etymology from the Greek of "speaking out."[4] Though definitions vary over time, for many scholars, as Ryan Welsh notes, ekphrasis is "the verbal representation of visual representation." For Welsh, most current concepts of ekphrasis refuse any meeting of the two separate modes of the verbal and the visual, exhibiting what W. J. T. Mitchell figures as "ekphrastic indifference" (Welsh 2007).

Attuned to ekphrasis, I will listen to unvoicing in examples where the voicetrack and image track both "define and describe" but at the same time also undo each other's and their own "essence and forms" (Wikipedia 2015). With unvoicing I propose a version of ekphrasis where a taken-for-granted verbal and visual relationship comes undone within a single medium (rather than between media). In this way, by troubling and foregrounding the relationship, unvoicing expresses the uneasy relation of verbal and visual not just in the voicetrack and soundtrack relation, but also in ekphrasis itself.

The best thing about animation

Frances Stark's *My Best Thing* is an artwork that is a film that is an animation that was made for the Venice Biennale (2011).[5] Stark is well known for the way she works with, and between, autobiography and readily available

corporate tools and platforms. For her, the pivotal concern is always with the process and the ideas. Before making this work, Stark spent time, she tells us, with an Italian boy in *chatroulette*, one of the sex/chat platforms on the Internet. Having used that experience to get past her writer's block, she is free to follow the trail of her extranormal desires in the program *xtranormal*. (I feel myself hovering over extranormal as a category of unvoice, but I will resist adding yet another category.)

The popular animation program *xtranormal*, which Stark uses to make the work, is widespread on the Internet. It promises that anyone who can type can make a movie. The work opens with the scene that is pretty much the main scene, two Playmobile characters, the heroine (Stark herself) and an Italian boy, it would seem, standing against a monochromatic green screen speaking to each other in computer voices that describe (each other's) action, which I cannot see. The action is happening behind the scenes, as it were: behind the green screen?

Let me interrupt the *action* for a minute to say a bit about that green screen. As the figures in *My Best Thing* stand in front of it for most of the film (except when Federico Fellini's film *8½* is projected on it and they stand aside, watching, as in a cinema), they remind me of the green screen of film, which can have any location and array of objects projected onto it.

Figure 5.1
Frances Stark, *My Best Thing*, 2011. Digital video, color, sound. Courtesy of the artist and Marc Foxx Gallery, Los Angeles.

A green screen is the ultimate site of projections; it is full of potential for locations and objects, real and imagined. While in conventional film the green screen hides itself behind the projections, here I am faced with the 'emptiness,' or I should say potentiality, of the green screen, as I am left to imagine projections (mirroring the imagining and projecting of Internet relations, not to mention all media). Here the green screen is a key player, reminding me of the way the actual is always "replete with the virtual" and that art makes that potential felt (Manning 2015). In Stark's work, standing there in front of—or is it on—that green screen, the characters are left unexpectedly free, with no place, no visual specificity or set of objects to locate them—or me. The sense of being unanchored, at the same time as the image track no longer anchors the voicetrack (nor vice versa), is amplified by the absence of affective sound or voice to pull me into those characters in the way we've come to expect of films. And then there is Stark's extranormal voice. It, too, hovers. It's neither affected nor affectless: it is a voice unvoiced of its affect. In its strange way, Stark's rather affectless voice speaks volumes about bodies—reminding me how voice and sound usually play such a key role in film's affect, in connecting our bodies to those of the film's characters, anchoring us in time and space.[6]

The characters—which in most *xtranormal* animations are extravagantly clothed—are stark naked in *My Best Thing*, bar the iconic fig leaves and absurdly childish/cute underpants exposing their mundane Playmobile under-selves. Like the characters, performances, *mise-en-scène*, and sound are all pared back, slow, and repetitive, which leaves me plenty of time, plenty of aural and visual attention for unvoice, for the way the voicetrack works so strangely with the image track. The characters' virtual nakedness might suggest a naked truth, an authenticity, and indeed Stark tells us elsewhere that she is "performing myself … on a keyboard" (Stark 2012). Yet, significantly, she does say *performing*, which signals a bringing into existence rather than expressing some essential authentic self—and so I sense her play with her self as a play with the premise that there can be a straight autobiography outside of artifice and convention. In Stark's work, the voicetrack performatively unvoices any familiar sense of authenticity as much as it does any familiar screen sex, which is one of its main topics of conversation.

Stark turned *xtranormal*—a program she was attracted to for its "banality" (Stark 2012) and a program that normally invites works that are cute

and bright and entertaining—into something pared down and stark. (I have to say that I love this artist's name, which she fully inhabits!) This strange and strangely provocative work is compelling, yet it is also somehow boring. In its uncanny way, it makes me notice the way that *boring* is another side of the coin to Ngai's interesting category of *interesting*.[7] Watching the film in which so little 'happens' in 90 minutes, in which the disjunction of voicetrack and image track is rarely resolved (except in a few musical interludes), I become fascinated with the way it is the voicetrack in particular that provokes the boredom that is both annoying and compelling.

Boredom involves lack of stimulation, lack of engagement with the world near and far, and general tedium. What I am curious about in this work is how the computer voices evoke and provoke these lacks, but in a strategically unvoicing way that is risky and provocative. Let me say a bit more about boredom. In an article on boredom in the *New Republic*, Michael Crowley expanded on how the diversions of all our handheld devices are "dealing a death blow to the idle moment … [and to the] 'profound boredom' that Heidegger recommended for its clarifying power. … [That is, boredom as a time where] as Lars Svendsen, a philosopher of boredom … has written, 'We experience time as time'" (Crowley 2006). Crowley and Dan Silver (who cites this article) both go on to explore the literary and philosophical fascinations with boredom … how interesting *boring* turns out to be (Silver 2012).

This understanding of boredom as a different, strangely intensified, sense of time echoes my experience of Stark's work. I remember my own sense of the work as a sort of endurance—we've become so accustomed to constant stimulations that to my ever-diminishing attention span it seemed like a very long hour and a half—in which I was left perhaps uncomfortably to experience time as time, in the fullness of its *boring* passing. And it was all the more boring, and interesting, because of the disjunction of voicetrack and image track. This suggests that a work that provokes boredom can actually work quite transgressively and bravely—transgressive in a way that artworks about sex once were, many art markets ago. But wait, this work *is* about sex … but I'll get back to that in a minute. The boredom of Stark's work produces, elicits uncertainty—uncertainty which is so important and compelling in art. I am left to wonder what affects I am feeling and what aesthetics I am experiencing: Is this an interesting but difficult piece of

conceptual writing? Is it autobiography, poetry, fiction? Or is it a film per-forming as animation, or vice versa, or something in between both? And what role does the voicetrack play in this uncertainty? How does it unvoice certainty?

Some of the deepest moments of uncertainty in this work come in the silences between the typing, silence which speaks in an unvoicing way, leaving me unsure what I am listening to, and what I am seeing. Notably many of these silences happen during the supposed moments of sex—moments which in this work are not familiarly erotic and certainly not pornographic but do reveal, do speak of the uncertainties of the connec-tions that sex promises. They speak of Marcello's "best thing"—but, and here is another paradox in the work, I never see it nor hear it nor sense it in familiar voicetrack ways. There is no quickening of breath, for instance, actually no breath at all, to speak the sexually engaged body. This is not the question of "Is sex boring?" but the question of whether mediated, including virtual, sex is boring. I find myself wondering: Have we gone past the days Andy Warhol celebrated when "Sex is more exciting on the screen and between the pages than between the sheets" (Warhol 1975, 44)? Well, in one way, teasingly, I don't know, because in Stark's work I never see the sex, never mind hear it voiced—rather, paradoxically again, her characters are most lacking in affect, movement, sound, voice during the sex and most animated before and after sex. Sex unhinged and unvoiced.

With so little affect in the voices and characters even before and after sex, what speaks volumes, then, are those gaps in the speaking, the silences. John Cage, who wrote the book on silence and made the artworks, also wrote a famous lecture on *nothing*—to which I'll return in the final chapter. The written text was wonderfully full of gaps, to evoke the noisy silence, the unvoiced speaking of nothing. And, reminding me of Cage, Stark tells us, "Nothing is enough."

I listen to typing's voiced force, as I do with concrete poetry, and the power of the gaps in the speech; the typing repeats the promise of the pro-gram, *xtranormal:* "If you can type you can make a movie" (Stark 2012). I imagine how this lure really speaks to Stark with her writer's block (so she tells us in the work), because not only can anyone who can type make a film, but if you can type you can also write. This is not, however, about writing a film script but the very act of typing, typing as a performative—

the clacking keyboard that speaks the pounding of (past) writer's block into writing. Because of course I remember that it is writer's block that first impels Stark to distract herself with the online sex that brings her face to face with Marcello's best thing. And this, at one level, is what the clacking keys in the soundtrack speak—voicing the hinge between writing and film-making, between voice and sound, between voice and image, between impasse and action. But at the same time, as they do so, the clacking keys unvoice certainties about what these relations should be—unhinging their essences, their hierarchies.

Unvoicing machinima

Animation has long been exemplary for undoing in production the usual voice/image relation of film, in that its action often follows the soundtrack rather than the sound playing its usual support role for the action. Anima-tion speaks an enchanted world where things speak, where actions speak, as much as any other character. With the Internet and gaming, a particular sort of animation emerged in the early twenty-first century known as machinima. Machinima is an offshoot of the online game world—a port-manteau of machine and animation. It usually works with video game engines to create animation works somewhere between cinema and com-puter games. These works often involve live laying down of voicetrack. Even though they are generally quite conventional, replaying the everyday aesthetics of gaming, machinima can be inventive and disruptive of the games they use in an unvoiced way. Since I'm not a gamer, I'm sure that many levels of reference and meaning are lost on me; nevertheless, I still get a sense of the way that voice is able to counterpoint the image and inflect it in a different way to its game origins—a sort of distorted, humor-ous, unvoiced echo. When this happens, it works to undermine a more anodyne or conservative interpellation in games—adding a new layer of interpellation, which is absent or not allowed in the commercial world of games.

One of the first machinima I encountered was Rooster Teeth's famous series *Red vs. Blue*, a hack of the game *Halo*, which first aired in 2003. While I am certainly not presenting this as typical, it is nonetheless exemplary of machinima's unvoicing potential. In the series' thirteen years the graphics have become more 'sophisticated,' but I remain most moved and intrigued

by the very first episode, *Why Are We Here?* (Rooster Teeth 2015). What I see are soldiers in a bleak canyon in what looks like (comes from) a first-person shooter game. But what I hear takes me by surprise and makes me laugh. The barely moving generic robot soldier bodies are voiced over by the teenage boy authors with scripts that are, I admit, typical of their familiar brand of humor. Although usually this sort of humor passes me by, here it speaks to me. It's not just the clever play between the existential and the mundanely locational of the title's eponymous question, though I do like that. It's the unvoiced way that the sometimes matter-of-fact, sometimes overexcited testosterone voices counterpoint the robotic, actually robot, bodies of military and sci fi video games. The voices can't stop moving and the bodies (unlike in their original games) can hardly move at all. As one Blue Robot says in answer to the other Blue Robot's endless question "what are they doing?"—"they're just standing there and talking, ok, that's all they're doing, that's all they ever do is just stand there and talk. … They're still just talking and they're still just standing there." Somehow the war game that this is playing with comes unstuck for me, as the voicetrack and image track both align and go their separate ways in this machinima unvoicing.

Lip sync

Perhaps the most common place for voicetrack to unvoice image track is in the many remixes on YouTube.[8] One of my favorites is the wonderfully named classic *Read My Lips: Bush & Blair* (Atmo Team/Rick Silva 2003). The "read my lips" in the title plays with George H. W. Bush's infamous and oft-repeated (1988 nomination speech) sound bite, "read my lips, no new taxes," but also gestures to how the lip sync is close and yet, intriguingly, not quite there. It's that "not quite" that adds a certain unvoicing factor to this work. Although the work is simple, and perhaps no longer so timely, the lip syncing remains uncanny. In this work we see U.S. President George W. Bush (son of the preceding) and UK Prime Minister Tony Blair speaking, but through the cutting and remixing it appears they are speaking/singing to each other, with Bush taking the Lionel Richie voice and Blair the Diana Ross voice in a karaoke version of *Endless Love*.

The special moment comes after Bush's opening declaration that "there's only you in my life" when Blair, in Diana Ross's voice, responds "My first

love." The exactness of the sync goes in and out, but triumphantly it feels like a match when Bush sings "And I." They duet on "your eyes, your eyes" looking sincerely at each other, but I know it's all a lie because of course these aren't their words, these aren't their voices … and yet is it unvoicing what they really feel inside (echoing LaBelle's unvoice)? The enchantment, the 'joy and disturbance,' as Bennett has put it, that I feel is palpable. I am thrilled with the sense that the artists can unhinge these two villains from their complacent power with this clever play between image and voice tracks.

For all its apparent easiness, there are also moments of artful uncanniness in the laughter the work evokes. Uncertainties lurk at the 'not quite' border of sync and out of sync. Somehow I sense that the low-res of the video adds to the uncertainty—reminding me that it has been manipulated yet also evoking an authenticity effect. For a moment I wonder if somehow it is the emotion surging through the voicetrack that is unsettling a clear clean image, producing this low-res effect, and affect. There is also an uncertain sense of ekphrasis in the work, where I wonder if the remixed voices are commenting on the song or the song on the video images. Each "defines and describes" the other in a strange way, at the very moment that they unhinge each other's and their own "essence and forms."

Speaking of lip sync reminds me of one of my most disturbing encounters with dubbing. As Steven Connor discusses, bad sync or sound breakdown can make us very uneasy: "The face which was so recently alive thickens and freezes, and looks nonplussed" (Merleau-Ponty, cited in Connor 2000, 11). This is the dubbing that induces what Antonin Artaud called "les souffrances de 'dubbing'" (Connor 2000, 20). The disturbing and pivotal moment of a "souffrance de 'dubbing'" for me—intensified by jetlag—was when I was in a hotel in Linz, Austria, watching a dubbed version of my (then) favorite American sitcom, *Seinfeld*. It was utterly compelling in its impossibility—could this be happening? How could these quintessential New Yorkers speak in German voices? Are they perhaps even well-known German voices that would resonate for locals in ways they don't for me?[9] Will I ever be able to listen to the New Yorkers in their own voices in the same way again? Before I was even thinking about these things in the way I have been for this book, it attuned me to the fluidity of voice/image relations in film and the disturbing potential of unvoicing.[10]

Inhabiting voicetracks

To move to another example of an unvoicing play with lip sync, in the very different register of video art, I'd like to turn to *The Forgotten Man* (2006). This is a work by Timothy Vernon Moore—TV Moore, as he calls himself, delightfully invoking the entanglement of subject and machine ("no pun intended," as he says). After months of playing around in the Australian Broadcasting Corporation's television archives, Moore found a period documentary about the sort of marginal people who were earlier recognized as vagrants or hobos. The documentary followed a group of the young people whom its narrator met "in the back streets of Sydney" and spoke to in their "pads." According to the narrator, unlike the earlier form of vagrant, with which the documentary opened, these young people, "the product of the 1960s," represented a different sort of nonconformist or outsider or prototypical artist. They were alienated youth outside 'normal' structures of work, family, home. What Moore does to make *The Forgotten Man* is himself perform the script of the documentary and record it over the image track. So as I watch all the people in the documentary—from the somewhat pompous ABC narrator to the snooty bureaucrats and 'experts,' from the Wayside Chapel's sympathetic director Reverend Ted Noffs to a critical politician, from the old vagrants (forgotten men) to the youths themselves—what I hear is Moore's unvoicing voice. Moore reperforms their words, lip syncing with amazing closeness—the same, but not quite. In doing this, he wants, as he says, to enter conversations about history and these particularly marginal people:

Looking at the footage in the present and understanding this particular social geography is forever altered now becomes like a quasi time capsule/artifact. Reshaped as an artwork that speaks to notions of performance, history, gentrification and home. I wanted to get inside this conversation from the past, so by re voicing all of the characters it allowed me to transcend into the past a little ... unbound by time yet grounded by imagination.[11]

I watch this video in wonder and wonderment ... whose voice am I listening to, why do they all have the 'same' voice? Is it the same? The lip sync is so neat, so 'authentic,' yet ... And then I wonder: What has become of these characters, now ventriloquized, haunted, *inhabited* by TV Moore— or is he *inhabited* by them?—to invoke Nicolas Bourriaud's figure.[12] Inhabiting, according to Bourriaud typifies today's postproduction and remix

Figure 5.2
TV Moore, *The Forgotten Man*, 2006. Film on DVD. Still from video. Commissioned by the Australian Broadcasting Corporation and Campbelltown Arts Centre. Courtesy of the artist and Roslyn Oxley 9 Gallery Sydney.

practices: "It is a matter of seizing all the codes of the culture, all the forms of everyday life, the works of the global patrimony, and making them function. To learn how to use forms, as the artists in question invite us to do, is above all to know how to make them one's own, to inhabit them. … Artists actively inhabit cultural and social forms" (Bourriaud 2002, 18). With TV Moore's work I understand how inhabiting is a figure that seems to particularly resonate with unvoice, as I've been thinking about it, bringing together notions of habit (technique, habitus) and home, in a somewhat *unheimlich*, uncanny way. TV Moore works with unvoice to inhabit the 'forgotten man' and all who discoursed around him, to remember them, but also paradoxically to displace them and himself. In so doing he provokes me to wonder … about them, about history, about documentary, and about the authenticity of voice.

Unvoicing portraits

Portraiture holds much rich potential for unvoice, in both my and LaBelle's sense. It has long promised to present and/or represent the truth of its subject, to reveal their inner essence. But as Ayelet Zohar has discussed, media art that plays with mimicry, masquerade, and camouflage works with a different take on portraiture, as an "evasive/elusive portrait" (Zohar 2011, 1). I will follow her lead to listen to the video work of Cao Fei and the installation work of performance artists Brown Council.

Zohar introduces me to Cao Fei's video *Rabid Dogs* (2002)—a simulation (neither "real" nor "fake," Zohar says) in which the artist portrays humans mimicking dogs in order to criticize doglike qualities of humans: "We love whips; need to bite; we dare not bark. We work tamely, faithfully and patiently like dogs" (Zohar 2011, 6). I am enticed by Zohar's understanding of this work as a portrait, in which, she says, Deleuze and Guattari's *becoming imperceptible* plays out into a "moment of the elusive portrait," which *renders visible and sonorous,* rather than *reproducing* the visible and sonorous (Zohar 2011, 6, 8). And so I turn to the video itself on the Internet, to find a most compelling, delightful, and disturbing work, an unvoiced video portrait of everyday workers today.

In the YouTube video (Cao 2002), I see the performers dressed in Burberry, performing in standard office settings, and I listen to their breathing, panting, barking, groaning, and growling to Chinese music, which moves from the frenzied to the more traditional-sounding (to my uneducated ears). There are frenetic visuals, too, with the repetitively opening elevator doors and the security camera scenes. There are two acts to this play. The first begins when elevators open and a group of performers come out, performing dog/becoming dog, panting, on their hands and knees, with painted faces and Burberry office outfits (shirts and ties for the boys, skirts, tights, and pumps for the girls). They talk on phones, read reports, walk round, spin round on chairs, type and of course even stick a panting doggy face into the camera in that way dogs love to do. What I listen to on the soundtrack is a lot of panting, arfing voices. The second act, at night, shows an office location signaled with hallway punch cards that presage scenes of intimidation. Here the cringing performers try to eat dog food in bowls, shrinking and muzzled, at the booted foot of a master. One of their number groans and growls to speak the humiliation of trying to eat while muzzled.

Figure 5.3
Cao Fei, *Rabid Dog—Dog Days,* 2002. C-print. Courtesy of Cao Fei and Vitamin Creative Space, photo by Cao Fei and Vitamin Creative Space.

In this wonderfully Artauding piece, there is of course plenty of caca, which falls into the food and generally adds to the degradation.

The doggy voices speak, with Brandon LaBelle's unvoice, about an inner doglike nature of humans today. There is also something supplementary to the portrait of inner self in this work. The Burberry outfits, the repetitions, and the excesses of the performance are not straightforward. As Zohar has alerted us, through unvoicing, the dog voices disturb the performance of portrait and portrait as performance—offering a conceptual comment on portraiture itself, as evasive and elusive.

Performing reperforming

A very different sort of unvoiced portrait is *Remembering Barbara Cleveland*, an interdisciplinary work by Brown Council,[13] that has a number of different iterations. Though I did not see the installation (Brown Council 2011a), I am familiar with their work and keen to engage with the documentation through the Internet. In this work the four members of Brown Council "re-perform a series of lectures given by Cleveland shortly before her death in 1981. These lectures are meditations on performance, history and memory, and through their re-performance, Brown Council give voice to this mythic feminist artist who has been left out of the pages of Australian art history" (Scanlines n.d.). Barbara Cleveland was, they tell us, one of first female performance artists working in Australia, in an innovative and experimental way. She literally disappeared (having gone to India, never to be heard from again) and has disappeared from the history of performance art.

In the video which is played in the installation,[14] Brown Council perform a reenactment of a performance-lecture given by Cleveland, repeating the performance four times, cutting back and forth between the four members, each wearing the same Barbara Cleveland shoulder-length wigs and lipstick as their costumes or 'masks'—their *personas*. Framed by the Barbara Cleveland wigs, the lips become both their own and other, through which they perform, repetitively speaking a voice that is always/already their own and other—an unvoice. And as they perform, they performatively create a tribute, a remembering, an undoing of conventional histories that have left Cleveland out (Out of the Blue 2013; Brown Council 2011b).

What I see are head shots, one after another, each performer delivering a line until another cuts in. It opens, "My name is Barbara Cleveland. I would like to ask you a question. Is it raining or are they spitting on us." Later she/they repeatedly tell me, "This is performance and this comes before it or me or you." "I am real. You are real. See? Hear me talking to you?" "My body is your body is everyone's body." There is repetition with a difference here, repetition of difference, repetition as difference, as each artist, each performer names herself Barbara Cleveland and takes turns with the texts. "Listen to every word I say. I am talking to you now. I am taking control. This is a lecture. … It is not what it seems." "Everything is a symbol, a sign, a costume, a voice. You are a figment of my imagination." "This is a document of what happened." "Whose voice are you listening to right now?"

Clearly Cleveland knew about the performative power of voice, as do Brown Council, now adding unvoice and mediation to the heady mix (Brown Council 2011b).

Suddenly, though, I begin to wonder if perhaps they are naked, as a naked breast fleetingly appears just as the final Barbara Cleveland who will speak the cycle stands up and moves away. Is this hint at nakedness a comment on the naked truth to which portraits can pretend? Is the performance an unvoicing of a portrait, through an uneasy mimesis of the portrait's 'subject' and portrait itself? Perhaps it's a sort of fictocritical portrait, with the image playing with authenticity, though disturbing it as each artist looks the part differently, one after another. And disturbing it all the more with the voicetrack which speaks (as) Barbara Cleveland, now multiplied and dislocated in time.

All is not what it seems, as the portrait speaks back: "You, staring at me and me staring back at you." The voicetrack and image track are as if in sync here in one way, but at another level they are not, as the *I* who speaks is not Barbara Cleveland, not back from the dead. Or is she? Is she haunting the work, ventriloquizing the performers in an unvoicing *final* performance? Which is precisely what we would expect in a work about performance and a dead performance artist. "Hear me talking to you?" gets repeated, a question more than an injunction. "But I lie." "We all lie." The lie of portraiture, revealed by this unvoicing.

I'm struck by how in the installation (Artspace, Sydney, Australia, 2011) the Barbara Clevelands stand silently in the wigs, facing the wall that announces *Barbara Cleveland,* while the video is playing on the adjacent wall. And thus the performers face the wall and the writing of the name of Barbara Cleveland, rather than face their 'own' faces performing her face.

Another video version of the work that I find online, *This Is Barbara Cleveland, 2013* (see BC 2013), opens with "My name is Barbara Cleveland. What you are about to see is performance. What you are about to hear is performance. This is performance." Unlike the relentlessly repeating identically (as it were) framed head shots, this single-channel video version cuts in images of performing bodies and close-ups on lips. In the middle it cuts to the artists telling us about Barbara Cleveland. Now they are 'themselves,' no longer in 'costume,' but by now that seems as strange to me as when they were Barbara Cleveland/s. When they are actually real, they seem less real. I find myself dazzled by how different they look from each other, when

Figure 5.4
Brown Council, *Remembering Barbara Cleveland*, 2011. Live performance and installation at "Nothing Like Performance," Artspace, Sydney. Image courtesy of the artists, photo by Alex Davies.

they looked so similar in costume. It breaks the unvoicing that character-izes the installation version, as now, without their masks—their personas—their lips speak their voices differently (BC 2013).

In Brown Council's unvoicing works, the red lips frame and shape the (un)voices and faces of the doubled personas—invoking the doubling of *persona* that is the performing of a performer performing. These doublings and inhabitings, these performative performances, become even more intense when in 2016 Brown Council for a while renamed itself Barbara Cleveland Institute or BC Institute and then BC.

Brown Council's unvoicing works speak of and through the persona, and in so doing they evoke the entangled intimacy of the relationship of voice and performativity, voice and face. As Steven Connor notes, both voice and face are at once intimate and vulnerable as they face (us) out into the world—expressing and performing us, I would add. But, while the world may 'know' us, through our voices and faces, we ourselves cannot appre-hend them in the same way: "We *are* our faces as we *are* our voices, partly because we cannot see or hear them as others do" (Connor 2000, 401). This,

for Connor, is the phenomenologically near but troubled relationship between voice and face. Through Brown Council's work—their performative play with voice and face, with lips and wigs and personas—I sense once again an entangling of Brandon LaBelle's unvoice (with its unsettling of the "fixity of inner and outer") with the unvoicing that I have been elaborating.

Subtitles and remixes

In lip sync works, the performance voicetracks do not only unvoice the 'original' mediated voice—reminding us yet again in Derridean fashion that there never really was an original—but also disrupt the image, undoing the usual 'as if' seamlessness of their relationship. Resonating with Frances Stark's work, there is another way that unvoice works to disrupt the soundtrack/image track relation, and this is through adding subtitles— subtitles that do not do the conventional translating of the voice that we are hearing. Instead these subtitles disturb the familiar voice, working in a way as a third voice, unvoicing both the soundtrack and image track. Typical of this is the Hitler *Downfall* remix genre, which has gone viral across the Internet. These works each take the same scene from the German film *Downfall*, in which Bruno Ganz, playing Hitler (in a way that feels like inhabiting), is ranting at his generals in the bunker in the final, losing days of the war. To the German soundtrack and image track of these scenes the remixers add subtitles in their own language, subtitles that tell a different story from that spoken in the film. (The versions I watch are all subtitled in English.) The subtitles, each in their own very local way, still speak the affect of the image at the same time as they disturb it through the humor of their inappropriateness—improper appropriation. These works are intriguing in part because while they are globally viral, they also vociferously speak of the local. Take a 2011 example from Melbourne, Australia, *Hitler Gets MAD at the Footy (AFL 2011 Qualifying Final, WCE vs COLL)*. The piece is about AFL football, a phenomenon mainly of the state of Victoria that I don't yet fully relate to (as a relatively recent Melbourne resident) but that I begin to understand when I witness the way my students, long-term Melburnians, come alive when I play it. The subtitles express a football fan's anger with the players, with Collingwood supporters, with the umpire, and with Channel 10's broadcast—it erupts with emotion that somehow both

perfectly fits the ranting Hitler and also couldn't be more absurd. As the nervous women outside console each other, the subtitles say, "We all hate it when he watches the footy" (Jinko43 2011). Both the typically Australian term "footy" (for football) and the particularly Melbourne emotion in the subtitles make me laugh with delight and unease as I watch a most serious German movie and listen to its German-language soundtrack that I don't understand. And with this layering of voices, with this unvoicing, I have an uneasy sense of the im/possibilities of ekphrasis, remembering what W. J. T. Mitchell said about the "indifference" of ekphrasis and the impossibility of intertwining the verbal and visual, always/already.

My sense is that the *Downfall* remixes' unvoicings work because of both the familiarity and the overloaded significations of Hitler's voice: it's the ranting mode rather than the content alone that has come to signify 'Hitlerness' for non-German-speakers. In a way, these remixes speak of an already unvoice quality of Hitler's mediated voice and then add a third voice to the mix. I was delighted, in this vein, to hear a colleague speak of the way the Soviets used to add laugh tracks to Hitler films—nothing is ever new, of course.[15]

Accidental unvoices

Richard Grayson's work *Messiah* revoices another familiar voice, though in a far different register from Hitler's: that of Handel's *Messiah*. In this case the subtitled words remain the same, but all else changes. *Messiah* (a two-projection video installation from 2004–2005; see Grayson 2004) turns out to be doubly unvoiced, though one of the unvoicings is inadvertent. Besides an intended revoicing, there is also an out-of-sync unvoiced quality to the work, which, as Grayson has explained, occurred accidentally. But then, of course, happy accident is so often what makes art.

Grayson's work comes out of his ongoing interest in belief systems and his concern with the way theology is taking over from enlightenment rationalism. To explore this in the work *Messiah*, Grayson emails *The Midnight Amblers*, a group of musicians from suburban Sydney, inviting them to rewrite and perform Handel's *Messiah* (1742) as country music—revoicing and rescoring it so that we can hear the words anew. He asks the band to get together in a backyard and perform the work, recording it with various DIY video cameras, and send the files to him to edit in Berlin. But through the

air and in the mix the sync turns out to be not quite right. Serendipitously, for Grayson, this actually serves to further "foreground the artifice" and "bring back the weirdness and the spookiness ... of something we take in a way as granted" (COFA 2010). As the out-of-sync mode redoubles the effects of re-rescoring and re-recording, once again there is an unvoicing in which soundtrack and image track do not seamlessly work together.

I encounter *Messiah* in the 2010 Sydney Biennale, located in a tunnel on Cockatoo Island. The tunnel is an intense place, moving participants from an expansive and bright outside space into a dark, intense, echoey domain. Off the tunnel there is a small low-ceilinged dark room, which houses Grayson's work. As I sit on a straw bale in that narrow space, I feel straw under my feet—the smell of the bales, straw on the floor—and they evoke for me memories of an Australian country music festival of my youth, though minus the pervasive smell of beer. Bringing contemporary art into conversation with the most quotidian in an unvoiced way—a zany

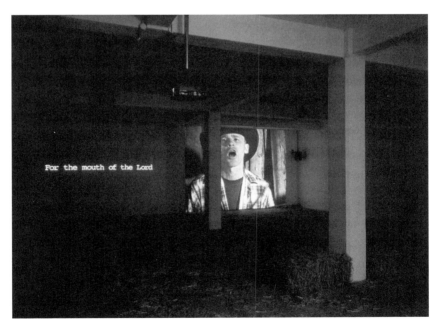

Figure 5.5
Richard Grayson, *Messiah*, 2004. Two-channel video installation, stereo sound. Installation shot. Courtesy of the artist and Matts Gallery, London, photo by John Riddy.

way even—*Messiah* lets loose in me a stream of even more bizarre memories. Strangely as I listen to the country and western version of "To see corruption," I am reminded of the music of the television series *True Blood*—my media memory intervening, adding (or finding?) undead, uncanny vampire undertones to the whole Messiah story. Along with the conceptual idea itself, and the multisensorial experience of the installation, it is this zany minor aesthetic that so intrigues me in this work. The work also makes me think, again, how much unvoice speaks to memory— how memory is always/already unvoiced, uncanny, never quite in sync with 'actual' events.

Rethinking animal voices with Henri

I want to return now to animals in the context of unvoice, to listen to how unvoiced soundtracks complicate the animal voices I listened to in chapter 2. And how better to do this than through cat videos, so distinctive and alluring, so popular on the Internet (O'Meara 2015). While cat videos often play with a minor aesthetic of slapstick zany-meets-cute, they sometimes complicate this with a certain "creaturely aesthetics," as Anat Pick might have it, calling us to share a sense of bodily vulnerability with the cats. Speaking both of generic feline cuteness but also expressing the intimate particularity of an individual cat, these videos can evoke a universality and a particularity at the same time.

I'm certainly not alone in this response to cat videos, given their popularity on the Internet and the type of spectatorship they engender, including cat video festivals to which people can sometimes even bring their own cats (O'Meara 2015). One prominent cat film festival is put on by the Walker Art Center in Minneapolis, and it brings the online cat video community off line with what Maria Miranda might figure as an unsitely blurring of the line between serious art and entertainment. The event is so popular that it has continued each year, attracting massive crowds (Walker Art Center 2015a and b). When I see that Radha O'Meara will be discussing the phenomenal popularity of cat videos on the Internet at a session of the 2015 Australasian Animal Studies Association conference, for instance, I am eager to attend. I am somewhat taken aback, however, during question time, when someone disparages the cats in cat videos as generic. With this question of the generic in mind, along with the

question of the 'gaze' in these videos, I turn to Henri the existential cat, in hopes that an existential cat will have something—unvoiced, of course— to say about that.

Although I do not respond to all cat videos as unvoiced, I certainly do those of Henri (winner of the Walker Art Center Cat Video Festival's first Golden Kitty Award, by the way). Watching these videos,[16] I encounter M. Henri going about his business while a voice, in French, expostulates on the existential questions of his existence. The voice is not that of Henri, however, but of someone else, which I know because of course Henri would speak better French. So what I am listening to is as if it is Henri speaking French 'badly,' telling me how he is an intellectual, depressed cat. At one level this is the familiar projection those of us with companion cats seem to endlessly enact. But at another level it disturbs that habitual scene, giving us the sense that it is indeed Henri who is ventriloquizing, rather than the other way around, or at least that a conversation is happening (though perhaps he is telling us that this is always the case?). The video is shot in black and white—like Henri himself (I sense) and like the new wave French cinema that it echoes. What is particularly odd here, then, is the French voice, which those familiar with French recognize as being spoken by someone who is not a French speaker. Herewith begins the unvoicing.

It's interesting that Henri presents himself as an existential cat— unvoicing seems often to play out when questions of existence, identity, and "what are we doing here" play out. Being a philosopher, or *doing* philosophy, Henri thinks about authenticity: he rethinks what I have examined elsewhere as the 'authenticity effect' of many earlier domestic YouTube videos. I listened to the voices in those videos, intimate voices, domestic voices, as calling out to the audience to relate to them as *authentic*. For me this was a performing of authenticity, which produced an "authenticity effect" (Neumark 2010a). But in the Henri videos, quintessentially domestic though they are, performativity is foregrounded, as his voicetrack speaking its uneasy French unvoices the image track. I sense in my gut that it is not Henri but a ventriloquized Henri, through his owner and back through him. I am *dumbstruck* by the ventriloquism, as Steven Connor would have it. For Connor, the ventriloquial voice speaks from some other place, as ventriloquism performs as mediator of human and nonhuman worlds (Connor 2000, 42–43). Yet here the ventriloquism is all the more uncanny

as I'm not sure of its source and from what place it is coming. I find myself compelled to search for the next episode. Listening to these reverberations of ventriloquized voices—of a cat becoming philosopher—means I can never think about authenticity on (or off) the Internet in quite the same way again.

While my focus is on listening, I do need to briefly address the question of what I have been watching with cat videos, especially since I am proposing that the senses do not operate separately. Without going into long debates about the gaze, or even the gaze in relation to animals, I'll return to Anat Pick here, who questions whether animals (in cinema) bear a "prurient and savvy" human look that distances them even further from us in modern life and, further, signals the loss of their "alluring animality" in life and art as they become "specter, abstraction, or loss" (Pick 2011a, 103–104, 110). Pick reads these negative understandings as self-fulfilling philosophy and counters with the "agency of the cinematic animal … not in the more problematic sense of animal subjectivity, but in terms of the animal's affective power vis-à-vis the human observer" (Pick 2011a, 109). She reminds us, as did Derrida's cat, that the animal, first of all, is watching us. Writing of and from the particular (rather than the abstract or metaphysical), Pick pricks my ears to the cat's familiarity and unknowability—its evocative, concrete, material, vulnerable—*creaturely*—particularity and plenitude. Perhaps this is what makes cat videos—like cats—so alluring, so mysterious, calling out to me to watch yet another. And as I do so, as I watch and listen to the uncanny unvoicetrack of Henri once more, I feel "a sense of astonishment and incomprehension that there should be beings like us, so unlike us, so astonishingly capable of being companions of ours and so unfathomably distant" (Cora Diamond cited in Pick 2011a, 186).

Rethinking animal voices—bear life

It was during a lecture by Anat Pick that I first heard about *Bear 71*, another work using a human to voice the animal. Pick told us she liked the work because the bear in the story is singular and not archetypal (Pick 2015). Intrigued, I came home from the lecture and tried to piece *Bear 71* together through traces on the Internet, from trailers to the 20-minute documentary (National Film Board of Canada 2012). *Bear 71* is an interactive

documentary project, video, installation, social narrative, and live event story world about the "intersection of animals, humans and technology." It is created by Jeremy Mendes and Leanne Allison, who make use of photos from fifteen remote motion detection cameras in the bears' habitat in Banff National Park in Canada. The story is told in the first person by an omniscient grizzly bear, voiced by well-known actor Mia Kirshner (speaking for "we grizzlies"), backed by disturbing and evocative music.[17]

Visually most of the footage from the park is low-res, which in one way helps to establish the elusive singularity of Bear 71, known only by her number. Yet watching and listening, I feel confused, vacillating between affective engagement and alienation. One minute I feel annoyed that Kirshner's unvoicing of Bear 71 somehow makes the actor the central character—her voice overpowering the low-res image—and I'm disturbed by the way in which that diminishes the bear; at other moments I hear the voicetrack speaking the vulnerability of creaturely poetics that Pick identifies.

Let me return to Pick's important figure here, to see what it can tell me about *Bear 71*:

There is ... a kind of provocation in the term "creature" because it hints at a certain animalization (or—to use a loaded term—'dehumanization') of the human, and, conversely, a certain humanization of the animal. It is an egalitarian term that refrains from simply extending moral consideration to animals based on capacities similar to our own that we grant they possess and which therefore entitle them to (certain limited) rights. Instead of extending such consideration to animals, I wanted to contract humanity. (Pick 2011b; see also Pick 2011a, introduction)

While I wonder about the risk of occluding Donna Haraway's ethical "radical otherness" (Whatmore 2002, 158) by bringing human and animal together under the umbrella of shared creaturely vulnerability, nonetheless I feel an affinity with Pick's figure of *creaturely*. It appeals to me as a way to avoid altogether the term "human," even when it is included in but exceeded by figurings such as *posthuman* or *more-than-human*. Pick wants to put life at the center as she attempts, she tells us, to think matter and nonmatter simultaneously (Pick 2011b). Like Jane Bennett, she raises important political and ethical questions at the heart of aesthetics. And, finally, her recognition of the power of the unharmonious reverberates with unvoicing itself—in both of their very literalnesses.

I return to *Bear 71*, attuned by the vulnerability of the creaturely aesthetics. The video opens with images of a bear snared, voicing her struggle with

snorting and scruffling. Visual close-ups focus on park rangers whom I also hear putting a horrible heavy VHF collar on her. Of course serendipity intervenes once more and I find myself engaging with this work on the very day I try to put collars with bells on my cats and they fight back. (This day, they win.) Thus begins the work and its lamentation for the loss of the wild. As Bear 71 tells us: "That snare had a breaking strength of two tons. The dart was full of something called Telazol brought to you by Pfizer, the same people who make Zoloft and Viagra. Then next thing I know I am wearing a VHF collar and I have my own radio frequency. They also gave me a number, Bear 71. ... Then again, it's hard to say where the wired world ends and the wild one begins. ... Think of us as refugees I guess" (National Film Board of Canada 2012).

She describes the trials of living in a habitat transformed by people with their cars and so on. Too many new smells, too much new movement. Dangers of becoming road kill with the freeway and railway which bisect the valley in which she lives. She invokes loss of natural life. "The forest has its own language. Maybe you can learn it with hidden cameras and test tubes, but I doubt it. ... What I really want you to understand is this. I

Figure 5.6
Jeremy Mendes, Leanne Allison, and the National Film Board of Canada, *Bear 71*, 2012. Web. Image from interactive documentary "Bear 71." Courtesy of the artists and National Film Board of Canada.

was a good bear. I raised three cubs eating berries in a valley that smells of hash browns."

I notice that I tend to write *she* instead of Bear 71—that's what my fingers say, telling of my unease about Kirshner's voicing of the bear. Kirshner's voice is distinctive (you may know her from other acting roles), with its particular range of very human tones and tonalities. It is despairing and ironic at times, with a characteristic half-laugh breaking through, tired, wistful, and dismally slow at others. Or it can be full of maternal pride, sincerely croaking. The little individuating timbres and tonalities, the half-laugh and croak are so Kirshner, speaking her body. Expressing a sense of the strangeness of things, the sadness of loss, her voice is moved, moving, and vulnerable. She directly addresses *you*, trying to interpellate and identify with *you*, but also at other times to assert her bear identity, separating herself from 'you'—"what looks random to you," she says. Is it Bear 71's suffering that catches in Kirshner's throat? A vulnerability is palpable, but the unvoicing confuses me.

I sense a contradictory push/pull when Bear 71 says "You know when you're young and you push boundaries" with a very Kirshner laugh in her voice. At moments like this, and another where she describes her sympathy for young girls who are praying in fear of Bear 71 and her cubs, is she saying, "Hey, I'm a bear and/but I'm just like you?" Is there a loss of difference here? Does sharing a sense of the vulnerability of life mean we have to erase difference and unknowability? Do we humans have to know everything, understand everything about a bear? Yet at the same time the script pushes against this, telling us, for instance, that forest has—speaks, I would say—its own language and we can't know everything. The script and therefore the voice speak emotions and responses that sound very familiar, familiarly human: "First rule of survival, don't do what comes naturally." "They call it aversive conditioning, I call it rubber bullets." "The rangers know where I am from the day I leave my den in the spring to the day I go back to sleep in the fall." "Sometimes you do things to keep yourself amused … and I remember thinking, put that in your [ranger's] notebook, go ahead analyse that." "Looking back on it now, it all seems unstoppable." I feel confused. I keep watching.

And listening. Is this narration somehow working like the acousmatic narration, voice of God narration, in Hollywood? Does the speaking as *I* do it? Christian Metz tells us that such a voice is experienced as enigmatic and

anxiogenic until its source is identified, visualized (Connor 2000, 19–20). Perhaps it is because I am a film-trained viewer that I am drawn to identify the speaking voice with Bear 71, rather than anxiously holding on to the uncanniness of a young woman speaking a bear's part in a film in the first person.

Pulled in, choral music swelling, moved by this voice, I cry despite myself at the climactic fatal moment as Bear 71 roars and charges at an oncoming train to defend her cub. "For eleven years I did everything right and then I made a mistake. Now my cub is on her own. More than a million years of evolution have prepared her to live in the wild, but let's face it, the wild isn't where she lives." The train, like the train of early cinema, is frightening, as I listen to her speaking from the dead, haunted, haunting. Interrupted by the unstoppable moment, where she is hit by the train. The film breaks up, and I break down.

What am I crying for, is it for the bear or because of what we have done? Is this an animal melodrama like the ones that used to make me cry at the movies when I was a kid? The unhappy ending and the voice that is neither cute nor exaggerated (along, importantly, with the more experimental though still very affective music) do certainly set it apart from the anthropomorphism of, say, Disney cartoons. Nevertheless, *Bear 71* does make me think again about anthropomorphism. With many new materialists I understand that a certain anthropomorphism is inevitable—we are humans, we have an embodied imagination and, furthermore, we cannot claim direct access to an animal's experience. What we can abjure, however, is anthropocentrism (Stengers 2011, 26; Braidotti and Vermeulen 2014).

Yet *Bear 71* does raise worries for me about its possibly excessive anthropomorphism: I wonder if the work opens awareness and thinking about anthropomorphism or whether it instantiates it and validates it unquestioningly. And, in so doing, spills over, perhaps, into anthropocentrism? In an odd way, *Bear 71* both voices and unvoices anthropomorphism. In one way, the soundtrack unvoices—after all, the bear is not Mia Kirshner and the script is not the words of either Kirshner or the bear. Yet at the same time the work also voices an all too taken-for-granted anthropomorphism. Still, given the inevitability of anthropomorphism, does it even matter?

I am left wondering whether the human voice is necessary to give me access to their experience, as *Bear 71* claims to. Do I need the human voice

and story to tug at my heartstrings, to punch me in the guts, in order to care? Does what Anat Pick's creaturely aesthetics figures as the voice of life have to be a human voice? In the end, I remain ambivalent.

But I am also haunted by this powerful work. Indeed, maybe what's unvoicing this work is haunted ventriloquism. Do I sense Bear 71 ventriloquized through Mia Kirshner—am I identifying with the voice as a human voice or a ventriloquized bear's voice? And what would ventriloquism do to Bear 71's body, and to my own? Steven Connor tells us that the ventriloquial voice can be seductive. Furthermore, he proposes, animating the dummy with the ventriloquist's voice (like a puppet or cartoon character, say) gives it a vocalic body, an imaginary body with apparently "a much wider range of gestures, facial expressions and tonalities than … when it is silent" (Connor 2000, 35–36, 38). But then Bear 71 already had such a body, right? I wonder: Is this the vocalic body that Kirshner gives to Bear 71 in order to call forth my identification, seducing me at the expense of Bear 71's specificity and difference? Is my unease a result of feeling seduced? Does taking the voice out of Kirshner's body and putting it into Bear 71 diminish Bear 71's own voice and body? (Leaving aside the prior reproduction, recording, etc. of any mediated voice.)

Or perhaps Bear 71 is ventriloquizing Kirshner, rather than the other way around? After all she is actually speaking after death, with the voice of prophecy that has long been associated with ventriloquism (Connor 2000, passim). "And I wonder," says Bear 71, or is it Kirschner, at the end. As do I. Now, pulled in again, I wonder: Am I listening to her bear life, not bare life, as Anat Pick would want: "unlike Giorgio Agamben's bare life or Judith Butler's precarious life, which remain within the confines of human life, creatureliness applies across the range of living beings and draws on the predicament of animals as in some sense exemplary of precarity as such" (Pick 2011b)?

Or has the human asserted itself through the voice in the urge of anthropomorphism, this time, at the expense of the animal? Is this a failure of its unvoicing in the end, unvoicing which would open our thinking about anthropomorphism, anthropocentrism and its destruction of bears' habitats and lives, bears, the bear, the wild, Banff National Park, national parks, and so on? I'm unsure, I remain both incredibly moved and deeply uncertain, which is, yes, perhaps the best thing.

Artaud again …

I will return now to minor aesthetics with an Artaudian twist, to help me listen to voices going off the rails, driven by extremes. I will consider whether these voices might be listened to as 'minor' voices, as Laura Cull discusses, voices that speak in particularly affective ways and ways that are "more than, rather than less than what we might consider a normal or everyday voice" (Cull 2012, 73–74). While Cull brings Deleuze to bear on human voices in order to understand, among other things, their political valence in theater, I bring her understandings to other, more-than-human voices. Following Cull, I ask: How do more-than-human voices produce their own bodies as well as those of their listeners?

To address these questions, I'll turn to my encounter with the work of Debra Petrovitch. Her installation *Solace in Black Sun* comes out of years of engaging with Artaud and working through how this engagement can play into and out of her own practice, exploring painful personal and political moments. Video is a strong and important part of *Solace in Black Sun*, and I will focus on the voice as it disturbs and unvoices the image tracks of the videos.

I enter the installation space and am surrounded by a series of video scenes, images, and texts, some interactive, against which runs a voicetrack—not so much holding the image tracks together as disturbing them. As I move around the room, I encounter scenes of a building that is slowly imploding, a close-up of hands lancing into a fish, pissing into a metal bowl, and young girls dragging and dragged down by heavy objects (so weighed down that the image itself distorts). One of the most telling audio moments (which amplifies visual scenes of cutting) is a cutting into Antonin Artaud's famously censored radio work, *To Have Done with the Judgment of God*—here fissured by Petrovitch's own sound and voice. As these voices cut and cut into each other, unvoicing each other, they speak about the relationship of Petrovitch's work with Artaud's. A particularly insistent voice in the work is that of urine hitting a metal pan—bodily emission and metal colliding. There are for me some disturbing and cruel urine moments where, for instance, randomly I hear the urine hit the metal as I watch a video of fish innards being dissected, leaving their own entrail traces on the artist's hands. I become obsessed with how present and foregrounded and disruptive the urine's metallic voice is

within the installation as assemblage's voicetrack of clacking and banging. The urine's voice resonates in a particularly and peculiarly female way with Artaud's obsession with bodily emissions and ambivalence about spoken language. As I listen to this most apt female voicing of the bodily, the usual singular connection of Artaud and caca is unvoiced. And as I watch the partial image, focused on the urine and pan rather than the artist herself urinating, I sense the metallic unvoice of the urine as more-than-human—interrupting a straightforward humanist sense of body, or femaleness, or inner identity. This raises the question: Is the voice of the urine speaking an inner unvoice of the artist, in LaBelle's sense? Or is it also the voice of collision, the cold metal pan responding to the hot flow of urine, calling out and unvoicing the other videos that I am watching at the same time? Or perhaps it is an impossible duet between them? Or even, as Ansa Lønstrup suggests, could this be a moment of polyphonic speaking and listening—conversation as polyphony?—as I imagine/listen to the voice of the urine in duet with the metal as the voice of the artist, of her urine? As Lønstrup listens to Petrovitch's work, through my writing it, she hears unvoice itself as polyphony, where the polyphony of voice

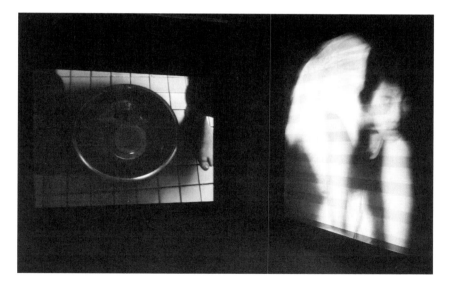

Figure 5.7
Debra Petrovitch, *Solace in Black Sun*, 2009 and 2015. Audiovisual interactive installation. Installation image. Courtesy of the artist. Photo by Debra Petrovitch.

itself, as Don Ihde discusses, is made audible in its unvoicing (Ihde 2007, passim).[18]

In her discussion of her work, Petrovitch expresses the impossibility of an "Artaudian work," arguing instead for "a kind of invoking of energies that disrupt and lance into an artwork" (Petrovitch 2015, 132–133). In this sense the urination scene is a vocally powerful way to unvoice, to rid herself "of the ingested built-up layered information regarding Artaud's ideas" (Petrovitch 2015, 158)—thus adding another layer to the unvoice of this assemblage. The urine's voice also emblematically engages with the challenges of making a work inspired by another, especially a so famous, dead artist, while needing to bring it into the artist's own personal (including in this case female) and broader current context. *Solace in Black Sun* is an intense and cruel work in which the unvoicing voicetracks perform an Artaudian disruption at the same time as they disrupt any promise that any work might perform *Artaudian.*

... And again

Another work that I experience as voicing the impossibility of restaging Artaud is a durational performance by sculptor Saskia Doherty, performed behind a huge glass window on a ledge outside the TarraWarra Museum of Art (October 2015, Healesville, Victoria, Australia), with the audience behind the pane, able to see but not to hear. The work is advertised by curators in a way that speaks the productive power of voice: "Saskia Doherty will be speaking to wet clay that is taking on the shape of her voice. As the clay dries, the time of her voice will be imprinted into its setting form. When spectators witness the destruction of the dried clay—both the object and the record contained within it—they will see, and hear, the artist's voice, literally breaking" (Liquid Architecture 2015). Voice, and time, imprinted into clay—this is the promise that calls me to this work and makes me want to engage with it here, even though the human voice has almost returned, or at least haunts this final example.

As it turns out, the work and its voices are rent with unvoicings and impossibilities. Although we are told by the curator, as we approach the window, that Doherty is restaging Artaud's *To Have Done with the Judgment of God*, it turns out that it is actually a durational performance of Jacques Brel's *Ne me quitte pas*, as I find out after the event. I am enchanted by this

confusion, which seems to me to have unvoicing at its very heart, and I'm interested in how well the work, as I imagine/experience it, speaks to the Artaudian im/possibilities that inflect unvoices. In a way, my own expectations—fueled by the rekindling of my interest in Artaud through Petrovitch's work and ignited by the curator's directions—produce my imagining and listening to Doherty's work's voicetrack. Standing inside the gallery, I see the artist outside speaking to the wet clay, which, according to the curators' promise, her voice is shaping, but I cannot hear either her own or the clay's now animated voice—all come to me only through a glass silenced. Perhaps it is the window that speaks, that silences the outside voices on its way through to my ears and that also speaks (of) the voices with which silence is alive. It is the window that mediates and unvoices the artist's voice and itself revoices the work in that very particular and impossible moment. Within the assemblage that is this work—an assemblage of curatorial discourse, gallery architecture, clay, Doherty's body, audience's expectations, imaginings and listenings—the window both silences and unvoices silence, bringing it into an (imagined) audibility, speaking.

While I am inside, immersed in silence, listening to the 'as if' Artaud's script being spoken into rectangular pieces of clay, I watch Doherty, sitting on the outside ledge, reciting—in the way that one speaks into and texts on a phone—and recording her voice onto the clay. The performance reminds me of how Artaud's piece was recorded but silenced when the French radio wouldn't allow it to be broadcast. I attune to Doherty's evoking the clay's voice, shaping the clay with her own voice so that its voice can emerge. I 'listen' to her voice magically animating these pieces of clay, Golem-like, but with an Artaudian twist, in that they are shaped uncannily like caca rather than bodies. She then throws each piece of clay over the edge of the ledge, where, now unvoiced, they lie on the ground—little pieces of caca, whose voices are now broken, broken up, reminders of Artaudian stutters. Later, at home when I check out Doherty's website, I am astonished to find a confusing title to the work and email her to find out what in fact she was reciting. She responds that the confusion arose because she was unable to reach the curator by text right before the performance. Nonetheless, despite this (to me, somehow quite fitting) moment of process unvoiced and derailed, for Doherty "Artaud's radio play was a strong reference around the piece in my mind … I guess I was also thinking about how the ear of the

listener became in some ways defunct within that performance, a defunct—yet strongly implied—organ; along with the invocation of the appendix as this weird outlier in the human body, a thing that won't quite submit itself to reason, as well as its textual relationship as an afterthought, an excess to the main body of a text."[19]

With an Artaudian cruelty, the human voice goes off the rails in my encounter with this work, performing and not performing as promised, stopped in its voicetracks by a window that has its own agenda to speak of and through silence: unvoicing, it disturbs the relationship between what I see and hear. And in this way, it speaks to me about how much we 'normally' hear through anticipation and imagination, through letting what we see guide what we hear, unable to attune ourselves to the unexpected things that voices might have to say. Its unvoicing opens my ears to the im/possibilities of listening and to its polyphonies.

The uncertainties of unvoicing

With unvoicing, as voice goes off the rails, voicetracks draw attention to themselves and their normally unnoticed relations to image tracks. In so doing, whether humorous or serious, whether uncanny or absurd, whether unexpectedly or deliberately, unvoicing raises questions about portraiture, about identity, about authenticity, about performance, and about mediation, media, and the arts. And these questions are not always of the answerable kind. Often the uncertainty of unvoicing is what provokes most powerfully—an invitation to imagining and thinking. From the first moment I listened to *Seinfeld* dubbed, I was entranced by this uncertainty, sensing there was more to it than just 'bad' lip sync. Since then I have come to relish the dynamic range of lip sync. And, even more, I have been drawn ineluctably to unvoicing—to its potentialities, possibilities and impossibilities, and what it has to say about mediated relations of soundtrack, voicetrack, and image track. In the final chapter, I'll track back to the attunements to voicetracks in previous chapters, now further enlivened with the potentialities and imaginings that unvoice has provoked.

6 Tracking Back

Conversations, once again

Let me begin this ending by tracking back to my introductory intention to engage in encounters with voice in media and contemporary art through listening. In particular, I wanted to listen in a way attuned by new materialist and other transdisciplinary theoretical approaches. My hope was that this would enable me to bring new materialist understandings of voice into wider discussions. To this end, I developed the strategy of *conversations*, sidestepping the intricacies of debates between new materialism, object-oriented ontologies, the more-than- human, and posthumanism itself, to mention the main contenders.

With this strategy of bringing voice studies into conversation with new materialism through my own engaged encounters with media and artworks, I hope, too, that I have been able to provoke new ways of thinking about and experiencing both voice and new materialism. My assumption has been that the thinking voiced by the works which I encountered can speak to theory just as theory often speaks to artists. These are the conversations I have hoped to have. I was provoked to this task in part by noticing how new materialists like Jane Bennett listened to things and assemblages *speaking* (as had phenomenologists such as Don Ihde). Others, too, in this posthumanist era have listened to the voices of things and animals, yet the task has remained to flesh out the question of the voice that speaks.[1] Outside of academia and art, in popular culture, too, from cartoons to animations to TV ads, the voices of animals, things, and events also frequently speak. It's so commonplace, something we're so used to from childhood, that in many ways we tend not to notice or at least not to think about it.

Our diverse and affective experiences of voice have exceeded our thinking about voice. This disjunction spoke to me as needing attention.

My particular concern has been to approach this conversation through the situated, carnal knowledge with which new materialism is so compatible. To do so, I have not adhered to any particular philosophical tradition, though I have engaged with numerous philosophers among other theorists. Because I am not a philosopher myself, I have been both hampered and freed from the need to speak within the discipline, to discourse with and within its parameters. I have benefited from the interdisciplinary and transversal approaches of cultural studies and sound studies as well as my own art practice, which attunes me to listening in many different ways. I have also benefited from living in Australia where Indigenous culture is ancient and alive, strong and vocal, and has much to teach about listening, and listening to country, in materialist, spiritual, and ethical ways that take for granted much that new materialism has worked to understand. I will begin this final chapter, then, by tracking back to my own practice and to being situated in Australia. I hope this discussion can also work as a way not so much to conclude but to reprise some of the issues threading through the preceding chapters—breath and coughing, memory and place, atmospheres and assemblages, the infrathin and undecidability, performativity and documentation, care and waiting, wayfaring and listening—returning to them from this different direction and revealing some of the energy that brought my attention to them.

Ahhh, ahem, cough … from *Talking about the Weather* to *Coalface*

In the preceding chapters I have for the most part avoided discussing the influence of my own art practice on the way I listen and the position from which I write. However, it is always there, in my listening and writing, and it calls out to come to the foreground here at least, at last. I'd like to talk about two works, *Talking about the Weather* and *Coalface*, which have particularly affected my thinking about voice and voicetracks. I raise them here, too, because both works were driven by emotional, ethical and political—new materialist—concerns for the environment in our posthumanist era. In a sense they helped me along my path to new materialism. In *Talking about the Weather*, breath became the voicetrack for an installation and textured the voicetrack of the videos that were part of it. Its focus

on breath focused my own experience of and thinking about breath as a voice in contemporary art. In *Coalface,* it was coughing that enlivened and disturbed the installation's voicetrack—and attuned my thinking about coughing as voice. And both of these works have provoked my thinking about art installations as assemblages enlivened by the voices that co-composed them—the voices they shaped and were shaped by.

Talking about the Weather began when Maria Miranda and I were reading *The Weather Makers*, Tim Flannery's book about global warming, and were struck by a very poetic passage about the aerial atmosphere—a passage that became the point of departure for our project: "The air you just exhaled has already spread far and wide. The CO_2 from a breath last week may now be feeding a plant on a distant continent, or plankton in a frozen sea. In a matter of months all of the CO_2 you just exhaled will have dispersed around the planet. Because of its dynamism, the atmosphere is on intimate terms with every aspect of our Earth" (Flannery 2005, 22). Climate change and the weather felt so frightening when we started this work in 2006 that we experienced the need to talk about it—obsessively, incessantly. We needed to talk about the weather with people—to connect with people, in the way that voice enables and speaks of in the act of talking. But how to do so without resorting to polemics, how to open our project up to imagination? We turned to 'pataphysics and its imaginary solutions. 'Pataphysics suggested a project of imaginary solutions to actual problems. It also proffered an invitation to an open-ended engagement with the city as a site of play. And where better to begin than with breath, a way into Tim Flannery's sense of atmosphere?

We began walking around cities, inviting strangers to contribute to our breath collection, the world's biggest, with which we would blow back global warming. This breath collection's blowing back global warming was our imaginary solution to the actual problem confronting us all. We were asking people to contribute the breath they would normally use to talk about the weather. We were struck by how differently people breathed in different places, breathing the place as they breathed their situated contributions to our collection. During these performative encounters in public places, where we shared talk and breath and energies, we collected the breath with a small microphone and tape recorder and recorded the event with a prosumer video camera. We saw these encounters with strangers, where we invited them into a zone of play together, as performatively

realizing the work. And for us, this zone was tinctured by the breath we shared—breath that spoke of place and relationships, of playfulness and serious politics, of the imaginable and unimaginable.

It felt like we were invoking a very intimate communication in that we were asking people to contribute something personal and vital—their life's breath. We were calling upon and calling forth their generosity. We were inviting them to enter this playful, performative zone with us, calling them in with an interpellating energy that said, "please come into this space/time and play with us for a minute." This moment was enabled by our media— small enough, ordinary enough, and quotidian enough not to be intimidating but also media enough to signal that something also out of the ordinary was going on. And, most importantly, it was animated by breath.

And so, too, was the installation. In the installations of the work, breath emerged even more vocally, as the soundtrack on the video of these encounters (listened to through headphones) was punctuated with the breaths that people contributed. And, taken from the tape recordings, the breaths on their own became the voicetrack that was the atmosphere, in every sense, of the installation spaces.

The breath that spoke here called out to and fueled my interest in the modalities of voice, breathing life, literally and metaphorically, into my sense of the complexities of voicetracks. As I discussed in the introduction, breath is an essential condition and part of voice: breath is compelling and intriguing in that it is both bodily and not—it starts in one body and then connects to/communicates with another. Breath, in its movement, enlivens the place it traverses—a place animated by affect that literally tinctures the air in that place. It is, indeed, the very stuff, the material energy of the atmosphere. But breath is also tinged with an edge of undecidability and ambiguity—especially in media; and, after a while and in the mix, it's hard to tell an exhale from an inhale (although at another level affectively and environmentally, it can be important to distinguish the two). This undecidability between exhale and inhale—two movements, in different directions, of the 'same' breath—is reminiscent of Marcel Duchamp's *infrathin*, which he used to describe the separation between two things that are the 'same' yet not. He presented the *infrathin* through examples because he saw it— heard it—as undefinable. According to Marjorie Perloff, Duchamp "playfully related *infrathin* to what he called *physique de baggage*, the science of 'determining the difference between volumes of air displaced by a clean

shirt (ironed and folded) and the same shirt when dirty' (#231)" (Perloff 2001). Another, breathy example was the tobacco smoke and the smell of the mouth exhaling it—the two odors married by the olfactory infrathin (Perloff 2001).

Let me say a bit more about the infrathin, which speaks of breath, yes, and also of art. For Erin Manning, infrathin is a productively useless and uselessly productive figure that evokes the thinking that art does—its process thinking—and the "conceptual feelings" it introduces. Manning's talk (Manning 2015), which I discussed in chapter 3, suggests to me that the infrathin speaks of the experience in the making of art, the time of making, and the "thisness" of the experience of the event to which art can attune us as it activates a feeling of the layeredness of time. She speaks of the infrathin as where consciousness and nonconsciousness are in co-composition. The infrathin reminds her, and me, that it is art that can create the conditions for another way of perceiving, and this makes possible other ways of living. This is no utilitarian injunction, quite the opposite, as Manning insists on the importance of the useless—a welcome relief, I must add, in these neoliberal days when 'outcome' and 'business' rule (see also Bolt 2011, chapter 2). Instead the infrathin speaks another sense of value, the value of art which values things not for their exchange value nor even their use value but their thingness, the thisness of the art event. To return to the making of *Talking about the Weather,* through this thinking about the infrathin of art, I remember the intensity of our encounters in our imaginary project of promising that our breath collection would blow back global warming. It was its very impossibility, which was at the same time its imperative, that animated the breath that voiced this project, paradoxically making it possible.

The impossible possibilities of the infrathin also return me to Amelia Jones, who approached Duchamp's figure as a *process* "that implicates the passage of one possibility to another, linking the live body to the things around it through intangible signs of the body as *hinge* between presence and absence" (Jones 2010, 148). The infinitesimal, infrathin "difference" between two objects (or bodies or objects and bodies) recalls, then, the situated body and the senses as being crucial to aesthetics, to the making and apprehension of art (Jones 2010, 148, 154). And so in *Talking about the Weather* it was listening to the breath of the people and the places that we encountered, as it left people's bodies and stirred the air that connected us

in that place (and to the planet) and entered our bodies and microphones, that made the work. These breaths, these voices, tinctured the atmosphere, as Böhme would put it; indeed they *were* the atmosphere in the installation. These breaths made the work in the infinitesimally different moments, animating the infrathin moment between the live and the documenting of the live. And they focused my attention on atmosphere itself as part of the assemblage which was the installation.

Along the way as I track back to *Talking about the Weather*, I am also reminded of Philip Auslander's approach to the performativity of documentation (Auslander 2006). Auslander's concept speaks to what was happening for us as we did these voice-centered performative encounters with strangers in public places, because there was no encounter outside the documenting moment for us—the documenting was what brought the encounters into play. Our encounters were not just instigated by the documenting but actually only happened because we were 'documenting' them. Our documenting microphone (and camera) were, then, an incitement to and integral part of these performative events at the very moment that they also evoked the importance of breath.

Back at the coalface

I'd like to briefly return to *Coalface*, which I introduced in the first chapter, to think about how what I wrote there is now inflected by the conversations in between. In December 2012, while on an artist residency in Beijing, Maria Miranda and I experienced extraordinarily thick and frightening air pollution. We quickly became fixated on the air quality index or AQI, incessantly consulting a little app on our smart phones that told us what degree of dangerous particle pollution to expect each day, from good to more or less healthy to dangerous to hazardous to off the charts. The AQI swung wildly during our residency between 178 and over 400. At the same time the Melbourne AQI was 14.

We had gone to Beijing with a project about walking and listening to the city as a way to think about modernity and the future.[2] And when we got there the future slapped us in the face and pounded us in our coughing lungs. It was both strikingly obvious, with the skyscrapers and the shopping malls and consumer heaven, and somehow difficult to discern through the fog of pollution. After spending a week in search of the best protective

Figure 6.1

Maria Miranda and Norie Neumark, *Coalface*, 2013. Installation, iPhone image. Courtesy of the artists, photo by Maria Miranda.

masks to make it safe to go outside, we took video and sound, looking for and into the future.

But when we returned home from Beijing, we realized that the direction our work had actually taken was into the fog and dirt of polluted air. Still viscerally obsessed with pollution, still coughing, we looked at and listened to our material anew. We read around the subject and discovered that the particulate matter 2.5 that we experienced in Beijing, and which the AQI measured, came also from Australian coal exported to China. This became the motivator for the way the project would unfold from then on, as *Coalface*.

During a monthlong artist residency at the Library Artspace in Melbourne late in 2013, we came face to face with Australian coal in a slow and meditative process of looking, listening, and waiting to see what unfolded. Coal is a fascinating, porous, and diversiform material, itself transformed from ancient rain forest plants, called *Lepidodendron*, that covered vast areas of the world, particularly the east coast of Australia. It was

the complexity and materiality of coal with which we wanted to engage and converse.

In the first week of the project we went on a road trip to Gippsland in eastern Victoria where there are three major open-cut coal mines and power stations close together, Hazelwood, Loy Yang, and Yallourn. Talking to people around the mines, we were unsettled by the coal industry's relation to the country, the industry apprehending the soil and earth as 'overburden'—to be dug up, piled high on trucks, and abandoned like a huge pile of rubbish. As if country didn't suffer from and wouldn't remember the voice of that intruding machinery.

Back in the Library Artspace, faced with our coal, we wanted to come closer. We engaged in a daily practice of meditation with it and care for it, which included watering it, since brown coal can dry out once exposed. With particulate matter 2.5 still in our lungs we wanted to sense differently the intimate encounter we had had in Beijing. We also listened to the sound recordings of streets, parks, and subways that I had made during our stay in Beijing; we heard the way they were endlessly punctuated with coughing, my own and other people's—coughs I often didn't notice until I listened back. For the soundtrack of the installation, we developed a shuffling playlist, using the field recordings, punctuated by traffic and coughing as one of the pieces, along with all sorts of popular culture songs about coal.

Throughout our time at the Library Artspace, we found ourselves encountering coal at its most infra-, intra-, and interbodily levels. It was a face-to-face encounter, visceral and intimate. *Coalface*, we said, but whose face—ours? coal's? And so it was that our engagement with coal, from walking the streets in Beijing to the road trips to Gippsland to the work in the Library Artspace, was a sort of wayfaring, listening to coal telling us things. And so it was that, face to face with coal, we listened to the Beijing coughs as new materialist voicings of the assemblage I described in the introduction. Each day as we worked on the installation, with the playlist to animate us, we listened to the coughs give voice to the assemblage and to the need to engage with all the ethical, political, emotional, and aesthetic concerns at the coalface back in Australia. And this work in the end also brings me back to the beginning and Yoko Ono's *Cough Piece*, which was, of course, one of the pieces that comprised the playlist in the installation.

Coalface turned out to be very timely, even more so as time passed. In Australia, in September 2014 the Hazelwood coal mine, which we visited

on our road trip, began to burn, spewing out dangerous pollution across the countryside, including nearby towns. Residents had to be evacuated. Each night I listened to residents coughing on the news. Coal was polluting the atmosphere, in their air and on the airwaves. And in China, too, the silence around pollution has lifted and pollution is now being recognized as a hazard rather than some sort of random weather event. As I watched the news and remembered listening to coughing residents of Beijing and East Gippsland in Australia, I involuntarily coughed—remembering the feeling of that pollution in my own body. And now in Australia in 2016, where we are witnessing how coal continues to dominate our economic discourse and government policies, I sense in my coughing body how very entangled are voice and politics.

Silences and the hauntings of voice

Silence has haunted this book, as it does the speaking voice. This was long ago figured by François Rabelais, whose Panurge and Pantagruel encountered frozen words and deeds—an encounter famous within sound studies and prescient for new materialism. This is an enchanting encounter—where voice and sound are visible and palpable to the touch and where words frozen in winter melt in spring into noisy voice and action:

Then the words and cries of men and women, the hacking, slashing, and hewing of battle-axes, the shocking, knocking, and jolting of armors and harnesses, the neighing of horses, and all other martial din and noise, froze in the air; and now, the rigor of the winter being over, by the succeeding serenity and warmth of the weather they melt and are heard.

… I think I have read that, on the edge of the mountain on which Moses received the Judaic law, the people saw the voices sensibly. Here, here, said Pantagruel, here are some that are not yet thawed. He then threw us on the deck whole handfuls of frozen words, which seemed to us like your rough sugar-plums, of many colors, like those used in heraldry … and when we had somewhat warmed them between our hands, they melted like snow, and we really heard them, but could not understand them, for it was a barbarous gibberish. One of them only, that was pretty big, having been warmed between Friar John's hands, gave a sound much like that of chestnuts when they are thrown into the fire without being first cut, which made us all start. This was the report of a field-piece in its time, cried Friar John.

… When they had been all melted together, we heard a strange noise, hin, hin, hin, hin, his, tick, tock, taack, bredelinbrededack, frr, frr, frr, bou, bou, bou, bou, bou, bou, bou, bou, track, track, trr, trr, trr, trrr, trrrrrr, on, on, on, on, on, on,

ououououon, gog, magog, and I do not know what other barbarous words, which the pilot said were the noise made by the charging squadrons, the shock and neighing of horses. (Rabelais 2014, chapter 56, 1)

Silence and shadows

As I come to the end of writing this final chapter, I serendipitously encounter a powerful exhibition at the Art Gallery of New South Wales entitled "When Silence Falls" (2016). Curated by Indigenous curator Cara Pinchbeck, the exhibition presents works by many Indigenous Australian artists, as well as others concerned with the silence that falls after violence. I go to the exhibition hoping to think about the voice of silence, which has hovered, mostly silently, occasionally speaking out, within the pages of this book—to think about how silence speaks. It was John Cage, of course, who listened so acutely to 'silence,' in his work and in his "Lecture on Nothing," which was a centerpiece of his book *Silence* (1939). This lecture, a beautiful and evocative piece of writing, expressed his thinking on silence conceptually, musically, and rhythmically; it was "printed in four columns to facilitate rhythmic reading" (Cage 1973, 109). As I encounter the text now, I am struck again by a profound apprehension of the silence of saying and not saying and between saying. I have to resist the desire to reprint the whole lecture or even just the first page and will simply try to reproduce a few lines which go over pages one and two, with apologies for the changes of spacing in this rendering:

```
    This space of time                           is organized
          We need not fear these       silences,—

we may love them      .                       This is a composed
talk              ,          for I am making it
      just as I make        a piece of music.        It is like a glass
      of milk    .                We need the      glass
and we need the   milk            .        Or again    it is like an
empty glass                into which                    at any
moment              anything              may be poured
```

As I type and read, as I type and listen, I marvel at how Cage co-composes a talk, music, and a glass of milk so that they may speak together of the fullness, the polyphony if you will, of silence. It is so full of potential that "at any moment" it may be actualized—or perhaps more than, different from

actualized—*listened to* in its present/absent fullness. And at the same time, time being of the essence for Cage here, I recall, of course, his influential work *4′33″* which borders on conceptual art, sound art, music, and, I would say, voice. It is a paradoxical work, performing all at the same time, performing them as and through silence. I listen to it as voiced by the fullness in the room, though I am aware that for many this is a 'musical' silence, driven by a 'score.'[3] But while many in sound studies worry that the work ultimately recuperates sound into music, I still find myself listening to this work as challenging any binary sense of what is music and what is sound, what is music and what is sound art, what is sound and what is silence, what is noise and what is signal. Indeed, if listened to with the attunements of new materialism and attention to the voicings of place, *4′33″* enlivens a sense of a silence that is able to voice itself, indeed always/already does, expressing place and memory and absence and presence at the same moment.

Remembering Don Ihde's ethical sense of the silence (replete with imagining) which listening, and then speaking, must respect (Ihde 2007, 180 and passim) and Salomé Voegelin's evocation that "silence is not the absence of sound but the beginning of listening" (Voegelin 2010, 83), I return to the silence in the exhibition "When Silence Falls." Here I come face to face, ear to ear, with a silence that resounds with a different plenitude, as it speaks, its curator explains, of the violence of "often unacknowledged events—massacres, ethnic cleansing, cultural displacement, political force—and provide[s] a voice for those who have been silenced" (Pinchbeck 2015, 3). Within a silence alive with suppressed (but irrepressible) voices and memories, I listen, as Pinchbeck invites, to a present absence and absent presence. I encounter works, images, and objects that remember those voices in country and of country, just as shadows remember light. This is silence resonating with the memory of country and of which country speaks in many of these works.

Pinchbeck calls the first room of the exhibition "country remains," and my ears are immediately and painfully pricked when I feel the atmosphere in the room. It is here that I encounter Indigenous artist Judy Watson's *Internal landscape* (1993)—a work animated by "whisperings of the past ... the indelible stain left on country by past events" (Pinchbeck 2015, 3). This beautifully subtle and disturbing work will be the final one that I will listen to in this book. As in much of her work, Watson is concerned here to

uncover hidden violence and massacres in her mother's and grandmother's country. In this work, it was a horrific event in 1883 "when the ears of massacred Aboriginal people were nailed to a wall at Lilydale Station near her family's country at Lawn Hill in Queensland" (Pinchbeck 2015, 4). Just as these events are hidden in official history, story and memory are, at first glance, (purposefully) also hidden in this gold-leafed, beautiful work. As curator Pinchbeck puts it, the massacres of which this work speaks and which I listen to through it were so horrific that Watson worked to disguise them within its rich textures to get past our conscious resistance to recognizing the voices of history (Pinchbeck 2015, 4). But recognize them I must, encountering this work as it speaks, calling out for me to listen, to listen in another way.

In the canvas pinned to the wall, Watson worked with figures of spears for the pins, which for her were not just pins but also "a bit like ears, listening devices, speakers." "Like a deadly poisonous dart" they pierce any resistance to listen to these painful memories. "For Watson," Pinchbeck continues, "these listening devices became an active presence in the landscape" (Pinchbeck 2015, 4). *Listening devices. Speakers. Deadly darts. Ears nailed to a wall.* Watson's work reimagines the anodyne figure of "pricking of ears" into a painful new actuality, opening me to listen to new intensities of the literal and metaphoric voice of country and memory. Her *listening devices* attune me to bloodied, full-throated silence, awakening my own listening to the absent presences, the noisy textured silences in country and its haunted voices. I'm stunned into silence by this work's, and the exhibition's, silent voicetracks, the voicetracks of silence. I am stopped in my tracks.

The write voice for the final word

I'd like to end this book, as I began, with the question of the write voice. From the vantage point of a final chapter, I have to say that in many ways it has been the media's and artworks' voices themselves that have provoked my writing voice. In the second chapter, I responded to the voices of animals calling forth a sympathetic, companionable writing, incited by their own affects and emotions. In the third chapter as I wayfared along the voicetracks of place, it was a sense of being grounded that tinctured my writing. In chapter 4, the voices of technology began to dislocate and

Figure 6.2
Judy Watson, *Internal landscape*, 1993. Synthetic polymer paint, gold leaf on canvas. Art Gallery of New South Wales, Purchased 1994. © Judy Watson. Licensed by Viscopy, Australia. Photo by Art Gallery of New South Wales.

disturb my write voice, and in the following chapter I found myself quite unhinged and writing frantically as I listened to unvoiced works, driven to questions upon questions. And now in this final chapter, I find that I have tracked back and come full circle in a way, as my write voice has been affected by memories: first there were the memories of voices and voice-tracks in my own artwork, and then the memories that spoke within the silences of others' works. And so in the end, as in the beginning, I sense that the write voice is the voice that writes itself, from where it is situated.

My concern here has been to find a way to write attuned by new materialism—to express my preference for new materialism by putting it to work, making it work for me, rather than arguing against other approaches. In following this track, encountering media and contemporary artworks, I have found that new materialism articulates volubly with animal studies and sound and voice studies—and that it speaks to feminist and other political and ethical concerns that are important to me, and, I believe, to the posthumanist era that we are all in together.

And so, speaking of politics and ethics, and why I have engaged in these conversations, let me return one last time to the enchantment and wayfaring of Jane Bennett and Tim Ingold—two of the many important and generous thinkers, along with artists, who have guided my listening and writing. I hope that after this reading—this wayfaring along the voicetracks in media and contemporary art—you, like I, come away with a sense that an engagement with voice can animate and intensify a sense of enchantment with the world. As animals, people, and things in the world have spoken here, I hope that they have been able to evoke a sense of the companionable and ethical connections and relations with all these others and in turn perhaps even open up possibilities of new ways of experiencing and engaging with the world through attuning to its voices.

Notes

Chapter 1

1. The debates within and around posthumanism and new materialism are extensive, as I return to in the section on new materialism below. For now, I will note that I am using posthumanism to refer to an era or context—a context in which theories of new materialism, object-oriented ontology, speculative realism, the more-than-human, and posthumanism itself signal an awareness of the need to move beyond anthropocentric thinking, aesthetics, ethics, and politics. (For this reason, like Dolphijn and van der Tuin (2012), I include theorists such as Rosi Braidotti and Karen Barad within new materialism.) While this does not necessarily accord with all those who adhere to posthumanism, I hope it is productive. What is interesting for my purposes here, though, is that voice speaks across many of these approaches, despite their differences. Timothy Morton, for instance, writing about *hyperobjects* reckons that artist Tara Donovan's plastic cups "are 'saying' something beyond their human use: something unspeakable for a human" (Morton 2013, 114).

2. The question of voice, presence, and absence, raised by Jacques Derrida, was responded to by Adriana Caverero (2005), as I discuss elsewhere (Neumark 2010b).

3. Erin Manning distinguishes more-than-human from more-than human: "For me, the more-than-human is a way of making operative ways of thinking the non-human without excising the force of human complicity from these worldlings. When I speak of the more-than human, I am focusing on the realm of the human, emphasizing that the category of the human is always modulated and affected by the more-than" (Manning 2016, 233–234). Although I agree with her point, I prefer to assume it when I use the term human, rather than repeat the hyphenating qualifier.

4. Voice studies has become recognized as a distinct area of study in the past decade. For example see Thomaidis and Macpherson (2015) and the *Journal of Interdisciplinary Voice Studies*, which they also edit (http://www.intellectbooks.co.uk/journals/view-Journal,id=248/). See also Neumark, Gibson, and van Leeuwen (2010).

5. Anna Gibbs in personal correspondence, March 2016.

6. See, for instance, Shouse (2005), Massumi (n.d.), and Gregg and Seigworth (2010). Anna Gibbs elaborates on the debates in affect theory, noting particularly the value of Silvan Tomkin's work for adding to Spinozan-Deleuzian approaches (Gibbs 2010).

7. Sara Ahmed's important work, which attends particularly to these performances, speaks to this blurring, in that she sometimes speaks of emotion and sometimes of affect. Generally, however, Ahmed is clear that she prefers the (more social) concept of emotion rather than affect to do this cultural and political thinking (Ahmed 2004). See also Antonia Hirsch (2001, 13).

8. I elaborated these in Neumark 2010 (a and b) and have used some of that material here.

9. As k-punk puts it, "It is not accidental that the word 'haunting' often refers to that which inhabits us but which we cannot ever grasp; we find 'haunting' precisely those Things which lurk at the back of our mind, on the tip of our tongue, just out of reach" (cited in Neumark 2010b, xviii). I return to k-punk's haunting in chapter 5.

10. In personal conversation and email in response to a draft of this chapter.

11. As Silverman put it, voice "is capable of being internalized at the same time as it is externalized, it can spill over from subject to object and object to subject, violating the bodily limits upon which classic subjectivity depends" (cited in LaBelle 2006, 63).

12. On the transversality of new materialism, see Dolphijn and van der Tuin (2012), particularly chapter 5.

13. In this I take my cue from Rick Dolphijn and Iris van der Tuin, who work with what they figure as transversal new materialism, even when interviewing significant theorists of posthumanism such as Braidotti and Barad (Dolphijn and van der Tuin 2012). See also Åsberg, Koobak, and Johnson (2011).

14. Creative practice as thinking and knowledge has been well developed in Australia (particularly in Melbourne, I note with interest) thanks to the seminal texts of Estelle Barrett and Barbara Bolt (2007), Lesley Duxbury, Elizabeth Grierson, and Dianne Waite (2008), and Paul Carter (2004), among others such as Lyndal Jones and Laura Brearley (Grierson and Brearley 2009). The work of Erin Manning and Brian Massumi and the 'immediations' of the SenseLab at Concordia University in Montreal, Canada, have been crucial in these developing practices and understandings (see, for instance, Manning and Massumi 2014).

15. For Ingold the figure of *meshwork* suggests a web of becoming, where things are the lines of force, immersed in their medium (Ingold 2011, 63, 70–72, 89–94; Ingold 2007, 80–81, 101–103). Following Ingold, I, too, tend to shy away from the term

"network." I would say, though, aside from issues about this term, that I don't read Ingold's and Latour's approaches as so radically opposed. To me it is often more a question of orientation than of fundamental difference.

16. See for example, Ingold (2011), 89–94.

17. I discuss this further in Neumark (2015a).

18. I encountered these notions of alchemy while making a radiophonic essay work, *Separation Anxiety: Not the Truth about Alchemy* (Neumark 1996).

19. This discussion of the fictive and the 'pataphysical is elaborated in Miranda (2003).

20. To track AQI, you can get an app on your phone, as we did.

21. Elsewhere Haraway (Haraway and Goodeve 2000, 66–67) does worry about the term "conversation," worrying about its humanist and anthropomorphizing implications through its links to speech. I nevertheless hope that my new materialist deployment of the term would have allayed her concerns.

22. Relationality is intricately connected with ethics and politics for feminists like Jane Bennett, who "contest[s] the critique of relationism offered by Graham Harman and Timothy Morton" (Bennett 2012, 225). Bennett's article provides a most useful entry into the debates between them. For a different approach to ethics, through the 'aloof,' 'withdrawn' objects of object-oriented ontology, see Introna (2009).

23. The situation she spoke about was one where, worried about the ethical and political implications of her own institutional role at her university in dealing with corporations, Rendell "challenged UCL's decision to form a partnership with the mining corporation BHP Billiton and accept $10 million of funding to create two new Institutes: the Institute for Sustainable Resources (the ISR) in London, UK and an International Energy Policy Institute in Adelaide, Australia, and to position the ISR in the Bartlett Faculty of the Built Environment of which I was at the time Vice Dean of Research" (Rendell 2014).

24. My Danish colleague, an important sound and voice theorist herself, Ansa Lønstrup, has pointed out that the term "conversation" could sound somewhat banal to Danish speakers. Her conversation about conversation has helped me recognize the very different inflection it has in Australia, where it has become a valued figure especially for artists engaged in relational and social practice as well as for academics working across disciplines, as a way to signal how this transversal work happens.

25. While Erin Manning is not talking about conversation per se in her keynote address, I find that her understandings about art help me recognize the artfulness of conversation (which is quite distinct from the traditional art of conversation) (Manning 2015).

26. In developing the figure of voicetrack, I am distinguishing this broader concept from vocal tracks, which have been importantly analyzed in relation to performance and technologies across media by Jacob Smith (2008).

27. Steven Connor (2015), who has written some of the most provocative and richly researched works on voice, recently questioned the tendencies of sound studies to dismiss other senses—particularly vision—as if the senses are, somehow and ultimately, separable. While I might not agree with all Connor's dismissals (of the phenomenology of listening, for example) in this provocative lecture, I certainly do respond to his unwillingness to simply reverse the vision/hearing hierarchy, rather than undo hierarchies and separations altogether. Further, I share his cultural historian's concern to hold on to dreamwork and magical thinking—the acousmania—in the experience of sound and voice (Connor 2015, passim, especially 10 of pdf). In a way, I would hope (as Ansa Lønstrup has suggested to me) that some of his concerns might be answered by my project here, which focuses on voice (rather than sound per se) and which entangles phenomenology with new materialism. Both are interwoven with memory and imagination through my methodology of listening and conversation (always/already situated in, and haunted by, time, history, and memory).

Chapter 2

1. See, for example, Barad (2003), 801.

2. Christian Marclay's incisive and enchanting remix demonstrates this, over and over (Marclay 1995).

3. "Becoming is to emit particles that take on certain relations of movement and rest because they enter a particular zone of proximity. Or, it is to emit particles that enter that zone because they take on those relations. ... [This is] a proximity 'that makes it impossible to say where the boundary between the human and the animal lies'" (Deleuze and Guattari 1987, 273). In this zone of proximity, the "terms of a becoming do not exchange places" nor identify (Deleuze and Guattari 1987, 306); they infect each other, in a contagion.

4. Neumark (1999b). I have condensed the story here, transcribing it in keeping with this written context, as compared to the more fluid radiophonic context for which it was recorded—while still trying to keep the feel of my friend's spoken, story-telling voice.

5. While sound and voice are not her particular concerns, Pick does suggest a vocative aspect of creaturely aesthetics and ethics when she discusses Vladimir Tyulkin's film *About Love*. Attending to the "living voice" of the wailing, mourning dogs, Pick writes about it as "a film about vocare: vocation and voice" (Pick 2011a, 117–118). To me this voice, this "living voice," echoes Kitty's kitty.

6. See also Koivunen 2001 and the *Affective Encounters* conference proceedings that she introduces.

7. I engage with this in a radiophonic essay (Neumark 1999a). See also Connor (2000), 3.

8. See, for example, his *Dogs That Know When Their Owners Are Coming Home: The Unexplained Powers of Animals* (Sheldrake 1999).

9. It's interesting, as Steve Baker reminds us, that Deleuze and Guattari responded to Hitchcock's doing birds not as imitation but as "an electronic sound like a field of intensities or a wave of vibrations, a continuous variation, like a terrible threat welling up inside us" (Baker 2000, 140; Deleuze and Guattari 1987, 305).

10. My concern here is neither to cavil against nor to recuperate Heidegger, whose language/thinking-centered sense of *Dasein* seems for many to close him to hearing the voices of animals and other nonhumans (Wolfe 2003, chapter 2). For Cary Wolfe, for instance, there is an abyss between Derrida and Heidegger in relation to animals and being, having to do with language and speech and the ability to speak "phenomenality as such." For Wolfe, Derrida, unlike Heidegger, refuses to generalize or homogenize the animal into animals in general (Wolfe 2003, 65–66). As he puts it:

The idea according to which man is the only speaking being, in the traditional form or in its Heideggerian form, seems to me at once indisplaceable and highly problematic. Of course if one defines language in such a way that it is reserved for what we call man, what is there to say? But if one reinscribes language in a network of possibilities that do not merely encompass it but mark it irreducibly from the inside, everything changes. I am thinking in particular of the mark in general, of the trace, of iterability, of *différance*. (Derrida cited in Wolfe 2003, 73)

11. The location was Stephen Mclaughlan Gallery.

12. The human collaborating performers were Jenny Barnes, Vanessa Chapple, Martina Copley, Viv Corringham, and Susan Pyke. They can be heard with their bird collaborators at http://www.ciclover.com/shooting.html.

13. Or perhaps it is even a Levinasian face? I would note that there is much debate around the question of Levinas's otherness and animals, and the way that he, in a humanist gesture, denied the animal a face; but this is a debate within philosophy that I cannot enter here.

14. See below, chapter 3, for discussion of Rose and Taylor's Fences Project.

15. From Wittgenstein's *Philosophical Investigations*, cited, for example by Wolfe (2003, 10).

16. As such, it is perhaps a far cry from what Alexandra Supper calls the experience of an "auditory sublime" sought after by so many art-science sonifications, to which I return in chapter 4 (Supper 2014).

Chapter 3

1. Jane Bennett, too, is drawn to Thoreau's work, which she reads through her ethical concerns and her attention to enchantment. She is attuned to Thoreau's sensibility, including "a deliberate and vivid way and practices of seeing, hearing, touching, smelling, and moving," which he cultivates through "a series of techniques of the self" (Bennett 2001, 95; see also 92–94 and Bennett 2010, 45–49).

2. A fascinating but more ontological way into vibration is postulated by Marcus Boon, whom I met during a sound-themed residency at the Society for the Humanities, Cornell University, in 2012, where he introduced the ideas of his forthcoming book *The Politics of Vibration*. Boon summed up this project in the *Sounding Out!* blog in 2013: "What borders remain when it comes to thinking about sound today? The field of sound studies has exploded in so many far-flung directions in the last few years. However, I argue that what is still somewhat off limits in the field is a consideration of the ontological status of sound: in other words, what it means to understand our own being in the world as a sonic phenomenon. Out of attempts to approach this sonic ontology, comes the realization that there are prohibitions, perhaps universal ones, on thinking about sound in this way, and from that emerges what I call the politics of vibration" (Boon 2013). Another participant in that residency, musicologist Nina Sun Eidsheim, was also moved by the power of vibrational thinking—in her case in relation to music and singing. In her recent important monograph *Sensing Sound: Singing and Listening as Vibrational Practice*, Eidsheim foregrounds vibration as a way into the multisensory and relational "thick event" of singing—for singer and listener. Of particular interest to my project here, Eidsheim notes that a vibrational approach to music enables a "dialogue" with new materialism as "vibration provides a route for thinking about fluidity and distribution that does not distinguish between or across media, and a portal for communicating beyond physical boundaries" (Eidsheim 2015, 16).

3. Another significant figure in this distinctive Australian phenomenon is Alan Lamb, along with Sarah Last and her interdisciplinary artist-led organization, Wired Lab, in rural New South Wales: "The installation of Wire instruments at The Wired Lab was established as a means to develop and further investigate aeolian harp phenomena pioneered by Australian sound art icon and all round polymath Dr Alan Lamb. Lamb has, for many years, been recording wires in the environment, both pre-existing (eg; derelict telegraph wires, fences etc) and constructed. This has resulted in several highly acclaimed releases, perhaps most notably *Night Passage* and film soundtracks. The WIRED Lab was established to expand and proliferate Lamb's legacy, and exemplify the possibilities rather than the limitations of regionally based art practices" (Wired Lab n.d.). See also Douglas Kahn's discussion of the history of artists working with fences in art and radio (Kahn 2013, 243–244).

4. I interviewed Jon Rose and Hollis Taylor for "Enchanted Voices: Voice in Australian Sound Art" (Neumark 2015a) and reproduce some of that material here.

5. Helen Grace, personal email to the author, August 30, 2011.

6. I reviewed the 2015 La Mama production for *RealTime* (http://www.realtimearts .net/article/127/11966). It has been documented on Vimeo (https://vimeo.com/ 93047802; https://vimeo.com/150974504).

7. One of the ways the project works is to host various other art projects, as the website explains (Jones n.d.).

8. This resonates with the moment where "the mute object does not reveal its own voice, it must be given voice … in its situated context" (Ihde 2007, 67, 73).

9. Personal conversations in Aarhus, Denmark, Spring 2014.

10. Hansen's work *The Sound of …* is online at http://www.ejdruphansen.dk/ the-sound-of/.

11. Personal conversations in Aarhus, Denmark, Spring 2014.

12. With the figure of *unsitely*, Maria Miranda discusses the complex relationships between works located in actual physical sites and works online, proposing that for the latter the sitedness of the audience engaging with them adds a further important dimension (Miranda 2013).

13. In another work, *Lys*, Hansen begins by saying to her assistant: "Film what you hear. Tape-record what you see." Her aim in that work, she explains to me in conversation, is for people to *see* their voices. This is not so much about visualizing voice or sonifying lines but evoking, through voice, the plurality and multimodality of the senses (personal conversations in Aarhus, Denmark, Spring 2014).

14. An excerpt of *Alter Bahnhof Walk* is at https://www.youtube.com/watch?v=sOkQ E7m31Pw&feature=kp.

15. For valuable discussion of Cardiff's work, see also Kim-Cohen 2009, 119, 222–224.

16. Filipa Matos Wunderlich discusses the different approaches to walking works, calling the sort of work Cardiff makes "conceptual walking." With conceptual walking, she says, artists make work which unfixes place, making it strange, evoking its uncanny side and shifting attention to what we don't normally see or hear in a place (Wunderlich 2008).

17. Personal conversation in Sydney, Australia, January 2016.

Chapter 4

1. The workings of the technologies of the amplification of voice, the microphone, megaphone, and loudspeaker, are certainly not transparent. As Steven Connor argues from a cultural historical perspective, "The technologies of the voice are actualizations of fantasies and desires concerning the voice, which predate the actual technologies. At the same time, the technologies which appear to familiarize the dissociated voice also revive some of the powers of the uncanny and the excessive with which the dissociated voice has long been associated" (Connor 2000, 40; see also 33–34, 38, 43). Although I suspect that from a media archaeological perspective some might question which comes first, Connor's recognition of the circulation of desires concerning voice and technologies is important.

2. The work was installed at the Mission for Seafarers, Melbourne, Australia, as part of Liquid Architecture 2015. Frances Dyson also presented a paper at the event in which she discussed the People's Microphone at Occupy events, which she elaborates in *The Tone of Our Times* (Dyson 2014).

3. For a discussion of the concept of media voices, particularly radio, as disembodied voices, see Neumark 2010b, xvii–xviii.

4. As a composer, making work and writing a very thought-provoking PhD dissertation about it, van Eck's concern is with microphones and loudspeakers that are used by musicians or sound artists as musical instruments. This means she listens to and works with them as sounding music, rather than sounding voice. When she speaks about an instrument's voice, she puts it in quotation marks. Nonetheless, I find her arguments can be extended and useful to think about voice in the context of new materialism, as I have tried to do here.

5. I am indebted to conversations in the spring of 2014 in Aarhus, Denmark, with Thomas Bjørnsten about sonification and to his writings that present artistic work being done with sonification, for example by Graham Harwood. Bjørnsten studies works that differ from the usual sonifications which I object to here, in that his examples work with data as an affordance for creative, avant-garde art. Bjørnsten argues that these particular sonifications work through "a truly explorative methodology for engaging with data beyond standardized software interfaces and algorithms in ways that we may use as an inspiration for thinking more imaginatively about both artistically- and academically-situated research work based on sonification processes" (Bjørnsten 2015).

6. Neumark (2010a); Neumark and Štromajer (2013).

7. The material here on Štromajer reworks material in Neumark (2010a) through a new materialist reading. His works are available online at intima.org.

8. It was performed live at SeaFair, Skopje Museum for Contemporary Art, Macedonia, 1998; Transmediale, Cultural Center Podewill, Berlin, Germany, 1999; and Opera SNG, Ljubljana, Slovenia, 1999. The work is archived online at Štromajer (n.d. (b)).

9. I discussed this in Neumark (2010a).

10. Some of these moments recall Jenny Holzer, as when, for instance, "I know the truth hearts" goes clacking across the screen in LED lights.

11. This is also evident in his *Steam Machine Music* https://www.youtube.com/watch?v=uYwg7tWB_MU. *Opaque Sounding* is available online at https://www.youtube.com/watch?v=nzybYC5nqJM.

12. Robotic art is now making a big and different comeback with art-science and in the context of posthumanism.

13. As Rinaldo says, *Autopoiesis* is named after a concept developed by Humberto Maturana and Francisco Varela, in what Katherine Hayles calls the "second wave" of cybernetics. With the concept of autopoiesis, Maturana and Varela "probed deeply into what it means to acknowledge that the observer ... does not so much discern preexisting systems as create them through the very act of observation" (Hayles 1999, 131). Hayles explains that in autopoietic processes, "the observer can observe only because the observer is structurally coupled to the phenomenon she sees" (Hayles 1999, 142).

14. See also Birringer's discussions in the Empyre list, November 2007 (Birringer 2007a).

15. "Circuit bending is the creative, DIY (Do It Yourself) short-circuiting of electronic devices such as low voltage, battery-powered guitar effects, children's toys and small digital synthesizers to create new musical instruments and sound generators." Wikipedia, http://en.wikipedia.org/wiki/Circuit_bending, accessed April 22, 2008.

16. Farman made this work with a number of artists who collaborated on different pieces within the work: "The Dashboard," a soundwork put together by Anna Gibbs with Brad Clinch and Helen Britton; "The Fender," with Brad Clinch (electronics and sound) and Helen Britton (surfaces); "Rear Vision" (car door), with Brad Clinch and Helen Britton; "The Car Trunk," with Brad Clinch, Helen Britton, and Ros Bandt; "The Sound of a Rusty Car Disintegrating," a soundwork with Ros Bandt and Brad Clinch.

17. Gibbs notes, in email conversation, the valuable role of sound artist Sherre DeLys in realizing this work: for instance, "I remember involved discussions about the different qualities and textures of static. I wanted the sense that the radio was restlessly searching the ether, finding things but unable to fix on anything, and for the things it found to obliquely reference that and aspects of car culture more

generally, also to actively interpellate the listener without direct address" (email, March 9, 2016).

18. Gibbs made these comments in the email cited above, in the spirit of adding another memory piece to the puzzle of a documentation in pieces that I was exploring with *Carsick*.

Chapter 5

1. In this chapter I use the more all-encompassing "soundtrack" along with or in place of "voicetrack" when I want to draw attention to the more traditional soundtrack/image track relationship. In this sense I am using "soundtrack" to encompass "voicetrack" but also to remind us of that traditional term.

2. *un Magazine*'s first editorial explains: "Our mission is to provide a discourse for work that is not normally reviewed. un Magazine will also allow emerging and established writers to publish unpredictable articles and to create an archive for our time. un Magazine will not suffer from the imposition of thematic editions; because art is not like fashion and we don't need to forecast trends. Each issue will be a reflection of the artwork that is actually out there, in galleries, studios and on the street" (Hibberd, 2004).

3. "It is always ambiguous, or more accurately 'undecidable', whether the supplement adds itself and 'is a plenitude enriching another plenitude, the fullest measure of presence', or whether 'the supplement supplements … adds only to replace … represents and makes an image … its place is assigned in the structure by the mark of an emptiness' (OG [*Of Grammatology*] 144). Ultimately, Derrida suggests that the supplement is both of these things, accretion and substitution (OG 200), which means that the supplement is 'not a signified more than a signifier, a representer than a presence, a writing than a speech' (OG 315). It comes before all such modalities" (Reynolds n.d.).

4. "Ekphrasis or ecphrasis … In ancient times, it referred to a description of any thing, person, or experience. The word comes from the Greek *ek* and φράσις *phrásis*, 'out' and 'speak' respectively, and the verb ἐκφράζειν *ekphrázein*, 'to proclaim or call an inanimate object by name'. … Ekphrasis has been considered generally to be a rhetorical device in which one medium of art tries to relate to another medium by defining and describing its essence and form, and in doing so, relate more directly to the audience, through its illuminative liveliness" (Wikipedia 2015).

5. Accessible on the Internet at https://vimeo.com/136163175.

6. My thinking about the role of sound (beyond human voice and music) in affectively imbricating the audience in film has benefited greatly from discussions with Eloise Ross and reading her PhD dissertation (Ross 2016).

7. Elaborating on her category of "interesting," Ngai cites William James: "Millions of items of the outward order are present to my sense which never properly enter into my experience. Why? Because they have no interest for me. My experience is what I agree to attend to. … Interest alone gives accent and emphasis, light and shade, background and foreground—intelligible perspective, in a word" (Ngai 2012 129).

8. While, as Mark Amerika has explored (Amerika 2011), remix is not new, with digital and especially Web 2.0 works, it plays out in ways that invite unvoiced approaches.

9. Speaking of dubbing films, both Daniel Warner and John Tebbutt have reminded me of the Italian habit of using well-known actors to dub films. This play between a local, familiar voice and a foreign body becomes (more or less) taken for granted, comfortable, expected. What I'm attuned to with unvoicing (as compared to that sort of dubbing, revoicing, or voice-over) is when the familiar becomes disturbed, unfamiliar, uneasy, uncanny.

10. The question of what happens when dubbing a particularly animated speaker into another language reminds me of watching Auslan (Australian Sign Language) signers in situations with non-native English speakers. I've been struck by how the signer's animation can contrast the flat, second-language English of the speaker. At times this gives a sense of double levels of translation, a dual not a mirror image, where the signer has more affect than the speaker—especially when signing emotive terms that are being delivered in a flat voice by the speaker, their voice flattened by speaking not their native language. In a palpable way this unvoicing reminds me that signing is indeed another language and as such has its own things to say (Sacks 1989).

11. Notes provided to me by TV Moore, April 2012.

12. *Inhabiting* is a figure that both Nicolas Bourriaud (2002) and Mark Amerika (2011) elaborate as emblematic of postproduction and remix culture. And haunting, as figured by Derrida, is also particularly apt here—residing as it does on the tip of the tongue, as discussed in chapter 1.

13. Brown Council (sometimes known as BC or Barbara Cleveland Institute or BC Institute) is a collaboration, based in Sydney, Australia, comprised of Frances Barrett, Kate Blackmore, Kelly Doley, and Diana Smith. They have worked together since 2007 making performance and video works "that straddle the contexts of gallery and stage, and draw on the historical lineages of both the visual and performing arts. Their work engages with concepts of spectacle and endurance, as well as the dialogue between 'liveness' and the performance document or trace" (Mass Action n.d.).

14. Accessible online at Brown Council 2011a. The installation is documented at Brown Council 2011b.

15. For more on laugh tracks, see Neumark 2010b.

16. The videos are accessible online, for instance, at https://www.youtube.com/watch?v=0M7ibPk37_U. Actually Henri also has his own Facebook page, Twitter feed, and store.

17. The music was by Radiohead, Sigur Ros, Atlas Sound, Tim Hecker, and Grouper. The story was written by J. B. MacKinnon.

18. Ansa Lønstrup in email correspondence with the author, February 2016.

19. Email exchange with the artist, December 11, 2015.

Chapter 6

1. Attention to human voice in general, and in relation to art and media, of course is not new, with a number of recent publications speaking particularly to interdisciplinarity. As I discussed in the introduction, Steven Connor, Brandon LaBelle, Adriana Cavarero, Mladen Dolar, and Ansa Lønstrup are among important recent scholars of voice, while earlier the field was opened, in very different ways, by Don Ihde and Jacques Derrida. My own coedited volume *Voice* also contributed to the development of the field, and more recently we have seen the publication of a *Voice Studies* anthology and *Journal of Interdisciplinary Voice Studies*.

2. Jane Rendell explains that "through the act of walking new connections are made and re-made, physically and conceptually over time and through space. Public concerns and private fantasies, past events and future imaginings, are brought into the here and now, into a relationship that is both sequential and simultaneous. Walking is a way of at once discovering and transforming the city" (Rendell 2006, 153).

3. Salomé Voegelin, for instance, argues strongly about the musical timing which frames the listening to silence in Cage's work—which she therefore apprehends as musical silence (Voegelin 2010, 79–81). I am, however, more attuned to Brandon LaBelle's particular listening (which he differentiates from Douglas Kahn's influential view that *4'33"* problematically recuperates noise and sound back into music): "It seems important here to underscore the contextual situation of *4'33"*, for the work was self-consciously 'written' so as to converse with music through its performance in a concert setting … producing a musical situation in which silence and noise, music and the social, may intersect and destabilize each other" (LaBelle 2006, 15). See also Seth Kim-Cohen's valuable discussion of the piece in Kim-Cohen (2009, passim, especially chapter 6).

References

Ahmed, Sara. 2001. "Communities that Feel: Intensity, Difference and Attachment." In Anu Koivunen and Susanna Paasonen, eds., *Affective Encounters: Rethinking Embodiment in Feminist Media Studies: Conference Proceedings*. Turku: University of Turku, School of Art.

Ahmed, Sara. 2004. *The Cultural Politics of Emotion*. London: Routledge.

Amerika, Mark. 2011. *Remix the Book*. Minneapolis: University of Minnesota Press.

Angelucci, Malcolm, and Chris Caines, eds. 2014. *Voice/Presence/Absence: An Interdisciplinary Dialogue on Voice and the Humanities*. Sydney: UTS ePress. https://epress.lib.uts.edu.au/books/voicepresenceabsence. Accessed December 2015.

Arrhenius, Sara, Susan Philipsz, James Lingwood, and Brigitte Franzen, eds. 2014. *Susan Philipsz: You Are Not Alone*. New York: Distributed Art Pub.

Åsberg, Cecilia, Redi Koobak, and Ericka Johnson. 2011. "Position Paper: Beyond the Humanist Imagination." *NORA* 19 (4): 280–284.

Atmo Team/Rick Silva. 2003. *Read My Lips: Bush & Blair.* https://archive.org/details/bush_blair. Accessed December 2015.

Auslander, Philip. 2006. "The Performativity of Performance Documentation." *PAJ* 84: 1–10.

Baker, Steve. 2000. *The Postmodern Animal*. London: Reaktion Books.

Baldessari, John. 1972. *Teaching a Plant the Alphabet*. http://ubu.com/film/baldessari_plant.html. Accessed October 2015.

Barad, Karen. 2003. "Posthumanist Performativity: Toward an Understanding of How Matter Comes to Matter." *Signs: Journal of Women in Culture and Society* 28 (3): 801–831.

Barad, Karen. 2012. "On Touching—The Inhuman that Therefore I Am." *differences* 23 (3).

Barad, Karen. 2015. "Ecologies of Nothingness and Troubling Time/s: On Devastation and the Im/possibilities of Endurance." Transversal Practices: Matter, Ecology and Relationality. VI International Conference on New Materialisms. Victorian College of the Arts, University of Melbourne.

Barbie Liberation Organization. 2008. https://www.youtube.com/watch?v=OVT4T7OR3iQ. Accessed November 2015.

Barrett, Estelle. 2013. "Materiality, Affect, and the Aesthetic Image." In Estelle Barrett and Barbara Bolt, eds., *Carnal Knowledge: Towards a 'New Materialism' through the Arts*. London: I. B. Tauris.

Barrett, Estelle, and Barbara Bolt, eds. 2007. *Practice as Research: Approaches to Creative Arts Enquiry*. London: I. B. Tauris.

Barrett, Estelle, and Barbara Bolt, eds. 2013. *Carnal Knowledge: Towards a 'New Materialism' through the Arts*. London: I. B. Tauris.

BC. 2013. *This Is Barbara Cleveland, 2013*. https://vimeo.com/80968002. Accessed June 2016.

Bennett, Jane. 2001. *The Enchantment of Modern Life: Attachments, Crossings and Ethics*. Princeton: Princeton University Press.

Bennett, Jane. 2010. *Vibrant Matter: A Political Ecology of Things*. Durham: Duke University Press.

Bennett, Jane. 2012. "Systems and Things: A Response to Graham Harman and Timothy Morton." *New Literary History* 43 (2): 225–233.

Bernstein, Richard. 2013. "The Pragmatic Turn: A Lecture by Selzer Philosopher Richard J. Bernstein." https://www.youtube.com/watch?v=gtc2SdIWErc. Accessed November 2014.

Bilal, Wafaa. 2010. *and Counting* …. http://wafaabilal.com/and-counting/. Accessed November 2015.

Bilal, Wafaa, Amy Goodman, and Anjali Kamat. 2010. "105,000 Tattoos: Iraqi Artist Wafaa Bilal Turns His Own Body into a Canvas to Commemorate Dead Iraqis & Americans." *Democracy Now*. http://www.democracynow.org/2010/3/9/105_000_tattoos_iraqi_artist_wafaa. Accessed November 2015.

Birringer, Johannes. 2007a. *Empyre*, November 29, 2007. https://lists.cofa.unsw.edu.au/pipermail/empyre/2007-November/000170.html. Accessed November 2007.

Birringer, Johannes. 2007b. "The Robot Often Cries. Why Shouldn't You?" *CYNETart, Trans-Media-Akademie Hellerau*, Dresden, Germany, November 2007. http://body-bytes.de/02/?p=520&language=en. Accessed November 2007.

Bjørnsten, Thomas. 2015. "From Particle Data to Particular Sounds: Reflections on the Affordances of Contemporary Sonification Practices." *Journal of Sonic Studies*, no. 10. https://www.researchcatalogue.net/view/220323/220324. Accessed November 2015.

Böhme, Gernot. 1993. "Atmosphere as the Fundamental Concept of a New Aesthetics." *Thesis Eleven* 36 (August): 113–126.

Böhme, Gernot. 2013. "The Art of the Stage Set as a Paradigm for an Aesthetics of Atmospheres." *Ambiances*. http://ambiances.revues.org/315. Accessed February 2014.

Bolt, Barbara. 2011. *Heidegger Reframed: Interpreting Key Thinkers for the Arts*. London: I. B. Tauris.

Bolt, Barbara. 2013. "Introduction: Toward a 'New Materialism' through the Arts." In Estelle Barrett and Barbara Bolt, eds., *Carnal Knowledge: Towards a 'New Materialism' through the Arts*. London: I. B. Tauris.

Bonnano, Mike. 1993. *Case Study: Barbie Liberation Organization*. http://beautifultrouble.org/case/barbie-liberation-organization/. Accessed October 2015.

Boon, Marcus. 2013. "One Nation under a Groove? Music, Sonic Borders, and the Politics of Vibration." http://soundstudiesblog.com/2013/02/04/one-nation-under-a-groove-sonic-borders-and-the-politics-of-vibration/. Accessed October 2015.

Bourriaud, Nicolas. 2002. *Postproduction: Culture as Screenplay: How Art Reprograms the World*. New York: Lukas & Sternberg.

Braidotti, Rosi. 2009. "Animals, Anomalies, and Inorganic Others: De-oedipalizing the Animal Other." *PMLA* 124 (2): 526–532.

Braidotti, Rosi. 2013. *The Posthuman*. Cambridge, UK: Polity Press.

Braidotti, Rosi, and Timotheus Vermeulen. 2014. "Borrowed Energy." *Frieze* 165 (September). http://www.frieze.com/issue/article/borrowed-energy/. Accessed June 2015.

Brown Council. 2011a. *Performance Histories: Remembering Barbara Cleveland*. Installed at "Nothing Like Performance," Artspace, Sydney. https://vimeo.com/33937142. Accessed December 2015.

Brown Council. 2011b. *Remembering Barbara Cleveland*. https://vimeo.com/44216128. Accessed December 2015.

Buchanan, Brett. 2015. "Transformative Compositions: Vinciane Despret's Animal Stories." Animal Publics: Emotions, Empathy, Activism. Australasian Animal Studies Association Conference, July 12–15, Melbourne.

Buck-Morss, Susan. 1993. "Aesthetics and Anaesthetics: Walter Benjamin's Artwork Essay Reconsidered." *New Formations* 20 (Summer).

Burton, Michael, and Michiko Nitta. n.d. *BurtonNitta: Projects by Michael Burton and Michiko Nitta* . http://www.burtonnitta.co.uk/algaeopera.html. Accessed June 2015.

Bussolini, Jeffrey. 2015. "The Philosophical Ethology of Roberto Marchesini." Animal Publics: Emotions, Empathy, Activism. Australasian Animal Studies Association Conference, July 12–15, Melbourne.

Cage, John. 1973. *Silence: Lectures and Writings*. London: Calder and Boyars.

Cao Fei. 2002. *Rabid Dogs*. https://www.youtube.com/watch?v=NJSd9m1deEU. Accessed October 2015.

Carbon Arts. n.d. *Melbourne Mussel Choir*. http://www.carbonarts.org/projects/melbourne-mussel-choir/. Accessed June 2015.

Cardiff, Janet, and George Bures Miller. 2012. *Alter Bahnhof Video Walk*. https://www.youtube.com/watch?v=sOkQE7m31Pw&feature=kp. Accessed January 2013.

Carter, Paul. 2004. *Material Thinking: The Theory and Practice of Creative Research*. Melbourne: Melbourne University Press.

Cavarero, Adriana. 2005. *For More Than One Voice: Toward a Philosophy of Vocal Expression*. Trans. P. A. Kottman. Stanford: Stanford University Press.

Christov-Bakargiev, Carolyn. 2014. "To Watch, to Listen, to Sing a Lullaby." In Sara Arrhenius, Susan Philipsz, James Lingwood, and Brigitte Franzen, eds., *Susan Philipsz: You Are Not Alone*. New York: Distributed Art Pub.

Chrulew, Matthew. 2015. "The Concept of 'Hybrid Community' in the Thought of Dominique Lestel." Animal Publics: Emotions, Empathy, Activism. Australasian Animal Studies Association Conference, July 12–15, Melbourne.

Clover, Catherine. 2012. *A Filth of Starlings*. Melbourne: Platform Public Contemporary Art Spaces.

Clover, Catherine. 2014. *Reading The Birds*. At re::set Trainspotters INC, part of MoreArt, 2014. http://exp-melb.blogspot.com.au/2014/10/reset-trainspotters-inc-upfield-bike.html. Accessed June 2015.

Clover, Catherine. 2015a. *Shooting the Breeze*. Melbourne: Stephen McLaughlan Gallery.

Clover, Catherine. 2015b. "Tell Me Something: Unlearning Common Noisy Wild Urban Birds through Listening, Voice and Language." PhD thesis, RMIT University, Melbourne.

COFA. 2010. "Sin of the World: Grayson's Messiah." *COFA Talks Online*. https://www.youtube.com/watch?v=-0nNadFyfuE. Accessed April 2013.

Connolly, William. 2013. "The 'New Materialism' and the Fragility of Things." *Millennium: Journal of International Studies* 41 (3).

Connor, Steven. 2000. *Dumbstruck: A Cultural History of Ventriloquism*. Oxford: Oxford University Press.

Connor, Steven. 2010. "Atmospherics." In Connor, *The Matter of Air: Science and Art of the Ethereal*. Chicago: University of Chicago Press. Available at http://www.stevenconnor.com/atmospherics/atmospherics.pdf, accessed October 2015.

Connor, Steven. 2014. "Surround Me." In Sara Arrhenius, Susan Philipsz, James Lingwood, and Brigitte Franzen, eds., *Susan Philipsz: You Are Not Alone*. New York: Distributed Art Pub.

Connor, Steven. 2015. "Acousmania." A lecture given at Sound Studies: Art, Experience, Politics, CRASSH, Cambridge, July 10. http://stevenconnor.com/acousmania.html. Accessed February 2016.

Coomer, Martin. 2014. "Vince woz'ere." *Timeout*, April 29–May 5.

Cox, Christoph. 2005. "Of Humans, Animals, and Monsters." In Nato Thompson with Christoph Cox and Joseph Thompson, eds., *Becoming Animal: Contemporary Art in the Animal Kingdom*. North Adams, MA: MASS MoCA Publications.

Crowley, Michael. 2006. "Prison Break." *New Republic*, April 24.

Cull, Laura. 2012. *Theatres of Immanence: Deleuze and the Ethics of Performance*. Houndmills, Basingstoke, UK: Palgrave Macmillan.

Daston, Lorraine, and Gregg Mitman. 2005a. "Introduction." In Daston and Mitman, eds., *Thinking with Animals: New Perspectives on Anthropomorphism*. New York: Columbia University Press.

Daston, Lorraine, and Gregg Mitman, eds. 2005b. *Thinking with Animals: New Perspectives on Anthropomorphism*. New York: Columbia University Press.

Deleuze, Gilles, and Félix Guattari. 1987. *A Thousand Plateaus: Capitalism and Schizophrenia*. Trans. Brian Massumi. Minneapolis: University of Minnesota Press.

DeLys, Sherre. 2004. *Long Ago, Parrot in an Interior*. ABC Radio National. http://mpegmedia.abc.net.au/rn/podcast/2013/05/smw_20130519_2005.mp3. Accessed November 2015.

Demers, Louis-Philippe, and Bill Vorn. 2009. "La Cour des Miracles Robotic Art Project." https://www.youtube.com/watch?v=14Y-OP4v3EY. Accessed September 2015.

Despret, Vinciane. 2004. "The Body We Care For: Figures of Anthropo-zoo-genesis." *Body and Society* 10 (2–3): 125–170.

Despret, Vinciane. 2008. "The Becomings of Subjectivity in Animal Worlds." *Subjectivity* 23:123–129.

Despret, Vinciane. 2013a. "From Secret Agents to Interagency." *History and Theory* 52 (4): 29–44.

Despret, Vinciane. 2013b. "Responding Bodies and Partial Affinities in Human-Animal Worlds." *Theory, Culture and Society* 30 (7/8): 51–76.

Doherty, Saskia. 2015. "Do Not Leave Me." *Saskia Doherty*. https://saskiadoherty .com/2015/11/02/time-out-of-time/. Accessed January 2016.

Dolar, Mladen. 2006. *A Voice and Nothing More*. Cambridge, MA: MIT Press.

Dolphijn, Rick, and Iris van der Tuin. 2012. *New Materialism: Interviews and Cartographies*. Ann Arbor, MI: MPublishing and Open Humanities Press. http:// www.openhumanitiespress.org/books/titles/new-materialism/.

Duxbury, L. E. M. Grierson, and D. Waite, eds. 2008. *Thinking through Practice: Art as Research in the Academy*. Melbourne: School of Art, RMIT University.

Dyson, Frances. 2014. *The Tone of Our Times: Sound, Sense, Economy, and Ecology*. Cambridge, MA: MIT Press.

Eidsheim, Nina Sun. 2015. *Sensing Sound: Singing and Listening as Vibrational Practice*. Durham: Duke University Press.

Flannery, Tim. 2005. *The Weather Makers: The History and Future Impact of Climate Change*. Melbourne: Text Publishing.

Fontana, Bill. 2009. "Harmonic Bridge." https://www.youtube.com/watch?v =L2KO38Z-2SU. Accessed November 2015.

Fontana, Bill. 2014. "Bill Fontana on Making the Sand Sing." http://www.thenational .ae/arts-culture/art/bill-fontana-on-making-the-sand-sing. Accessed November 2015.

Fuller, Matthew. 2007. "Art for Animals." http://v2.nl/archive/articles/art-for-animals. Accessed November 2015.

Galperina, Marina. 2012. *Wafaa Bilal's Invisible Casualties Tattoo*. http://flavorwire .com/339858/10-contemporary-works-of-political-art-that-work/8. Accessed November 2015.

Gibbs, Anna. 2010. "After Affect: Sympathy, Synchrony and Mimetic Communication." In Melissa Gregg and Gregory J. Seigworth, eds., *The Affect Theory Reader*. Durham: Duke University Press.

Gibbs, Anna. 2015. "Mimesis as a Mode of Knowing: Vision and Movement in the Aesthetic Practice of Jean Painlevé." *Angelaki Journal of the Theoretical Humanities* 20:3. Available at https://www.academia.edu/15184096/MIMESIS_AS_A_MODE_OF _KNOWING.

Grayson, Richard. 2004. *Messiah 2004 (Extract)*. https://vimeo.com/41556829. Accessed November 2007.

Gregg, Melissa, and Gregory J. Seigworth, eds. 2010. *The Affect Theory Reader.* Durham: Duke University Press.

Grierson, Elizabeth, and Laura Brearley. 2009. *Creative Arts Research: Narratives of Methodologies and Practices.* Rotterdam: Sense Publishers.

Hansen, Elle-Mie Ejdrup. 2013a. *In-betweenness.* http://www.ejdruphansen.dk/in-betweenness/. Accessed June 2014.

Hansen, Elle-Mie Ejdrup. 2013b. *The Sound of …* http://www.ejdruphansen.dk/the-sound-of/. Accessed June 2014.

Hansen, Mark, and Ben Rubin. 2009. "Listening Post, Real-Time Data Responsive Environment." https://www.youtube.com/watch?v=dD36IajCz6A. Accessed July 2015.

Haraway, Donna. 1988. "Situated Knowledges: The Science Question Questions in Feminism and the Privilege of Partial Perspective." *Feminist Studies* 14 (3): 575–599.

Haraway, Donna. 2008. *When Species Meet.* Minneapolis: University of Minnesota Press.

Haraway, Donna, and Thyrza Goodeve. 2000. *How Like a Leaf: An Interview with Thyrza Nichols Goodeve.* New York: Routledge.

Hawkins, Gay. 2006. *The Ethics of Waste: How We Relate to Rubbish.* Lanham, MD: Rowman and Littlefield.

Hayles, N. Katherine. 1999. *How We Became Posthuman: Virtual Bodies in Cybernetics, Literature, and Informatics.* Chicago: University of Chicago Press.

Heidegger, Martin. 1962. *Being and Time* (1927). Trans. John Macquarrie and Edward Robinson. New York: Harper and Row.

Hibberd, Lily. 2004. "un Editorial." *un Magazine* (1). http://unprojects.org.au/content/1.magazine/2.issues/1.issue-1-1/un1.1.pdf

High, Kathy. 2000–2005. *Everyday Problems of the Living, a Serial.* https://vimeo.com/80733777. Accessed March 2014.

Hirsch, Antonia. 2001. "Intangible Economics: An Introduction." In Anu Koivunen and Susanna Paasonen, eds., *Affective Encounters: Rethinking Embodiment in Feminist Media Studies: Conference Proceedings.* Turku: University of Turku, School of Art.

Hoskins, Te Kawehau, and Alison Jones. 2015. "Thingly Power: A Ta Moko Signature on Paper." Transversal Practices: Matter, Ecology and Relationality. VI International Conference on New Materialisms. Victorian College of the Arts, University of Melbourne.

Hugill, Andrew. 2012. *Pataphysics: A Useless Guide.* Cambridge, MA: MIT Press.

Ihde, Don. 2007. *Listening and Voice: Phenomenologies of Sound*. 2nd ed. Albany: State University of New York Press.

Ingold, Tim. 2007. *Lines: A Brief History*. London: Routledge.

Ingold, Tim. 2011. *Being Alive: Essays on Movement, Knowledge, and Description*. London: Routledge.

Introna, Lucas D. 2009. "Ethics and Speaking of Things." *Theory, Culture and Society* 26 (4): 25–46.

Jarry, Alfred. 1980. "Exploits and Opinions of Dr Faustroll: A Neo-Scientific Novel." In *Selected Works of Alfred Jarry*, ed. Roger Shattuck and Simon Watson Taylor. London: Eyre Methuen.

Jasper, Adam, and Sianne Ngai. 2011. "Our Aesthetics Categories: An Interview with Sianne Ngai." *Cabinet*, no. 43. http://www.cabinetmagazine.org/issues/43/jasper _ngai.php. Accessed November 2014.

Jeremijenko, Natalie. 2004. "If Things Can Talk, What Do They Say? If We Can Talk to Things, What Do We Say?" In Noah Wardrip-Fruin and Pat Harrigan, eds., *First Person: New Media as Story, Performance, and Game*. Cambridge, MA: MIT Press.

Jinko43. 2011. *Hitler Gets MAD at the Footy (AFL 2011 Qualifying Final, WCE vs COLL*. http://www.youtube.com/watch?v=DeMCv7ddzXU. Accessed March 2013.

Jones, Amelia. 2010. Space, Body and Self in Nauman's Work. In *The "Do It Yourself" Artwork: Participation from Fluxus to New Media*, ed. Anna Dezeuze. Manchester: Manchester University Press.

Jones, Lyndal. 2015. "With an Eye to Four Walls and Two Ears to the Ground: Making Art by Moving through a House." Transversal Practices: Matter Ecology and Relationality: VI International Conference on New Materialisms. Melbourne.

Jones, Lyndal. 2016. *The Avoca Project*. Melbourne: Heide Museum of Modern Art.

Jones, Lyndal. n.d. *The Avoca Project: Art, Place, Climate Change*. http://avocaproject.org/. Accessed March 2015.

Kahn, Douglas. 2013. *Earth Sound Earth Signal: Energies and Earth Magnitude in the Arts*. Berkeley: University of California Press.

Kim-Cohen, Seth. 2009. *In the Blink of an Ear: Toward a Non-Cochlear Sonic Art*. New York: Continuum.

Koivunen, Anu. 2001. "Preface: The Affective Turn?" In Anu Koivunen and Susanna Paasonen, eds., *Affective Encounters: Rethinking Embodiment in Feminist Media Studies: Conference Proceedings*. Turku: University of Turku, School of Art, Literature and Music Series A, 49. https://susannapaasonen.files.wordpress.com/2014/11/proceedings.pdf. Accessed Feb. 24, 2015.

k-pun. 2006. "Hauntology Now." Posted January 17, 2006. http://k-punk .abstractdynamics.org/archives/007230.html. Accessed February 5, 2008.

LaBelle, Brandon. 2006. *Background Noise: Perspectives on Sound Art*. New York: Continuum.

LaBelle, Brandon. 2010. *Acoustic Territories: Sound Culture and Everyday Life*. New York: Continuum.

LaBelle, Brandon. 2014. *Lexicon of the Mouth: Poetics and Politics of Voice and the Oral Imaginary*. New York: Bloomsbury.

Lang, Pe, and Marianthi Papalexandri-Alexandri. 2014. *Untitled V*. http:// kunsthalaarhus.dk/en/programmes/spor-festival-2014-sound-installation-untitled-v.

Latour, Bruno. 2004a. "How to Talk about the Body? The Normative Dimension of Science Studies." *Body and Society* 10 (2–3): 205–229.

Latour, Bruno. 2004b. *Politics of Nature: How to Bring the Sciences into Democracy*. Trans. Catherine Porter. Cambridge, MA: Harvard University Press.

Latour, Bruno. 2005. *Reassembling the Social: An Introduction to Actor-Network-Theory*. Oxford: Oxford University Press.

Latour, Bruno. 2013. "The Anthropocene and the Destruction of the Image of the Globe." Lecture, University of Edinburgh. https://www.youtube.com/watch?v=4 -l6FQN4P1c. Accessed March 2014.

Latour, Bruno. 2014. "Agency at the Time of the Anthropocene." *New Literary History* 45:1–18.

Leber, Sonia, and David Chesworth. n.d. *The Way You Move Me*. http:// leberandchesworth.com/filmworks/the-way-you-move-me/. Accessed June 2013.

Lingis, Alphonso. 2009. "The Voices of Things." *Senses and Society* 4 (3): 273–282.

Liquid Architecture. 2015. *Time out of Time*. http://www.liquidarchitecture.org.au/ program/time-out-of-time/. Accessed December 2015.

Lønstrup, Ansa. 2014. "Face the Voice: Voice and Listening in an Exhibition: Tony Oursler's *Face to Face*." In Malcolm Angelucci and Chris Caines, eds., *Voice/Presence/ Absence: An Interdisciplinary Dialogue on Voice and the Humanities*. Sydney: UTS ePress. https://epress.lib.uts.edu.au/books/voicepresenceabsence. Accessed January 2015.

Lucier, Alvin. n.d. *I Am Sitting in a Room*. http://ubumexico.centro.org.mx/sound/ source/Lucier-Alvin_Sitting.mp3. Accessed June 2013.

Manning, Erin. 2015. "For Pragmatics of the Useless or the Value of the iInfrathin—27 Propositions." Keynote address at Transversal Practices: Matter, Ecology and Relationality. VI International Conference on New Materialisms. Victorian College of the Arts, University of Melbourne.

Manning, Erin. 2016. *The Minor Gesture*. Durham: Duke University Press.

Manning, Erin, and Brian Massumi. 2014. *Thought in the Act: Passages in the Ecology of Experience*. Minneapolis: University of Minnesota Press.

Marclay, Christian. 1995. *Telephones*. https://www.youtube.com/watch?v=yH5HTPjPvyE. Accessed March 2012.

Mass Action. n.d. "137 Cakes in 90 Hours: About Brown Council." http://browncouncil.com/massaction/browncouncil. Accessed December 2015.

Massumi, Brian. 2014. *What Animals Teach Us about Politics*. Durham: Duke University Press.

Massumi, Brian. n.d. "The Autonomy of Affect." http://www.brianmassumi.com/textes/Autonomy%20of%20Affect.PDF. Accessed June 2015. Another version available in *Cultural Critique, The Politics of Systems and Environments*, no. 31, part II (Autumn 1995): 83–109.

McGrath, John E. 2001. *Loving Big Brother: Performance, Privacy and Surveillance Space*. London: Routledge.

Migone, Christof. 2012. *Sonic Somatic: Performances of the Unsound Body*. Los Angeles: Errant Bodies Press.

Miranda, Maria. 2003. "Museum of Rumour: Fictive Art in New Media." MVA thesis, Sydney College of the Arts.

Miranda, Maria. 2013. *Unsitely Aesthetics: Uncertain Practices in Contemporary Art*. Los Angeles: Errant Bodies Press.

Mitchell, W. J. T. 2001. "The Work of Art in the Age of Biocybernetic Reproduction." Lecture, Museum of Contemporary Art, Sydney, August 7.

Morton, Timothy. 2013. *Hyperobjects: Philosophy and Ecology after the End of the World*. Minneapolis: University of Minnesota Press.

National Film Board of Canada. 2012. *Bear 71*. http://bear71.nfb.ca/#/bear71.

Netburn, Deborah. 2012. "A Chat with the Cat behind 'Le Chat Noir.'" *Los Angeles Times*, October 24. http://articles.latimes.com/2012/oct/24/business/la-fi-cat-video-20121024. Accessed October 2015.

Neumark, Norie. 1996. *Separation Anxiety: Not the Truth about Alchemy*. Staten Island, NY: New Radio and Performing Arts.

Neumark, Norie. 1999a. *Dead Centre: The Body with Organs*. Sydney: Listening Room, ABC Classic FM.

Neumark, Norie. 1999b. *Esprit de Corps: Oscillating with Emotion*. Sydney: Listening Room, ABC Classic FM.

Neumark, Norie. 2010a. "Doing Things with Voices: Performativity and Voice." In Norie Neumark, Ross Gibson, and Theo van Leeuwen, eds., *Voice: Vocal Aesthetics in Digital Arts and Media*. Cambridge, MA: MIT Press.

Neumark, Norie. 2010b. "Introduction: The Paradox of Voice." In Norie Neumark, Ross Gibson, and Theo van Leeuwen, eds., *Voice: Vocal Aesthetics in Digital Arts and Media*. Cambridge, MA: MIT Press.

Neumark, Norie. 2015a. "Enchanted Voices: Voice in Australian Sound Art." In Thomaidis Konstantinos and Ben Macpherson, eds., *Voice Studies: Critical Approaches to Process, Performance and Experience*. London: Routledge.

Neumark, Norie. 2015b. "Mapping Soundfields: A User's Manual." *Journal of Sonic Studies*, no. 10 (October). https://www.researchcatalogue.net/view/219795/219796. Accessed October 2015.

Neumark, Norie, Ross Gibson, and Theo van Leeuwen, eds. 2010. *Voice: Vocal Aesthetics in Digital Arts and Media*. Cambridge, MA: MIT Press.

Neumark, Norie, and Maria Miranda. 2013. *Coalface*. Melbourne: Library Artspace.

Neumark, Norie, and Igor Štromajer. 2013. "Conversation." In Maria Miranda, *Unsitely Aesthetics: Uncertain Practices in Contemporary Art*. Los Angeles: Errant Bodies Press.

Ngai, Sianne. 2007. *Ugly Feelings*. Cambridge, MA: Harvard University Press.

Ngai, Sianne. 2012. *Our Aesthetic Categories: Zany, Cute, Interesting*. Cambridge, MA: Harvard University Press.

O'Meara, Radha. 2015. "Did the Lumiere Brothers Invent Internet Cat Videos in the 1890s?" Animal Publics: Emotions, Empathy, Activism. Australasian Animal Studies Association Conference, July 12–15, Melbourne.

Ono, Yoko. 1961. *Cough Piece.* http://ubumexico.centro.org.mx/sound/ono_yoko/Ono-Yoko_Cough-Piece_1961.mp3 . Accessed March 2013.

Out of the Blue. 2013. *Brown Council: Remembering Barbara Cleveland*. http://www.outoftheblue.org.uk/brown-council/. Accessed December 2015.

Parikka, Jussi. 2012. "New Materialism as Media Theory: Medianatures and Dirty Matter." *Communication and Critical/Cultural Studies* 9 (1): 95–100.

Parker, Andrew, and Eve Kosofsky Sedgwick. 1995. "Introduction: Performativity and Performance." In Andrew Parker and Eve Kosofsky Sedgwick, eds., *Performativity and Performance*. Abingdon, UK: Routledge.

Parker, Andrew, and Eve Kosofsky Sedgwick. 2004. "Introduction to Performativity and Performance." In Henry Bial, ed., *The Performance Studies Reader*. London: Routledge.

Pellegrinelli, Lara. 2010. "Artist Tattoos Indelible Iraq Memorial into His Skin." National Public Radio. http://www.npr.org/templates/story/story.php?storyId =127348258. Accessed November 2015.

Perloff, Marjorie. 2001. "'But Isn't the Same at Least the Same?' Translatability." In *Wittgenstein, Duchamp, and Jacques Roubaud. Jacket*, no. 14 (July). http://jacketmagazine.com/14/perl-witt.html. Accessed July 2010.

Petrovitch, Debra. 2015. "Discomfort of the Flesh: Antonin Artaud's Theatre Realized with New Media Techniques." PhD thesis, Sydney College of the Arts, University of Sydney. http://hdl.handle.net/2123/14178. Accessed March 2016.

Philipsz, Susan. 2011. "You Look at Things Differently by Hearing Things Differently." Melbourne Town Hall, August 18.

Philipsz, Susan. 2015. "General: Susan Philipsz." *Pure Volume*. http://www.purevolume.com/listeners/piquantmercenar77/posts/1975567/Susan+Philipsz. Accessed January 2016.

Pick, Anat. 2011a. *Creaturely Poetics: Animality and Vulnerability in Literature and Film*. New York: Columbia University Press.

Pick, Anat. 2011b. "Interview with Anat Pick, Author of Creaturely Poetics." *CUPblog*. Columbia University Press blog. http://www.cupblog.org/?p=4001. Accessed September 2015.

Pick, Anat. 2015. "Vegan Cinema." Animal Publics: Emotions, Empathy, Activism. Australasian Animal Studies Association Conference, July 12–15, Melbourne.

Pinchbeck, Cara. 2015. "When Silence Falls: An Introduction." In *When Silence Falls*. Sydney: Art Gallery of New South Wales.

Rabelais, François. 2014. *Five Books of the Lives, Heroic Deeds and Sayings of Gargantua and His Son Pantagruel*. Trans. Thomas Urquhart and Peter Antony Motteux. https://ebooks.adelaide.edu.au/r/rabelais/francois/r11g/book4.56.html. Accessed December 2015.

Rendell, Jane. 2006. *Art and Architecture: A Place Between*. London: I. B. Tauris.

Rendell, Jane. 2010. *Site-Writing: The Architecture of Art Criticism*. London: I. B. Tauris.

Rendell, Jane. 2014. "Configuring Critique." The Future of the Discipline, ACUADS 2014. Melbourne.

Reynolds, Jack. n.d. "Jacques Derrida (1930–2004)." *Internet Encyclopedia of Philosophy* . http://www.iep.utm.edu/derrida/. Accessed March 2016.

Riis, Morten. 2014. *Opaque Sounding*. https://www.youtube.com/watch?v =nzybYC5nqJM. Accessed October 2014.

Riis, Morten. 2015. "Where Are the Ears of the Machine? Towards a Sounding Micro-temporal Object-Oriented Ontology." *Journal of Sonic Studies*, no. 10. https://www.researchcatalogue.net/view/219290/21929.1. Accessed November 2015.

Rinaldo, Ken. 2013. *Autopoiesis*. https://www.youtube.com/watch?v=3w53KboB-00&ebc=ANyPxKozBeZRfk769T5_KUsDtuXIAZHMu0XauSwefgBLnoldx81byA6FP4I-hM0RswxsJtLuFSU4OSTJA22e6_X4xyRxNV7aJtw. Accessed February 2014.

Ronell, Avital. 1989. *The Telephone Book: Technology, Schizophrenia, Electric Speech.* Lincoln: University of Nebraska Press.

Rooster Teeth. 2015. *Why Are We Here?—Episode 1—Red vs. Blue Season 1.* https://www.youtube.com/watch?v=9N8IpxO6rKs. Accessed January 2016.

Roosth, Sophia. 2009. "Screaming Yeast: Sonocytology, Cytoplasmic Milieus, and Cellular Subjectivities." *Critical Inquiry* 35 (2):332–350.

Rose, Deborah Bird. 1996. *Nourishing Terrains: Australian Aboriginal Views of Landscape and Wilderness.* Canberra: Australian Heritage Commission.

Rose, Jodi. 2011a. "PechaKuchaMaastricht." https://www.youtube.com/watch?v=7ClvBVVT2go. Accessed November 2015.

Rose, Jodi. 2011b. "Singing Bridges." https://www.youtube.com/watch?v=sj-FfpTf1Cs. Accessed November 2015.

Rose, Jon. 2012a. "Lines in Red Sand." In John Zorn, ed., *Arcana VI: Musicians on Music.* New York: Hips Road/Tzadik.

Rose, Jon. 2012b. *Syd and George.* ABC. http://www.abc.net.au/radionational/programs/intothemusic/syd-and-george-by-jon-rose/3933256. Accessed June 2014.

Rose, Jon. n.d. *Syd and George.* http://www.jonroseweb.com/h_radio_syd_and_george.html. Accessed June 2014.

Ross, Eloise. 2016. "The Anxiety of the Cinematic Moment: Sound and Sensory Participation in Late Classical Hollywood Cinema," PhD dissertation, La Trobe University, Melbourne.

Ross, Monica. 2007a. *Empyre*, November 20, 2007. https://lists.cofa.unsw.edu.au/pipermail/empyre/2007-November/000135.html.

Ross, Monica. 2007b. *Empyre*, November 25, 2007. https://lists.cofa.unsw.edu.au/pipermail/empyre/2007-November/000153.html.

Ross, Monica. 2007c. "The Trouble with Performance Art." In *This Will Not Happen without You: From the Collective Archive of The Basement Group, Projects UK and Locus+ (1977–2077).* Newcastle upon Tyne: Locus+Publications.

RTMark. 2000a. "The Barbie Liberation Organization." http://www.rtmark.com/ blo.html. Accessed October 2015.

RTMark. 2000b. "B.L.O. 'Operation Newspeak' Script." http://www.rtmark.com/ bloscript.html. Accessed October 2015.

Ryzik, Melena. 2012. "At Cat Video Film Festival, Stars Purr for Close-Ups." *New York Times.* http://www.nytimes.com/2012/09/01/movies/at-cat-video-film-festival-stars -purr-for-close-ups.html. Accessed January 2016.

Sacks, Oliver. 1989. *Seeing Voices: A Journey into the World of the Deaf.* Berkeley: University of California Press.

Scanlines. n.d. "This Is Barbara Cleveland." *Scanlines.* http://scanlines.net/object/ barbara-cleveland.

Segade, Manuel. 2007. "Memory Trigger: Susan Philipsz Talks to Manuel Segade about the Emotional and Psychological Properties of Song, and How This Became the Basis for Her Art." *C: International Contemporary Art*, no. 95 (Fall). http://connection .ebscohost.com/c/interviews/26918067/memory-trigger. Accessed August 2011.

Shattuck, Roger, and Simon W. Taylor, eds. 1980. *Selected Works of Alfred Jarry.* New York: Grove Press.

Shaviro, Steven. 2006. "A Voice and Nothing More." *The Pinocchio Theory*, posted April 14, 2006. http://www.shaviro.com/Blog/?p=489. Accessed January 2008.

Sheldrake, Rupert. 1981. "Three Approaches to Biology: Part II. Vitalism." *Theoria to Theory* 14: 227–240.

Sheldrake, Rupert. 1988. *The Presence of the Past: Morphic Resonance and the Habits of Nature.* Rochester, VT: Park Street Press.

Sheldrake, Rupert. 1999. *Dogs That Know When Their Owners Are Coming Home: The Unexplained Powers of Animals.* New York: Three Rivers Press.

Sheldrake, Rupert. n.d. "Morphic Resonance and Morphic Fields—an Introduction." http://www.sheldrake.org/research/morphic-resonance/introduction. Accessed December 2015.

Shouse, Erik. 2005. "Feeling, Emotion, Affect." *M/C Journal* 8 (6).

Siegert, Bernhard. 1999. *Relays: Literature as an Epoch of the Postal System.* Trans. Kevin Repp. Stanford: Stanford University Press.

Silver, Dan. 2012. "Boredom." *The Point.* http://thepointmag.com/2012/examined -life/boredom-3. Accessed June 2013.

Smith, Jacob. 2008. *Vocal Tracks: Performance and Sound Media.* Berkeley: University of California Press.

Stark, Frances. 2012. *Frances Stark—My Best Thing.* https://vimeo.com/38244867. Accessed June 2013.

Stengers, Isabelle. 2011. *Thinking with Whitehead: A Free and Wild Creation of Concepts.* Trans. Michael Chase. Cambridge, MA: Harvard University Press.

Sterne, Jonathan, and Mitchell Akiyama. 2012. "The Recording that Never Wanted to Be Heard, and Other Stories of Sonification." In Trevor Pinch and Karin Bijsterveld, eds., *The Oxford Handbook of Sound Studies.* New York: Oxford University Press.

Štromajer, Igor. n.d. (a). *Ballettikka Internettikka: Stattikka.* http://www.intima.org/bi/stattikka/index.html. Accessed March 2016.

Štromajer, Igor. n.d. (b). *Intima.org: Opperra Teorettikka Internettikka.* http://www.intima.org/oppera/oti/. Accessed March 2016.

Supper, Alexandra. 2014. "Sublime Frequencies: The Construction of Sublime Listening Experiences in the Sonification of Scientific Data." *Social Studies of Science* 44 (1): 34–58.

Taussig, Michael. 1993. *Mimesis and Alterity: A Particular History of the Senses.* London: Routledge.

Taussig, Michael. 2010. "Humming." In Norie Neumark, Ross Gibson, and Theo van Leeuwen, eds., *Voice: Vocal Aesthetics in Digital Arts and Media.* Cambridge, MA: MIT Press.

Taylor, Hollis. 2007. *Post Impressions: A Travel Book for Tragic Intellectuals.* Portland, OR: Twisted Fiddle.

Taylor, Hollis. 2014. "The Chimeric Voice: Birdsong, Imitation, and the Definition of Music." In Malcolm Angelucci and Chris Caines, eds., *Voice/Presence/Absence: An Interdisciplinary Dialogue on Voice and the Humanities.* Sydney: UTS ePress. https://epress.lib.uts.edu.au/books/voicepresenceabsence. Accessed January 2015.

Ten Bos, René. 2009. *"Talking to the Animals." The Philosopher's Zone.* ABC Radio National.

Thomaidis, Konstantinos, and Ben Macpherson. 2015. *Voice Studies: Critical Approaches to Process, Performance and Experience.* London: Routledge.

Thompson, Nato, with Christoph Cox and Joseph Thompson, eds. 2005. *Becoming Animal: Contemporary Art in the Animal Kingdom.* North Adams, MA: MASS MoCA Publications.

Tiatia, Angela. 2013. *Edging and Seaming.* http://www.angelatiatia.com/work. Accessed February 2016.

Tiatia, Angela. 2015. "Angela Tiatia." QAGOMA. https://www.qagoma.qld.gov.au/whats-on/exhibitions/apt8/artists/angela-tiatia. Accessed February 2016.

Toor, Amar. 2012. "Listen to Alvin Lucier's Chilling Aural Decay." http://www.theverge.com/2012/12/29/3814240/alvin-lucier-i-am-sitting-in-a-room-video. Accessed March 2015.

Toydeath. n.d. www.toydeath.com. Accessed June 2008.

van Eck, Cathy. 2013. "Between Air and Electricity: Microphones and Loudspeakers as Musical Instruments." PhD thesis, University of Leiden.

Velonaki, Mari. 2013. *Fish-Bird*. https://www.youtube.com/watch?v=CG5kcBtd9zI. Accessed September 2015.

Voegelin, Salomé. 2010. *Listening to Noise and Silence: Towards a Philosophy of Sound Art*. New York: Continuum.

von Uexküll, Jakob. 2010. *A Foray into the Worlds of Animals and Humans with A Theory of Meaning*. Trans. Joseph D. O'Neill. Minneapolis: University of Minnesota Press.

Vorn, Bill. 2015. "La Cour des Miracles at the Contemporary Art Museum of Montreal (Voice Over)." http://billvorn.concordia.ca/robography/Cour.html. Accessed December 2015.

Walker Art Center. 2015a. "Internet Cat Video Festival 2015." http://www.walkerart.org/calendar/2015/internet-cat-video-festival-2015. Accessed December 2015.

Walker Art Center. 2015b. "The Visitors: The People of #catvidfest." http://blogs.walkerart.org/walkerseen/2014/08/15/the-visitors-the-people-of-catvidfest/. Accessed December 2015.

Warhol, Andy. 1975. *The Philosophy of Andy Warhol (From A to B and Back Again)*. New York: Harcourt.

Welsh, Ryan. 2007. "Ekphrasis." *University of Chicago: Theories of Media: Keywords Glossary*. http://csmt.uchicago.edu/glossary2004/ekphrasis.htm. Accessed December 2015.

Whatmore, Sarah. 2002. *Hybrid Geographies: Natures, Cultures, Spaces*. London: Sage.

Wikipedia. 2015. "Ekphrasis." https://en.wikipedia.org/wiki/Ekphrasis. Accessed December 2015.

Wikipedia. 2016. "Machinima." https://en.wikipedia.org/wiki/Machinima. Accessed December 2015.

Wired Lab. n.d. http://wiredlab.org/sno/. Accessed January 2016.

Wolfe, Cary. 2003. *Animal Rites: American Culture, the Discourse of Species, and Posthumanist Theory*. Chicago: University of Chicago Press.

Wunderlich, Filipa Matos. 2008. "Walking and Rhythmicity: Sensing Urban Space." *Journal of Urban Design* 13 (1): 125–139.

Zohar, Ayelet. 2011. "The Elu[va]sive Portrait: Mimicry, Masquerade and Camouflage: Conceptual and Theoretical Notes, an Introduction." *Trans-Asia Photography Review* 3 (1) (Fall).

Index

Note: Page numbers followed by *f* denote illustrations.